ARTWORDS

DISCOURSE ON
THE 60s AND 70s

ARTWORDS

DISCOURSE ON
THE 60s AND 70s

by JEANNE SIEGEL

DA CAPO PRESS • NEW YORK

Library of Congress Cataloging in Publication Data

Siegel, Jeanne.
 Artwords : discourse on the 60s and 70s / by Jeanne
Siegel. — 1st Da Capo Press ed.
 p. cm.
 Originally published: Ann Arbor, Mich. : UMI Research Press,
c1985.
 Includes index.
 ISBN 0-306-80474-3
 1. Art, Modern — 20th century — Themes, motives. 2. Artists —
— New York N.Y. — Interviews. 3. Artists — Interviews. I. Title.
N6490.S496 1992 91-33358
709′04′6 — dc20 CIP

First Da Capo Press edition 1992

This Da Capo Press paperback edition of *Artwords* is an unabridged
republication of the edition published in Ann Arbor, Michigan in 1985.
It is reprinted by arrangement with the author.

Published by Da Capo Press, Inc.
A Subsidiary of Plenum Publishing Corporation
233 Spring Street, New York, N.Y. 10013

Contents

List of Plates

Acknowledgments

Fifteen of the interviews appearing in this book were recorded initially for broadcast on radio station WBAI between 1966 and 1970. WBAI was a nonprofit, noncommercial, listener-subscribed radio station located in midtown Manhattan under the auspices of the Pacifica Foundation. Founded in 1960, it was dedicated to radical ideas in art, music, and politics. I was attracted to WBAI partly because by the mid-sixties, the station represented what seemed to be the last voice of the free press in that time of political turmoil. Furthermore, its presentation had an informality that appealed to the artist. It was *the* station that creative people turned on while working in their studios.

Four of the broadcast interviews were published later in leading art periodicals. Four others were commissioned directly by the art magazines. I wish to thank *ARTnews, Arts, Art in America, Artforum,* and *Studio International* for granting permission to reprint the articles.

I also want to thank two young art historians, Maurice Berger and Monroe Denton, for their assistance in editing portions of the manuscript. In transcribing the artists' words I strove to stay as close to the original tape as possible, only editing where absolutely essential for coherence and brevity. My greatest debt is to the artists who were not only informative but so good-humored.

Introduction

Artists developed a pervasive desire to discuss, explain, and control their work through their own words by the mid-sixties perhaps as in no other time in history. Artists' writings began to appear frequently in art periodicals, and a number of painters and sculptors found a new forum as reviewers and critics.

This ran counter to the image of the visual artist throughout most of western history. If not "a bumpkin or Dionysian or dumbbell" as Ad Reinhardt phrased it, the artist was certainly considered an inarticulate person who was able to express himself only through paint or stone.

Closer to the truth, artists have been generally reluctant to talk about their work. This reticence was partly due to the idea that the visual product is the end point, and they did not want to dissipate their energies. This sensibility was reflected in the often-heard phrase, "If I talk about it, I can't do it."

Elitism may also have been to blame for this silence. A clear example of this was the stance taken by the Abstract Expressionists in the 1950s; feeling that they were totally unwanted and misunderstood by a hostile public, they turned their backs to it. But the frequent meetings at The Club testify to the fact that artists of even this earlier period at least enjoyed talking about art to each other.

The elitist position became doctrinaire for one group of artists who matured in the early sixties—the Color Field painters, Morris Louis, Kenneth Noland, and Jules Olitski. Their opposition to personal statements about their work, however, did not hinder discussion; in reality they chose to enter into dialogue with only a few artists and critics (particularly Clement Greenberg) whose opinions they respected.

But this laconic stance was the exception by the mid-sixties. The artist emerged first through the written word, then via personal appearances on radio and television, to become a truly public figure.

There are many reasons for the development of this phenomenon. From an art historical point of view, it is a logical link in a chain that

started with the art itself. The radical and hermetic nature of Abstract Expressionism enhanced the critic's function as a necessary source of enlightenment for a mystified audience. The peculiar nature of the art demanded a new form of criticism—one that was based on the premise that the art expressed itself only through its own medium. This "formalist criticism" limited itself to a descriptive analysis of the work on exclusively formal grounds (i.e., questions of space, color, shape, and brushwork). In order to conduct such analysis, it became mandatory for the critic to draw closer to the artist—to be a privileged observer of the creative process. This was exemplified first by the modernist critic, Clement Greenberg, who gave critical judgments in the studios of artists he supported, made choices of the best work for exhibitions, and mediated with the gallery. Although Greenberg had already made his formalist criticism known by the early sixties, younger critics such as Michael Fried and Rosalind Krauss were to spread and finally codify his theories within the same decade.

The reaction was obvious. Who, artists questioned, was better equipped to discuss a work in terms of choice of materials and process, than the artist himself. Such an attitude largely accounts for the sudden spurt of critical writing that appeared around 1964 by Minimalist sculptors such as Donald Judd, Mel Bochner, and Robert Smithson in *Arts* magazine, and a little later by Robert Morris in *Artforum*. As writers, these artists were engaged in explaining not only their own Minimal sculpture but evaluating other artists' work as well, an activity that continued into the seventies. The shift was away from critical techniques founded on notions of aesthetic metaphor and gesture to a more abbreviated "literalness" or apodictic statement.

At the same time what became as significant as primacy of medium (and ultimately to replace it) was the "intention" of the artist. Now the artist's personal account of intention in the work became more important than any subjective interpretation offered by the critic, often accompanying the work as text along with the title. This would develop into documentation of inaccessible or ephemeral works in the late sixties.

The artist's desire to articulate his ideas can be correlated with the more intellectual, anti-aesthetic attitude embodied by the conceptual art of the mid-sixties. Marcel Duchamp, the seminal influence on the conceptualist movement with his radical stand against traditional artmaking, had a great deal to say. Having given up painting in 1915, Duchamp settled in New York in 1942 to spend a great deal of time playing chess, designing catalogs, serving on juries, conducting interviews, participating in round tables, and writing critical pieces. His first televised interview was broadcast on NBC in 1956. During the sixties (Duchamp died in 1968) he had

important extended interviews published and continued to write notes that are crucial for the understanding of his works.

Duchamp's influence differed for different artists. Both Jasper Johns and Robert Rauschenberg were referred to as Neo-Dadaist largely through the influence of Duchamp, whom they both knew and admired. Pulling Duchamp's concerns back into painting, Johns introduced banal objects and writing into his paintings by incorporating the titles. Duchamp's interest in language and its relation to thought and vision was of paramount concern to Johns. Rauschenberg's first acknowledgment of Duchamp was in 1953, when he erased a drawing by Willem de Kooning—an iconoclastic act echoing Duchamp's adding a moustache and goatee to the *Mona Lisa*. While neither Johns nor Rauschenberg shared Duchamp's nihilism toward art in general, Rauschenberg made the incorporation of the reproduced image a major factor in his art, which assumes a seminal role in the current post-modernist argument.

Duchamp's direct and indirect influence on Pop artists is too complex to recount here. However, Andy Warhol's drawing on advertising as imagery can be cited as one instance of Duchamp's influence on the usage of language. Language obviously fascinated Duchamp throughout his career, and this characteristic as an influence on younger artists was to peak in the work of Joseph Kosuth, starting with his dictionary definitions. Kosuth, the purest of the conceptual artists, eliminated the visual element entirely to make art out of words.

The fact that the art of this period was difficult to grasp without the benefit of some interpretation did not mean, as Tom Wolfe simplistically and sensationally put it in *The Painted Word* (1975), that the work was *lost* without critical theory. Today's global acceptance of Abstract Expressionism reflects the frequent pattern of transformation from rejection to embrace in the case of new art movements. The ease of publicity and dissemination of information in today's world demands faster and broader understanding of areas that might previously have escaped the public's awareness. In Wolfe's mad desire to shout "corruption," he underestimated both the artist and the art.

There is no *one* explanation for the more public appearance of the artist. These interviews attest to the degree of complexity of the art world in the sixties and seventies and the increasing interchange between what had previously been considered separate and unmixable disciplines.

A number of the interviews reveal the kind of artistic sensibility that in the early sixties rejected not only a large part of Abstract Expressionism but the options of formalism as well. This sensibility was represented by the Pop artists who reintroduced subject matter into art and searched for a style that deliberately broke away from characteristics identified

only with the medium of painting or sculpture. Thus, Robert Rauschenberg combined paintings with real objects, and Roy Lichtenstein painted in a style that had its source in advertising, or Sunday comic printing methods. The Pop philosophy held that art related to life, and "real life" in the early 1960s meant the media—radio, film, and television. Not surprisingly, Rauschenberg, Claes Oldenburg, Andy Warhol, Allan Kaprow and Larry Rivers all made numerous public appearances. Marshall McLuhan's conclusion in 1966 that "in this electric age of computers, satellites, radio and television, the writer can no longer be someone who sits up in his garret pounding a typewriter," could apply to the painter as well.

One product of this freedom to circulate and to play a new public role was the acceptability of the notion of the artist as performer. It was an idea that had its origins in Jackson Pollock's method of using the canvas as an arena but it led, through many intermediate stages, to Performance and Video Art.

The mid-sixties saw the beginning of official art world recognition of artists' work in video. The first sale of an artist's video tape was in 1969. In the same year, the Howard Wise Gallery held an exhibition of video artists working in New York. Among the artists included in this book who have been periodically attracted to the video medium are Allan Kaprow and Robert Rauschenberg. In all instances it was an attempt to make art that broke out of a static form to incorporate the element of time, thus converting the work into something more dematerialized and therefore bypassing the rapidly developing image of the art object as a consumer product. Kaprow and Oldenburg had already been leaders in interdisciplinary works that engaged the general culture. At the same time, video art emphasized the need for an art that was informed by a general culture.

Hans Haacke, who showed kinetic art at the Wise Gallery in the sixties, was to explore another side of this artist/viewer participation. Using the newly available computers, he was able to gather information which integrated and related the art and the culture. The sociopolitical aspects with which Haacke became involved in 1969 have continued to interest him to the present.

Although Warhol was to move into narrative film, his early sixties static film loops involving real time and boredom were precursors to video. Warhol's interest in media, publicity, and dissemination led him to found *Interview* magazine in 1972 and his own television program in the 1980s. Both of these perpetuate the interview format.

The idea of the artist as a remote figure, isolated from society and destined to achieve success only after he was dead, was declining. A

newly receptive climate allowed the younger sixties generation to begin careers with the feeling that they could "make it" in their own time. The new artist discovered he (and, increasingly, *she*) could garner recognition almost immediately by capitalizing on the accelerated dissemination of information through the media.

Political reasons also account for the artist's pull toward the public eye. The insurgent reaction against the Vietnam War, which focused as a movement in 1965 and peaked in 1968, served as a major motivation and source of frustration (see the panel discussion on Social Protest Art, Vietnam). Many artists took aggressively activist positions against the war. Antiwar demonstrations in the United States marked 1967. In 1968 Robert Kennedy was assassinated. There were student rebellions in Europe and the U.S. By 1970, antiwar demonstrations closed many U.S. colleges. The Ohio National Guard killed four students at Kent State University. The year before in New York the Art Workers Coalition was established, and artists' protests against the war followed. Protests against the museums reflected artists' dissatisfactions with "establishment" attitudes and policies at home. The demands on the part of artists to gain greater control in choices and general policy made by museums reflected a pervasive desire for individual power— part of the "doing your own thing" attitude—which was the essence of sixties culture.

Not only international but ethnic issues caused a response. In 1968 Martin Luther King was assassinated, and Eldridge Cleaver published *Soul on Ice*. Events cut across stylistic differences. The Black Power movement inspired the formation of black artists' clubs, exhibitions of black art, protests against traditional museums and the formation of new ones. The spearhead of this movement in the New York community, Romare Bearden, participates in two interviews that deal with black artists' problems. In one he reveals some of the harsh circumstances and surprising successes the black artist faced in the nineteenth century, and in a panel discussion he argues for what black artists must do in order to produce art that convinces.

In the late 1960s, one of the most poignant signs of the distance between the "elitist" museums and the broader issues of the culture was marked by the Metropolitan Museum's 1968 exhibition *Harlem on My Mind*. The institution's recently appointed director, Thomas Hoving, was no doubt prompted by sincere motives in mounting a show glorifying the Harlem Renaissance from 1900-1930, but insensitivity characterized the exhibition. Even the show's title, borrowed from a 1933 Irving Berlin song for Ethel Waters ("I've a longing to be low down/ and my 'parlez vous'/ will not ring true/ with Harlem on my mind"), was viewed by most as an insult. The catalogue for the exhibition was withdrawn, in part

because of an essay entry by a young black woman, Candice Van Ellison ("Behind every hurdle that the Afro-American has yet to jump stands the Jew who has already cleared it"). The charges of racism that were applied to the Metropolitan hovered over other institutions in the country. Artists joined picket lines; an unknown vandal scratched the letter "H" in several European masterpieces at the Metropolitan. That several of the works thus defaced were Rembrandts located in the premier museum of a former Dutch colony marked a growing concern with the power of art to be subjected to the forces of imperialism.

The publication of Betty Friedan's *The Feminine Mystique* in 1963 introduced another important topic of this volatile political mix. The feminist movement in art would crystallize in the 1970s with the founding of the first women's cooperative galleries in 1972-73, AIR and Soho 20 in New York. The important exhibition, *Women Artists: 1550-1950,* which opened at the Brooklyn Museum in 1977, lies just beyond the chronological reach of the current book. The issue of femininity right before these crucial events is touched on in the interview with Louise Nevelson.

The establishment of the National Endowment for the Arts and the National Endowment for the Humanities in 1965 was a crucial event for the period under consideration. The two organizations were the largest governmental funding operations to aid the arts and humanities since the Treasury Relief Projects under the Works Project Administration. Unlike those earlier efforts, these organizations were permanent rather than stop-gap measures. The legislation, signed by President Lyndon Johnson, could be seen as an institutional memorial to his predecessor, John Kennedy, whose assassination in Dallas on November 22, 1963, ended the major partisanship for the arts offered by that president and his wife Jacqueline. The effects of the legislation were to make the arts more responsive to a wider base of the American population through funding programs based on attendance and support figures. Ironically, such support at times favored the ephemeral and difficult works that were created at the time by advanced artists. Since the idea of purchase by museums was replaced in part by the more European notion of the *kunsthalle,* or succession of temporary exhibitions, a broad spectrum of social and political concerns figured in the scheduling of American art institutions, some of which are discussed in interviews.

The second half of the sixties saw a good number of major exhibitions informing us of trends developing during the period of these interviews. 1966 was a watershed year with *Systemic Painting* at the Guggenheim Museum, *Primary Structures* at the Jewish Museum, and *9 Evenings: Theatre and Engineering* at the Twenty-fifth Street Armory. By 1969 *New York Paintings: 1940-1970* was held at the Metropolitan Museum, its cur-

atorial approach sealing the modernist theories of quality and avantgardism and American dominance over Paris. In 1970, *Information* was presented at the Museum of Modern Art and *Conceptual Art and Conceptual Aspects* at the New York Cultural Center, highlighting the newer, antimaterialist art forms.

And behind it all was the development of SoHo. The area of Manhattan "south of Houston" Street was the new frontier. Although their actions were not sanctioned by New York Housing Department regulations, it was principally in this area that the artists lived and worked. Here in the streets Oldenburg, Kaprow, Rauschenberg, and Nevelson found the junk materials that they used for sculpture and props for Happenings. The factories dumped their waste products daily. Adolph Gottlieb and Lichtenstein shared a landmark bank building on Spring and Bowery. Donald Judd bought a building on the corner of Mercer and Spring. Haacke and Carl Andre were among the first wave of artists to move into Westbeth when it opened in 1969. This building, which occupies a city block on West Street in Greenwich Village, was renovated for the express purpose of housing visual and performing artists at affordable rents. As for watering places, the shift was from the Cedar Tavern on Eighth Street to Finelli's on the corner of Prince and then to the Spring Street Bar on West Broadway. The proximity made for a lively exchange of ideas and social life. It also set up a highly competitive situation, forcing artists to work hard. They separated into conclaves based on style.

The first SoHo gallery to open was Paula Cooper's in 1968. She was advised to do so by friends and supporters, including legendary dealers Richard Bellamy and Leo Castelli, who were still located uptown. The national press began to pay attention. *Esquire* magazine in the early 1970s saluted the new community and its work ethic in an article, "SoHo: Where the Avant Gardest Works the Hardest." Beginning in the early seventies, the *Gallery Guide* became a necessity to list the changing exhibitions and places of interest; a map of 1972 indicated thirty-two such establishments. By 1980, it would take two pages to print the map, one to list seventy galleries, one to feature almost thirty "artists' " bars and cafes, bookstores, and art supply shops.

In ordering the interviews, it seemed appropriate to start with Marcel Duchamp, whose influence was seminal to the development of American art from the Armory Show of 1913 onward. His ideas become a thread that weaves together a great deal of the disparate art of the sixties and seventies. His presence, having taken hold in the late fifties, began to expand in the early sixties with artists like Rauschenberg questioning the established modes of painting and sculpture and Allan Kaprow exploring

chance, collaboration, and the ephemeral. Duchamp's contribution to conceptual art reached a crescendo in the very different approaches of Hans Haacke and Joseph Kosuth.

The interviews move chronologically from the formalist concerns of the sixties with that decade's grounding in myth and the sublime (although these ideas were not universal; the most notable exception in this context would be Reinhardt) that emphasized the hand-painting of the object, to the fabricated object, and finally to the elimination of the "art" object entirely.

If Duchamp was a bridge from Dada to Post-Modernism, Barnett Newman was to influence both younger painterly painters and minimal sculptors. The younger artists reveal this in the interview on Newman. Still steeped in formalist language, Judd talks about "primacy of wholeness" and raises the problem of illusionism in Newman's paintings. He reveals Newman's dislike of "staining." On the other hand, Phillip Wofford admires the older artist's attention to showing the "hand." A number of the interviewed artists refer to Newman's use of color and see a good deal of his genius as residing in his development of "line." However, it should be noted that his influence goes far beyond those included in these interviews (particularly to Frank Stella). Newman's presence as a father figure and art world participant is worthy of mention. Both Larry Poons and Warhol touch on this aspect.

Alexander Liberman, a contemporary and friend of Newman, shared a common concern in the fifties with a kind of immaculate painting, symmetry, and random activation of a field without gestural traces (pointed out by Lawrence Alloway in *Systemic Painting, 1966*). Liberman's conceptual approach in designing a painting and having it executed by workmen was to become of interest to the Minimalists.

While Adolph Gottlieb does not have the polemical place of Newman or Reinhardt, his two interviews elucidate issues that are currently controversial and are being reexamined. His first interview reveals the artist's familiarity with Surrealist doctrine. But mainly what is revealed is an artist's involvement with pictorial problems—the use of the grid, the issue of flat space, of focal point, and of moving toward abstraction, which necessitated symbolic representation. A diehard modernist, Gottlieb's talent for color and shape became interesting to younger artists of a cooler sensibility.

In the second of his interviews, conducted in 1973, Gottlieb makes the connection between the rise of American art as the center of world art and the development of America as a world power, an attitude about Abstract Expressionism that is to become increasingly solidified in critical writings of the seventies. Taking an elitist position, he was convinced that

only a few special people educated in art and literature could appreciate true art.

Another alternative to Abstract Expressionism resides in the art and ideas of Ad Reinhardt. He reconciled earlier geometric art with sixties field painting. With an anti-Expressionist attitude, Reinhardt's art showed a strictly geometrical layout, economy of form, neat surface, monochrome color, and like Newman, stressed the holistic properties of painting.

Reinhardt's influence on Stella, Judd, Morris and Dan Flavin was in the form of an elimination of textured surface and gesture, a suppression of internal relationships (from Newman), and the reintroduction into art of geometric forms. The move toward cooler art is reflected in the followers of Reinhardt, in Minimalism, and Pop Art.

Reinhardt's "art for art's sake" stance is diametrically opposed to Rauschenberg's urge to wed art and life. The latter is continued in the attitudes of Oldenburg and Kaprow. Yet, Reinhardt's significance resurfaces in another context in the early thoughts of Kosuth.

A good deal of Reinhardt's influence was to come through his writings as much as from his art. Having already articulated his reductivist position in his "Twelve Rules for a New Academy" in the late fifties, his "art-as-art dogma" was published in *ARTnews* in 1964, further codifying his ideas as well as his writing style. Reinhardt's literary approach evolved into a kind of reductivist poetic style which pared statement down to the truthful bone at least as he saw it. He wrote letters to the editors (*ARTnews*) and statements in *The Village Voice* during the sixties. He mailed postcards with his ideas tersely listed—a literary form that was catchy and self-publicizing at the same time. The style of writing itself was another manifestation of a desire for "control" that clearly characterized his work and which he believed in as moral principle.

This style had its influence on the writing of younger artists—in reviews by Judd, personal writings by Sol Lewitt, and Carl Andre's concrete poetry. The three artists adopted a clean, no-nonsense approach that was appropriate to the Minimalist turn of mind and that was a form of rhetoric that convinced by its clear, literal stating of the information, thus apparently lending a factual basis to the argument. Reinhardt talked about what art was "not," which appealed to the reductivist nature of the Minimalists who, at that time, looked as if they were eliminating almost everything. Later Kosuth drew directly from Reinhardt in the creation of his titles.

What accounts for the relevance of these interviews to the world of the early eighties? Particularly pertinent are the political attitudes of the sixties juxtaposed with the recent events in Central America and the response on the part of artists to both. The lull of the seventies has been

broken by rallies and stands against U.S. policies on the part of newly galvanized artists and public.

Both Hans Haacke and Leon Golub feel there are more young artists socially engaged than earlier. This generation, which came of age in the sixties, easily expresses itself in an anti-authoritarian way. Today's youth have the freedom to be less respectful.

While Haacke and Golub share the opinion that museums, at least American ones, are not much more receptive to "political art" than they were fifteen years ago, there have been some concrete benefits from the original Art Workers Coalition demands. The call for museums to have a free day to all was partially met, in the form of free evenings, special student rates, and one day where the visitor can "pay what you will." In one state (California), the Artist's Contract was legalized, allowing the creator to share in the appreciated value of his work in subsequent sales. In August 1983, a New York state law gave artists the right to sue if alterations made in their works have damaged their reputations. These alterations could include the framing of the work, organization and design of exhibitions, and reproductions of works in catalogues.

The constant flux of art is documented most explicitly in Hans Haacke's discussion of his shift away from Minimal concerns to more ephemeral artwork. Haacke, more than most other artists of his generation, exemplifies the "transitional" phenomenon of artmaking that has become a characteristic since the late sixties. By the eighties, the artists' freedom to make radical stylistic shifts in his or her form of expression is accepted as part of the historical thrust away from modernist premises of the "avant-garde." It is but one more manifestation of the legacy of Marcel Duchamp.

Much of the current relevance of an artist such as Joseph Kosuth is in what could be considered a reaction to his ideas—in the return to the conventional mode of painting in one sector of artmaking in the eighties. This represents a negation of the intellectual stance that was, in part, stated through its conceptual form.

Meanwhile, Kosuth argues that the return to painting in its present (eighties) form reinforces his prognosis that painting is dead or at least dying. His reading is grounded in the idea of recent painting's "deconstructive" approach—an approach directed against Modernism by using clichéd past art and poor craft to undermine the principle of "quality." It robs the art of its social meaning. Paintings such as David Salle's, where almost everything is on the level of reference, could not have existed without the preceding conceptual art. Conceptualism forced a more intellectual response to art.

Kosuth's influence is directly evident in the continued interest in the employment of words. Although the coupling of visual art with words

has its source in early twentieth-century collage, words as primary signifiers were given a particular license through Conceptual Art. This tendency has manifested itself in the recent conflation of verbal message with art work that often sits outside of painting.

The relevance of these artists' points of view and their work in relation to the eighties is still in the process of formulation, but some important ideas have already become apparent. The influence of artists like Warhol and Rauschenberg, for example, is being felt with surprising intensity. Warholian methodology and life style has been reincarnated in the careers of young New Wavers.

The new figurative art cannot be considered without touching on Pop. Julian Schnabel's origins are inevitably linked to Rauschenberg's propensity for assemblage. The role of the "appropriated image," claimed as a signature of Post-Modernism, cannot be traced without considering its use in Lichtenstein's "art of reference." The appropriated image implies the knowing of sources from which to appropriate, and this, in many instances, means from earlier art.

This attention to and validation of art history and art criticism, I believe, was encouraged by the dissemination of art information through the art magazines in the sixties. The four leading periodicals, *ARTnews, Arts, Art in America,* and particularly *Artforum,* which had moved its headquarters from California to New York in 1967, became guides for artmaking. This information had its origins in New York and a standard joke was that you could tell the art by the distance away from this central point. More seriously, I believe this activity accounts, in large measure, for the historical consciousness of the young eighties generation. In retrospect, one could conclude that, contrary to Wolfe's prediction, with the return of representationalism, art theory has not only not been abandoned but has flowered.

Quite apart from direct connections between generations, there have been artists in every period who have emerged as the theorists and chroniclers of their age—from Vasari to Mondrian and Kandinsky. In our time this has been true of such diverse artists as Marcel Duchamp, Ad Reinhardt, George Rickey, and Allan Kaprow. They all have something to say in this book. Paradoxically, one artist who is included, Andy Warhol, has, in part, built his public image on his seeming muteness.

There are critics who would deny the status of an interview as "criticism." This position is based on the belief that a proper art historical methodology must remain unaffected by the artist's bias. But the real fact is that the critic should be capable of evaluating the artist's views along with biographical data and other more transpersonal approaches such as period styles, formal analysis, and sociological or political factors. The

interview form retains its privilege as primary material and a unique record of intention. As documents these selections stand beside the works, the events, and the careers they discuss. Future quotation may remove certain concepts from context, but their inclusion in this volume is intended to offer an intact view of some of the primary concerns of the art of this period. These words stand in a dialectical position to the future critical structures in which they may be incorporated. The reader is invited to observe the interaction between myself as interviewer and the artist/subjects. We shared the experience of this period of great flux.

However, bear in mind that the interviews do not constitute a survey of the period. Although the development of these historical phenomena in the late sixties and early seventies may appear cohesive in retrospect, the subjects were randomly, even intuitively, chosen. When I structured interviews for broadcast on WBAI, my choices were personal and not based on preconceived theory. The activity afforded me the opportunity to talk to artists and obtain some insight into their works and life styles. As an interviewer, I tried to touch on what I considered to be a spectrum of interesting current issues but also to catch the speech patterns of the individual artist. In looking back, I might have included other artists of the period, but I would not have eliminated any that are here. They seem to have particular relevance today.

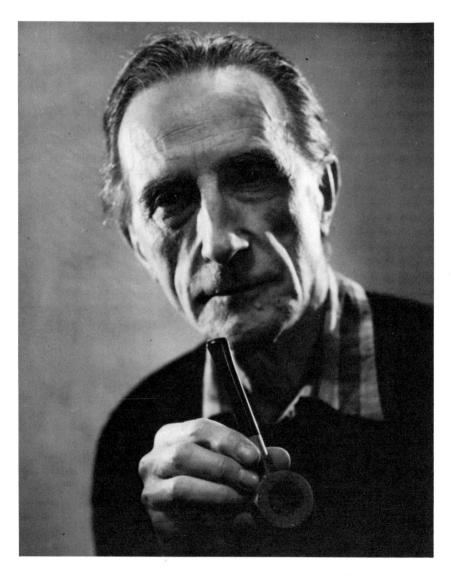

1. Marcel Duchamp, ca. 1960
 By: John D. Schiff

Some Late Thoughts of Marcel Duchamp

One of Marcel Duchamp's last public statements, this interview coincided with the publication in 1967 of "A l'infinitif," a limited facsimile edition of seventy-nine unpublished notes from 1912 to 1920. Duchamp died in Paris on October 2, 1968 at the age of eighty-one.

A seminal figure in the history of Modernism, Duchamp had come to influence a generation of artists after World War II; Jasper Johns, Robert Rauschenberg, John Cage, Merce Cunningham, and Andy Warhol are the direct forebears of the artist's intellectual legacy. Duchamp's use of mathematics and his emphasis on the realm of ideas, issues discussed here, were to be a generative force in the development of Minimalism and Conceptual art in the late sixties and seventies.

Just before conducting this interview, I suggested to Duchamp that he might be bored with interviews, having participated in so many. "No, not at all," he responded "you see, I make it up differently every time."

Jeanne Siegel: *Mr. Duchamp, would you agree with me if I said that at least a few of the chief concerns of the avant-garde today, like kinetics, optics, and mathematics, were implied in your painting* Nude Descending a Staircase?

Marcel Duchamp: Not quite, but as a gesture, not knowing what I was doing anyway, it did help put the mind of people in another direction than they had been used to: a full crop of young artists, who became old artists like [George] Bellows, all took a new direction. I'm not exactly responsible—it just happened to be at the Armory Show in which all these Cubists and Futurists helped the American people to think differently about art.

What about the idea of motion?

The motion was there—it had been with the Futurists as well. Balla had done the *Dog on a Leash* and you could see 20,000 leashes and 20,000

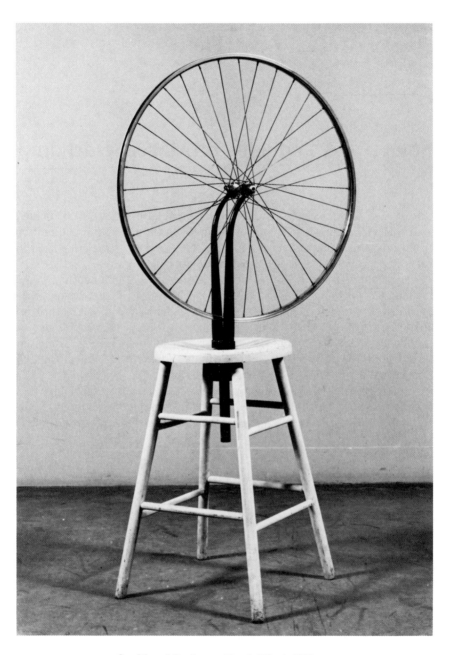

2. Marcel Duchamp, *Bicycle Wheel*, 1951
The Sidney and Harriet Janis Collection
The Museum of Modern Art, New York

animal legs but the movement was only painted or, at least, described on the canvas so it's only a little later that actual movement took place, for example, in the mobiles of Calder and in my *Bicycle Wheel.*

Did you expect people to spin your Bicycle Wheel *or move it in any way?*

No, I did not. I used it for my own use—I mean, I didn't see anything in it except to have it in my studio. It never was shown even to people as a thing. It was a gadget, if you wish, for an artist in his own studio to see a movement of the wheel, which is a very simple movement, and can become aesthetic, if you want to give it that adjective. And it was a pleasure like a fire in the fireplace, you see. It moves all the time and it helps having something moving in your silent studio when you work at something. It became important only much, much later when people discovered it and thought they might talk about it and say something.

Was it the only Readymade that included movement?

Yes, there's none other.

Do you feel that there is a stylistic similarity in the Readymades?

Oh, yes. I mean, not plastic, not visual, but the idea is the choice of a readymade object. You can choose many objects if you want but the thing was to choose one that you were not attracted to for its shape or anything, you see. It was through a feeling of indifference toward it that I would choose it and that was difficult because anything becomes beautiful if you look at it long enough. In other words, that bottle drier, at the time I did it, was not especially interesting in shape or anything, but nowadays it's reproduced in all the sculpture primers, you know, and the people think it's a good piece of sculpture and they like it. They say it's beautiful but it was not for this beauty that I chose it. Indifference, you see, there is a form of indifference in life after all. We are indifferent to many things, aren't we, and so, especially in painting or art, generally, it's a matter of taste. A painter paints and applies his taste to what he paints and, in the case of the Readymade it was to get rid of that intention or feeling and completely eliminate the existence of taste, bad or good or indifferent.

How would you differentiate between your Bicycle Wheel *and Jasper Johns's* Ale Cans?

Well, really, his is in the same vein, it's the same idea. He applied it to something like the can and he did it beautifully, in fact. I like them very much.

Wouldn't you make a distinction in that he applied paint to them?

No, because his applying paint to it was absolutely mechanical or, at least, as close to the printed thing as possible. It was not an act of painting, actually, the printing was just like printing except it was made by hand by him. That doesn't add a thing to it—it's just the idea of imitating the ale can that is important.

Would you differentiate between your putting a moustache on Leonardo da Vinci's Mona Lisa *and Robert Rauschenberg's erasing a drawing by de Kooning?*

These are very close to one another. These two ideas have the same background. All these things have a background that is not visible. You have to think and it comes from your thoughts, from grey matter more than you recognize again, you see.

Wouldn't you say that putting a moustache on the Mona Lisa *has more humor?*

Yes, but it's the same conceptual consideration of a thing, of an action. It's true, of course, humor is very important in my life, as you know. That's the only reason for living, in fact.

What is the significance of your manuscript notes "à l'infinitif" that have just been published?

These notes are from just about the time, 1912, when I absolutely changed my life, so to speak, in regard to art and decided to completely forget about the Nude and forget about the Futurists and so forth. So they are with the intention of doing something else which I didn't know at the time what it was going to be naturally. They were jottings, you see, on a piece of paper, any piece of paper. They are general, without any destination to speak of, just an idea that comes to you when you dream a bit or read and I put them down for eventual use if necessary.

Did you carry out many of the ideas like "making a painting or sculpture as one winds up a reel of moving picture film" or "buy a dictionary and cross out the words to be crossed out?"

No, not exactly, but you see all these notes had almost a common character—they were always written in the infinitive tense; *à l'infinitif* in French means to do things, eventually to do this, which, of course I never did.

Some of the most difficult notes to comprehend deal with the fourth dimension. Haven't you continued to explore this concept?

Yes, this is also a little sin of mine, because I'm not a mathematician. I'm now reading a book on the fourth dimension and notice how childish and naive I am about that fourth dimension so that I just jotted down these notes thinking I could add something to it. But I can see that I'm really a little too naive for this kind of work.

Did you propose a series of things to be looked at with one eye?

Yes, there's a painting in The Museum of Modern Art which has the name *To be looked at for an Hour with One Eye* and, of course, people sometimes try. I just tell them not to do it because there's nothing to gain except exhaustion.

What was the extent of your experiments with optics?

This was around 1920 when I made designs like spirals, giving the idea of a corkscrew when it turns. I mean, giving it the third dimension. In other words, on a flat drawing, turning, the design begins to come up to you and you create a third dimension optically which interested me very much. Then in 1934, from abstract drawings which were spirals alone, I went on further by reconstituting the object like, for example, the fish in a bowl turning. I called them Rotoreliefs. It's a relief obtained by rotation. That's the origin of the word. I did twelve drawings at that time and published them and I even had the nerve to show them in Paris in a big international fair for gadgets. I had a whole stand with the electric motors making those things turn, hoping people would buy them. Cheap, too, and in the course of the month I sold one. I had a secretary doing this, you know. I couldn't stay there all day so it was a pure flop, the whole thing.

Were you ever interested in dazzle or moiré effects?

Only once. I spoke in those notes in the *Green Box* of the system "Lincoln-Wilson," because I had seen in a shop somewhere an advertisement of those two faces, the face of Lincoln on one side and the face of Wilson on the other, and when you looked on the left you would see Lincoln, and when you looked on the right you would see Wilson. I call that system "Lincoln-Wilson" which is the same idea as the moiré. Because you see, those lines have two facets. And if you look at one facet you see one thing, if you look at the other facet you see another.

How would you describe the optical effects in your film, Anemic Cinema*?*

Well, it was the same thing really. It was this thing I did in 1925 before I did the Rotorelief but it was in the same vein, so to speak. It was the same sequence of ideas, because it was a spiral, most of it, plus a sentence, a spiraling sentence which was made of very amusing puns. There would be a pun and then an image and then a pun and image twelve times.

What did the title mean?

Anemic Cinema is an anagram, Anemic being the anagram of Cinema—the same letters.

Was that the only film you ever made?

The only one and I didn't even call it a film because the idea was the effect and not the film, the film being only a medium to carry the idea.

Do you think there is any connection between Dada events and Happenings?

Certainly, a great connection. There were many Dada manifestations in Paris in 1920 where all these young men were shouting on the stage and people insulting the public and so forth which were fun. There were two or three years of that which were very, very amusing and very gay and sort of destroying everything, not physically but there were even fights in the audience. The idea of the Happenings are different but not so different. It's another form of excitement of young men, angry or not angry, to demonstrate vitality—it is sort of inviting the audience to take part in the show. Happenings are a little more peaceful in a way, so peaceful, in fact, that they are boring at times, which is a characteristic that Dada manifestations did not have. They were purely very pugnacious and very violent, in a way.

Is Dadaism still a force in Europe?

I couldn't tell you much about what the European artists think about it. They are very much influenced by the American views on art, no doubt about that. But, at the same time, there's a remnant of tradition-alism in Europe that does not exist here. People can't ever forget that they are the grandsons of Victor Hugo in France and so forth, you know. In poetry, also, like Rimbaud—the young, the avant-garde, they cannot forget about that, and it does show in their works that they have not forgotten about traditionalism. Here we have no such thing so that makes a great difference.

Do you believe that there's a real understanding of Dada in the United States?

Yes, to a great extent, because even as we know it, except having been there, there's always a deformation, a distortion of this in souvenirs, and even, you know, when you tell a story about that, you, in spite of yourself, change the story as you saw it, because you have not an exact memory or you want to twist it anyway for the fun of it. So the history of things becomes so distorted in the end that it's very difficult to get a real picture. It becomes more important in the remembrance of it than it actually was at the time, as usual.

Are you still an avid chess player?

No. I've given up that ambition because it was an ambition to be a very good chess player, but there comes a time in your life when you realize it's better not to insist.

Do you still play chess with other Dadaists?

Oh, yes, we still play a few games for fun. Just for fun is delightful.

Do you ever see Hans Richter?

He's not here now. He's been living in Switzerland for long years and he's very active there. He has shows of his paintings and he paints a lot, too. He's really a painter become a *cinéaste*. He's exactly my age. In fact, Arp, Richter, and myself are exactly the same age, one month difference, and poor Arp died and I don't know who's going to die first, Richter or I.

You make it sound as if the contest continues.

It's a race, like everything, yes.

Did you ever have any desire to return to painting?

No, none whatsoever, no. It was not even a decision—it was a lack of interest.

But you have worked very closely with the museums in the United States, haven't you?

Oh, yes. I act like an artist although I'm not one.

[This interview with Marcel Duchamp was conducted in February 1967 at the time of an exhibition at the Cordier and Ekstrom Gallery in New York. It was broadcast April 10 on WBAI as part of a series "Great Artists in America Today," and published in *Arts*, Summer 1969.]

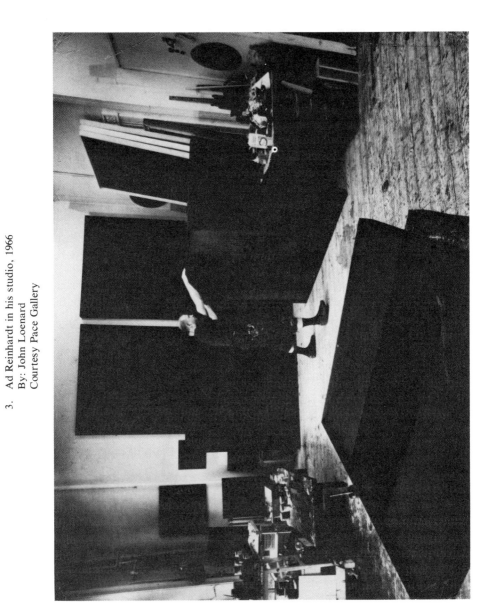

3. Ad Reinhardt in his studio, 1966
 By: John Loenard
 Courtesy Pace Gallery

Ad Reinhardt: Art as Art

Ad Reinhardt worked on the Federal Art Project in the 1930s, was an art critic and cartoonist for *P.M.*, and one of the founders of the artists' Club in the 1940s. He was a teacher, writer, and scholar with a penchant for Eastern art, but was assured his true place as a painter only in the 1960s when other artists became receptive to a more minimal and constructivist approach. Finally, in January 1967, after five exhibitions of his "timeless" paintings shown in four major American cities in the previous three years, Reinhardt was given a retrospective at the Jewish Museum in New York.

Jeanne Siegel: *At the time of your Retrospective you delivered two lectures that you titled "Artists among Artists" and "Artists in Art History". What did you mean by "Artists among Artists"?*
Ad Reinhardt: I meant artists in a classic or academic situation in which they related to each other, come from each other, and talk to each other rather than the more romantic idea in which the artists talk to a public or become celebrities.

Is it that you prefer artists talking to each other rather than to the public?
Yes. I think the talking to a public or relating to mass media is another problem. I like the idea of the museum world and the university-academic situation where artists talk to each other or where artists or art students study with artists.

Need one world be exclusive of the other?
Yes. A lot of the art museums show movies and automobiles and everything but a museum of fine art should have just fine art in it. The museum of fine art is quite separate from a museum of decorative art or a museum of primitive art or of folk art or a museum of natural history or a museum of archeology or a museum of military art.

Must there be a sharp distinction made between primitive and fine art?

Yes, just as you would make a distinction between fine and applied art or fine and commercial art—art schools make that distinction. The distinction fine art versus other art is extremely important. It was an achievement in awareness of what fine art *is,* and today that definition or the boundary lines have been not only blurred but the attempt has been to break it up so that the attitude is anything can be art and intermedia and mixing up all the arts. But the one central achievement of the twentieth century was that each art explored what it says in its own medium, and now to mix them all up again is going back to what Folk and Pop art is.

There is a strong desire today, among many artists to eliminate museums completely—what might be called an anti-objet d'art attitude.

That's the revival of primarily an anti-art position that the Futurists had and certainly German Expressionists had and the Fauvists had and the Dadaists and Surrealists had. The surrealist idea is always anti-art programmatically, but the idea is then that anything in the streets is art or that the museum shouldn't be a separate place. The Italian futurist idea was smash the museums. I am talking about a museum as a storehouse and as a place where the best things that have been done are protected. Sometimes artists take an anti-art attitude simply because they're reacting against the pressure of an art establishment or an art mannerism or an art manner or fashion that becomes oppressive.

You believe that an artist should have knowledge of art history. How should the artist go about gathering this information?

He should study it and see it and know the whole thing as the only way to get past it or to get rid of it. He should have a Malrauxian approach—the André Malraux idea of the imaginary museum in which you just know all the art that's been done.

Should he take courses in fine arts or should he follow the old tradition of copying masterpieces in the museums?

He doesn't have to do it. He certainly should study it and see it in reproductions. That's the imaginary museum, I guess, a museum without walls. And travel. The idea that the artist should be an irrational or a bumpkin or a Dionysian or a dumbbell is, I think, on the way out. It's never been around seriously anyway. I suppose it was a way of artists protecting themselves, to pretend they were drunks or children or mad geniuses. That act saved them a lot of trouble.

Must the viewer also have some knowledge of art history in order to appreciate a painting?

There's no way of looking at works of art without knowing something about them beforehand. One doesn't have to be a Renaissance scholar, but the people who, for example, travel and look at the great museums in the world have trouble—even Mark Twain said, "All I get in the Louvre is hot feet."

The museum certainly is a problem today, because all the work that's serious or important finishes up there anyway, traditional or modern. And the private collector and private collection and art in one's home may be on its way out, if I were going to talk like McLuhan talks, who said that baseball is all through and that the automobile is finished. There is no reason for art becoming furniture or people living with it. And it ought to be in a public place where it can be seen anytime anybody wants to.

How did you feel about your recent Retrospective?

It wasn't a Retrospective really. I put up a selection of smaller, older paintings on the upper floors because the curator insisted on it. But it was mostly within the last decade. It was a new curator at the Jewish Museum, Sam Hunter, that asked me. Otherwise none of the museums are ready or gave me any indication that they wanted to give me a show. So I was all set to have a show in Whitechapel in London but I had it at the Jewish Museum.

It was the first time that you've had the chance to see 128 of your own paintings hanging together. Did you enjoy it?

I don't know about enjoying it. It's trouble and it's something that one has to do. And it's great to have it behind one because one doesn't really work for oneself. That's a myth. Artists have to show their work. It doesn't mean they have to sell it, or peddle it, or use it for anything, but they have to show it.

What was your reaction to the critical comment?

I didn't get too many pieces that were critically interesting. I got an awful lot of publicity if you want to call it that. Sometimes there's a tendency for a lot of people, artists too, to think of those as the same thing. If an artist becomes a celebrity, then the criticism doesn't interest him. It's publicity, and bad publicity is better than no publicity.

In other words, you felt that there was no real understanding on the part of the critics?

There are a number of ways of talking about understanding. I never felt misunderstood. I remember a modern artist being attacked for being

unintelligible and inarticulate and I've always made myself as clear as one could possibly be.

In a verbal way or through your paintings?
 Both.

In some observers' minds a dichotomy exists between your verbal expressions and your paintings.
 Someone said, not about my paintings, but about some others, but if somebody had said it about my paintings it would have been good, that these may be the first paintings that *can't* be misunderstood.

That in itself is a provocative statement.
 Yes, I've always claimed that they were the last paintings that artists were making. And another interviewer asked me, "Well, why aren't artists making paintings like yours?" And I said, "I don't know. You have to ask them."

What was your reaction when Hilton Kramer in his review summed up your paintings by saying, "The apparent solemnity of these black paintings harbors a deadpan wit"?
 That's all right. He tried to make it out to be a black humor or black comedy. That's not accurate. I once said that art is too serious to be serious about. I've been called a black monk, which is not accurate either. I'm not religious and I've been called a godless mystic, which is not true. And now I've been called the prince of darkness. You know, you could only use those terms tongue in cheek. I'm not any more monkish, for example, than any artist who has to work alone.

I thought that the term black monk alluded to the all-black paintings which contain a cruciform shape.
 It is mostly said in relation to a purely aesthetic, hermetic approach— an "art as art" approach. That's why I was defining art as "art as art" and not art as history or archeology or something else. And then I defined the artist also as artist, not artist as a human being. The attempt to make a commentator out of me in a human sense is not accurate, though certainly all artists' work, and mine too, comments on other previous art work. It comes from other art work and it comments on it and also changes traditional work.

So then, the cruciform should be read as another interpretation of an earlier art form rather than having anything to do with religion.
 That's right. It's an aesthetic device now and besides, I tried to paint it out or remove it so you're not aware of the cross.

Do you believe that it's possible to eliminate all associations in a painting?

It's not only possible but it's been done and it has to be done, and most works of art have to be seen purely aesthetically anyway. If you go into the Greek rooms now at the Metropolitan Museum you have to look at the work fairly purely. There are no aids around you. They used to tell you stories about the gods and about the narrative they may have represented once, but right now a fragment is a hand or an ear or a foot or an ancient Egyptian torso or a figure, and it has no associations unless you want it to. I think most people bring a great deal to the object that the object can't take. For a long time everyone looked at Egyptian sculpture as if it were terrifying—stiff and rigid and staring—and it's just not true. It doesn't have any terror. It may have had once. It may have been used for some purpose once, but certainly it has lost that purpose when it entered a museum.

Let's go back to your remark that you thought of your paintings as the last paintings being made. It reminded me that around 1913 the same statement was made about Malevich's paintings. And somewhat of the same aura existed at the time, in that painting was thought to be dying and many artists were shifting to other areas like advertising and industrial design.

If I were to say that I am making the last paintings, I don't mean that painting is dying. You go back to the beginning all the time anyway. There's the idea that art is one thing, that maybe it doesn't have a beginning or an ending, and maybe it isn't as historical as one thinks. Let's say in the museum of fine art or in a book you can arrange rooms and chapters so that they're chronological. But you could also see it all simultaneously, the way Malraux did, for example, by skipping around, out of time and place, abstracting everything from its particular association.

Nevertheless, the comparison to Malevich is inevitable and one of the interesting differences between Malevich's evolution of forms and yours was that after having arrived at a most simplified form, the white square on a white surface, he then reverted to more complex geometrical shapes whereas you did just the reverse.

Simplicity and complexity are words that are used now in a variety of ways to mean each other and not as opposed. I'm not too familiar with Malevich's sequences, but it seems to me that he was involved in a certain kind of complexity and then he went to a certain kind of simplicity and I'm not sure that he would call the things that followed more complex again just because there were more things in them. In general, though, I guess the idea is to take things and stuff out of painting. My Retrospective looked like a Mondrian retrospective in that it looked like stages

towards simplification. And there's no question that I come from Mondrian and Malevich as every artist does today.

But by reduction you move toward really a more complex idea. The more stuff that's in a painting, the simpler it is—like a Rubens painting with animals and food and nudes—from a painter's point that's extremely simple painting. A Poussin painting is, let's say, complex. It might have a seventeenth-century French sky, Greek costumes, a Roman or Hebraic story, and French figures. It was such a conglomeration of artistic forms that the paintings have to be seen just as painting. And he painted also the same paintings over and over again, and made them with less action, killed the narrative more and more or the allegory, or whatever original meaning it had, so that the artistic mainstream lies with the Poussinists instead of with the Rubenists who wanted to stick stuff in.

This not wanting to "stick stuff in" includes imagery of a political nature?
I think an artist should participate in any protests against war—as a human being. There's no way they can participate as an artist without being almost fraudulent or self-mocking about what they're doing. There are no good images or good ideas that one can make. There are no effective paintings or objects that one can make against the war. There's been a complete exhaustion of images. A broken doll with red paint poured over it or a piece of barbed wire may seem to be a symbol or something like that, but that's not the realm of the fine artist anyway.

Does this mean there should be no reference in a title of a work?
Yes. There were three big shows last year—the Robert Motherwell, the Larry Rivers, and the Louise Nevelson. And I did object to their titling or referring their work to some of the great events or important events in the century like the Spanish Civil War or the Russian Revolution or an Homage to Six Million Jews. Artists don't need to do that. If the work is good, it's good. It just doesn't add anything but it does subtract!

How do your titles read?
I don't have titles.

None at all?
I started to make jokes about it because I repaint a painting so that I'm calling them ultimate paintings, timeless paintings. *Ultimate Painting, No. 39* or *Timeless Painting*, 1960.

[The interview with Ad Reinhardt was conducted and broadcast on June 13, 1967 on WBAI as one in the series "Great Artists in America Today."]

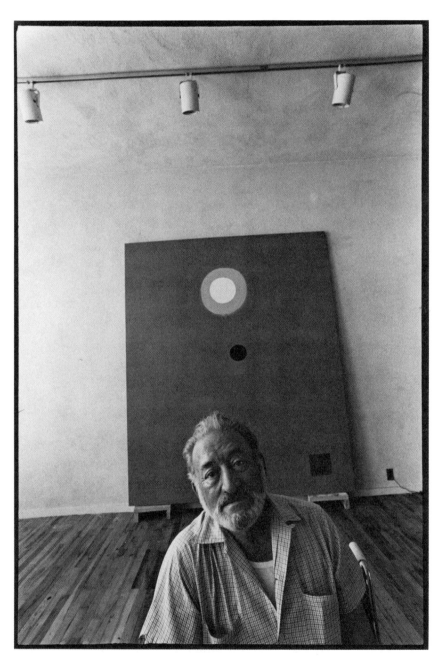

4. Adolph Gottlieb; early 1970s
By: Arnold Newman

Adolph Gottlieb: Two Views

1. Shifting Concepts: Pictographs, Imaginary Landscapes, Bursts

Despite his controversal status during his life, in retrospect Adolph Gottlieb's Pictographs have come to be greatly admired. Historically, the grid, which forms the underlying structure of the Pictographs is the hallmark emblem of Modernism and Gottlieb's own emphasis on "flat space" reveals his obsession with modernist tenets. Two younger, major figures of the sixties have expressed a debt to Gottlieb, namely Kenneth Noland and Frank Stella.

The revival in the eighties of interest in Surrealism, myth, and symbolic imagery, lends additional relevance to Gottlieb's comments.

Jeanne Siegel: *At what point did you arrive at the concept of the Pictographs?*
Adolph Gottlieb: It was in 1937. I had been working for a year in Arizona. My work was becoming more abstract and I became interested very much in the curious things that you find in the sands of the desert. And I'd set them up and make a still life. I started doing that in Tucson. Then I went to the ocean and I found similar things on the beaches. I'd collect these things and I'd set them up and paint still lifes. And then I started painting these objects in boxlike arrangements. They were fragmented pieces of things that had been worn and weathered, and they had no connection with each other. So therefore I divided them, and I made boxes—I painted boxes which had compartments, and each one of these things was isolated, so that you saw it by itself. But then there was a total—a sort of a total combination.

I didn't do very many paintings like that, but it led to the idea of the Pictographs where instead of having a realistic representation of an object in a box, I had more of a symbolic representation. And at the time I was interested in Surrealism, the ideas of Surrealism. So the thought occurred

to me that if I wanted to represent some sort of reality, that is, which was my reality, I could do it by tapping the subconscious in some way. So I used the process that was similar to automatic writing, which was using the method of free association. And I would start by having an arbitrary division of the canvas into rough rectangular areas, and with the process of free association I would put various images and symbols within these compartments. And it was irrational. There was no logical or rational design in the placing of these. It was purely following an impulse, which was irrational, trying to use the method of free association. And then when all of these images and symbols were combined, they could not be read like a rebus. There was no direct connection one to the other. And, by the strange juxtapositions that occurred, a new kind of significance stemmed from this juxtaposition.

I don't want to give the impression that I was trying to convey some kind of literary message. I wasn't a writer, I was a painter. I was really trying to make paintings. Actually, I was involved with pictorial problems, such as the type of space I was using. I was trying to flatten out space. There was an article written in a magazine at the time that said Gottlieb kills space. Well, I was trying to kill space. That is, I was trying to kill the old three-dimensional deep space, which may have been valid for the representation of actual objects and figures, but for what I was painting, that kind of space wasn't the right space. So I had to try to invent some other kind of pictorial space, which I did with this method of using lines that went out at the edges of the canvas and formed these rectangular frames. So that it was a continuous space and the paintings had no definite focal point. If there was a focal point, there were, I would say, numerous focal points, which were distributed as I chose. And this was, I think, a painterly problem primarily. It was not an attempt to translate a literary message into a pictorial form.

But you did have certain favorite symbols that seemed to carry over from one painting to another.

I did have certain symbols that were repeated and carried over from one painting to another. But my favorite symbols were those which I didn't understand. If I knew too well what the symbol signified, then I would eliminate it because then it got to be boring. I wanted these symbols to have, in juxtaposition, a certain kind of ambiguity and mystery. However, I was not a symbolic painter in the sense that through symbolism I was trying to communicate with people. This was not my intention. I was making a painting. That was the first thing I was concerned with, making a painting, and to make the painting work in terms of a

structure that I invented for myself, and to give this structure a certain solidity and strength.

After the Pictographs you started painting what I think you labeled "Imaginary Landscapes." Were they meant to be abstractions from nature?

After the Pictographs I started painting what I called "Imaginary Landscapes." This does not mean that they were meant to be abstractions from landscapes. When I'm in the presence of nature I never think about painting. And when I'm painting I never think about nature. The reason that I called some of those paintings Imaginary Landscapes was because they had a line going across from one side to the other. Now it's impossible to have a painting with a line going across from one side to the other without thinking of that as a horizon. Everybody automatically thinks of it that way. So I accept this reaction, and I have it just as well as anyone else. However, the problem which I was involved in was dividing a canvas into two parts, and then having disparate images in each area, which is a problem that I've always been involved in, which is the juxtaposition of disparate images. And the painting stands or falls on whether these things are unified. There has to be a complete unity. But obviously unity and oneness doesn't mean anything unless you have some sort of polarities. In other words, there has to be a conflict. If there is no conflict, and a resolution of some sort of opposites, there's no tension and everything is rather meaningless.

What do you feel are the major differences between the Pictographs and your recent work?

There's a tremendous difference between my recent things and the Pictographs. The Pictographs were all-over paintings. There was no beginning, and no end, no definite focal point. However, when I broke away from that aspect of my work and got into the Imaginary Landscapes and into what people call the Bursts I was working with definite focal points. By focal point I mean a point within the rectangle of the canvas to which one's eye is drawn. In portraits, for example, the focal point is the head. So instead of numerous focal points as in my Pictographs I used only one or two. And that's the great difference in what I was doing before and what I have been doing since the late fifties. It's a different spatial concept, and naturally the forms are different. Well, the space was determined by the forms. The character of the forms required a different kind of space, pictorial space, which is to say a flat space.

[This interview with Adolph Gottlieb was conducted and broadcast on WBAI on May 8, 1967 as part of the series "Great Artists in America Today." It was condensed and published in *Arts* in February 1968.]

2. Gottlieb at Seventy

Shortly before this meeting with Gottlieb, he had suffered a stroke but continued to paint while confined to a wheelchair. At the same time, perhaps because of his physical restriction, he began to make monotypes. The artist died less than a year later.

This interview is more general and personal than the earlier one. Gottlieb's elitist attitude was typical of the Abstract Expressionists and his idea that art was going into a phase of democratization was prophetic.

Jeanne Siegel: *You're seventy years old and you've been painting for over thirty years. You've seen a lot of changes.*
Adolph Gottlieb: I've lived through one of the most interesting periods in art. When I was young it was the developments in France of Post-Impressionism and Cubism. And then later it was extremely interesting to see the center of art shift from Paris to New York and for American art to become independent and no longer provincial. Up until that time American art had been somewhat provincial. It was provincial because it always had one eye on what was happening in Paris. If I may use a political metaphor, French art was sort of imperialistic and the American artists were like colonial subjects, and then in the 1940s American artists had something equivalent to the Boston Tea Party, and we dumped the foreign tea overboard.

Do you think this shift from provincial to independent was at least in part political?
Yes. It seemed to coincide with the development of America as a world power, and it seems to me that there are other precedents for that in history. When Spain and Holland were at the height of their power, their art flourished. You never have a really independent art developing in a backward country.

Was it associated with Marxist ideas?
I think that Marxist ideas were very strong in this country for a while, and they were very prevalent in the art world in the 1930s and 40s, but I don't think they had any effect on the art. If they had any effect, the effect was harmful.

In what way?
The way it is in the Soviet Union—where they want to control the ideological content of painting. They have specific people who are dele-

gated to supervise that. This existed here in the 1930s, for instance, in the American Artists Congress, an organization that existed for exhibition purposes. Because of this problem, I and some other artists finally resigned and the Congress was exposed and broken up in 1939.

When I think about the 1940s in relation to your paintings, the words that come to my mind are "myth" and "ambiguity," "the tragic and the timeless." Do these words still have meaning for you?
Of course they do. But "timeless"—that was a slight exaggeration. What was really meant was something which would last for more than a few years, something that was on a very high level.

As distinguished from "American scene" and "social protest" paintings which were prevalent in the 1930s?
That was the official art in this country for a while. The artists in the forties had to make a break with official American art, and they also had to make some kind of break with the accepted French art—to dissociate themselves from the Surrealists.

Do you believe that was accomplished?
Yes, even though a great deal of 1940s art had to do with automatism, which was an important element in Surrealism.

Another crucial issue was "flatness." How do you feel about that now?
It still is a problem in painting—to retain the integrity of the flat surface.

Do you think about it today when you paint a picture?
I'm accustomed to thinking in those terms.

What do you see as the major difference between the 1940s and the 1970s?
There was more of a spirit of rebellion in the forties. The artists seemed to feel that they were in a vanguard and in the front line. I don't see any sign of that now. It seems to me that most of the artists are young Republicans, although I don't think they would admit it.

What do you mean by a young Republican?
I mean someone who's retrogressive—a young man who ought to be forward-looking but isn't. The photo-realists, for instance, although it's not confined to one style.

How do you see your own work as it evolved over this period of 30 years?
Well, that is a big question. It is not really for me to say.

What do you deal with in your current paintings as compared to your work of five years ago?
I don't think my work has changed that fast. My work has changed in periods of decades. I did Pictographs for about 10 to 12 years, and then I started to do what I call "Imaginary Landscapes" and that evolved into what is referred to as "Bursts." But that took quite a while. I've been doing things of that sort since the late fifties.

From what I see in the new work in your studio now, there appears to be a blending of the "Landscapes" and the "Bursts" imagery. Do you agree with that?
Not quite. Those are two separate phases of my work, and I'm quite content to have them remain as separate phases.

Then how would you classify what you are doing right now?
Right now, I am trying not to be classified.

Color has become increasingly important.
That's not true. Color has always been important.

Recently de Kooning said that he gets tired of mixing his colors.
If I used his colors, I'd get tired of them too.

Olitski makes a point of never using a color directly from the tube.
I have no rules. The only restriction lies in the number of colors that are manufactured.

When you start a painting, then, how do you choose the colors?
I have an image in my mind which is in terms of forms and colors. I suppose that I have certain predilections for disparate shapes and colors.

Then the choice of the first color sets the direction?
Yes.

Wouldn't a group of finished paintings on the wall influence your choices for the next piece?
I guess I am influenced by my own work.

5. Adolph Gottlieb, *Blast I*, 1957
Collection, The Museum of Modern Art, New York.
Philip Johnson Fund

Do you usually keep a canvas around when it is finished?
Generally I put it away. I'm not a series painter, really.

What do you mean by series?
There are painters who work in what is called series. They do this in preparation for a show. I have never painted specifically for a show. I do what I feel is necessary for my own development and if it fits into a show—good and well. After my paintings are finished, and if someone invites me to have a show, I make a selection of works that I have finished and it doesn't matter to me whether they are homogeneous or not.

By a series, then, you mean a very close stylistic relationship in a particular group of paintings?
Series paintings are like a suite. To me a painting is a unique thing. By that I don't mean it is unrelated to other paintings, but it isn't like a chapter in a novel.

You mentioned that recently you've been working in a new medium—monotype. Could you tell me about that?
Monotypes are very simple. They are unique pieces that are one of a kind even though they are produced somewhat like graphics.

They are small in comparison to a painting, aren't they? How does the change in scale affect your image?
It doesn't affect my thinking really. Normally my style in painting is related to a free movement of the arm. Naturally, if I work small, I have to work within the limitations of a wrist movement.

You mentioned that you still refer to a particular text?
I found Max Forner's book on painters' materials and techniques extremely useful and a valuable guide to technical procedure. Although I know it almost completely from memory, occasionally I still refer to it.

Have you remained friends with other Abstract Expressionists?
Not professionally. We don't have anything like what the Club used to be. I may run into some of them at a cocktail party, and we speak to each other.

It seems artists tend to separate when they mature.
They only band together for mutual self-protection.

From what?
From the hostile world.

Wasn't there some exchange of ideas?
To a certain extent, yes, but each man was extremely individualistic and didn't want to recognize any indebtedness to a colleague.

But doesn't just knowing what the other person is thinking or doing stimulate individual ideas?
Yes. There is a story about Titian. He was visited in his studio by King Philip of Spain and the King noticed some brushes that were as big as brooms and he said to Titian, "Why do you use such big brushes?" Titian said, "To be different from Michelangelo."

What was your personal reaction to some of your contemporaries—for instance, de Kooning?
I try not to be schmaltzy.

What else do you try not to be?
I try not to be too easily understood. I don't feel lonely and unappreciated, and I don't want to please every Tom, Dick, and Harry.

What about Martin Friedman's theory of dualities that explains the content in your Bursts? Do you accept that?
Some people see them as yin and yang, which is okay with me, but there are other people who see them as objects in outer space, which I vehemently reject.

Why do you reject one association and not the other?
I can't help what people see. They might see Little Red Riding Hood in the painting.

But then, is yin and yang an idea of yours?
It's not an idea of mine, but it may exist there. It has a certain universality.

Is there anything else you are trying to get rid of?
I would like to get rid of the idea that art is for everybody. It isn't for everybody. People are always talking about art reaching more people. I don't see why they should want to reach so many people. For the large

mass of people there are other things that can appeal to them. The average man can get along without art.

Then whom is art for?
It is for just a few special people who are educated in art and literature.

Why do you bring this up at this particular time?
Because I think art is going into what I call the democratization of art, a kind of egalitarian point of view, which assumes that everybody can understand and appreciate art.

Don't you think more people in this country have become interested in art just by virtue of having had Abstract Expressionism?
I don't think the size of the audience counts for very much. I think that the great quantitative audience is for Hollywood and Walt Disney, and I think that's the future of art—in that direction. More and more people will get their kicks from Disneyland.

In retrospect, have you ever doubted for one minute your step into abstraction?
I have never doubted it.

At this time then, do you see any validity for a revival of Realism?
No. I think it's a retrograde tendency.

Have you ever gotten tired of painting?
No, so far I haven't.

[This second interview was conducted in Gottlieb's studio in Easthampton, Long Island in the summer of 1973. It was published in *ARTnews* in December 1973.]

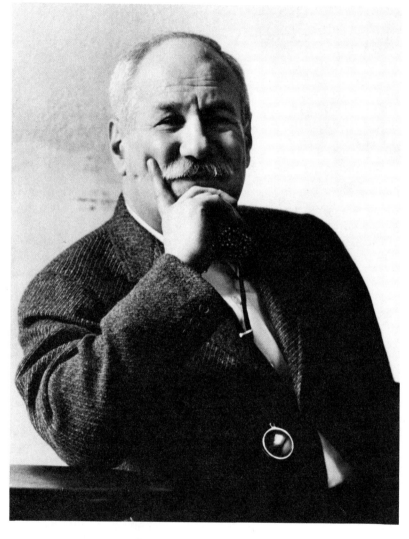

6. Barnett Newman
By: Alexander Liberman

Around Barnett Newman

These interviews were published on the occasion of Barnett Newman's posthumous retrospective at the Museum of Modern Art, held a year after he died. The artists interviewed—Dan Christensen, Lawrence Poons, Donald Judd, Andy Warhol, Philip Wofford, Robert Murray, Saul Steinberg, Alexander Liberman, Clement Meadmore, Dan Flavin, and Tony Smith—were chosen because they had all had some personal contact with Newman. Alexander Liberman was particularly close. However, Newman had parted from most of his contemporaries and enjoyed socializing with younger artists. Donald Judd and Dan Flavin were among those whom Newman favored.

The artists' statements point up the various aspects that individual artists were impressed with in Newman's painting, and also the contradictory reactions to Newman's sculpture, *Broken Obelisk*.

Dan Christensen

Jeanne Siegel: *Your recent paintings bring Barnett Newman to mind.*
Dan Christensen: Yes, possibly because of the stripes. I run into Barney Newman when I'm working, occasionally, like one color with a stripe in the early stages of a painting. And I sometimes wish I could just leave it like that but it's not complete for me. Maybe it's because I've seen Barney Newman's that it's not complete.

But my work doesn't have that much to do with Newman, mostly because the way I work is flat and indeterminate, when I start. I think Newman must have painted pretty much, can I say "determinedly"? I don't think he painted unstretched but started with a given shape and worked on that shape to make what he ended up with; where Pollock didn't, Louis didn't. Perhaps my coil paintings were more related to Newman than the recent more rectangular ones. Because the painting is set, in fact, the painting revolves around its shape which is preset and

that was like the given thing that I was working with. Then I started working on the floor and making crops and making additions or subtractions, cutting off something, and it was much freer and it came to what I am doing now through that.

Newman must have taken a long time to paint a lot of his pictures. It's the kind of painting that's very laborious. Every color, each stripe has to be exactly right for his painting to make it and I don't have to think about it that way. I can put down anything and put it down fast, cut it off or throw it away. For me, cropping a picture gets very difficult and some of my paintings have been cut three times and I often stretched them and if they're still not right I restretched them. Eventually I might just throw that particular painting away. Maybe it's just two sides of the same coin, but Newman never inspired me to go make a painting like Newman's. But what's really important is that Newman did, in fact, make some great paintings.

Were they great because of his use of colors?

I don't think his primary thing was color really. I'm not saying he was a bad colorist—I'm just not hit right off with the color of them. I can remember a very washy green picture with two stripes that is in the Metropolitan. That's good color. In the Newmans I liked, I might get a sensation of a red but I get more of a sensation of solidity, or tightness, something really physically together. They were shaped exactly right, scaled exactly right, the lines were in the right place. I can see where many of the Minimal sculptors came from Newman, from that kind of physicality, of completeness.

Larry Poons

Larry Poons: I went and saw the French & Co. show (in March, 1959). I had just moved down from Boston and I had an experience at that show about painting that I can't really put into words. I was very moved by his paintings. I didn't know why, I had never seen any paintings like them. They were terrific. They were baffling—I didn't know what they were. Also they gave me a strange kind of confidence that I could paint. In front of de Kooning's paintings, for example, a young, impressionable artist will more than likely experience incapability rather than enthusiasm and hope. What I got from Barney's paintings the first time I saw them and subsequently was a feeling of being capable of painting.

I wrote him a letter—I got his address from a *Newsweek* article—and maybe a month later I got a phone call. "Come up to my house. I'm having a party." After the party broke up he asked me to stay and we

talked. I talked about my paintings and he talked about his poetry and I talked about poetry and he read some poetry of his and we were drinking vodka and having a good time. He read Vachel Lindsay's "The Congo" with all sound effects and everything. It was all very nice and he was very encouraging. He came down to the studio that summer and looked at work and he dug it. Sometime later, I mentioned to him that I was having a rough time with my father with what I was doing. Barney said very quickly. "Oh, let me talk to your father." So we set up a luncheon date at Sloppy Louie's—my father, myself and Barney. Barney was a pretty impressive figure to my father, a businessman with a practical frame of mind, and I guess even the very sight of Barney impressed him in the way that he would be impressed. Barney came around to saying, "Look, your son wants to be an artist—that's a noble profession; you ought to get off his back about it." My father got interested in Barney's painting *Abraham* because it was Abraham who was willing to slay his son, which made the point, so there was an act from Barney . . . That was, at that time, and is still now, one of the most important things that anybody has ever done for me.

Did you remain freiends?

Yes. We saw each other infrequently. It wasn't like seeing each other every day. He came to my studio twice and to all of my shows. Barney was one of those encouraging people; for a young artist to meet a real artist—just knowing him—made you realize that you were an artist. That was one of the things that Barney projected. He would relate to you as a peer and not as an older artist and that was the beautiful thing about him.

Don Judd

Jeanne Siegel: *You stated, in 1964, that you thought Barnett Newman's paintings were some of the best done in the United States in the last fifteen years and that Newman was the best painter in this country. Do you feel the same way today?*

Don Judd: I don't know if he is the greatest but he's one of very few. I'm in favor of comparing artists but it's a very difficult thing to do. Anyway, he's one of the best.

At that time you saw his work as a very definite statement about the rectangle.

I think certainly that he and other people developed the rectangle as a thing itself.

Was he directly responsible for anything that you were doing in the early sixties?

No, I don't think so. The timing was sort of wrong, somehow—my timing. The moments when I came to figure certain things out didn't quite coincide with the ones when I could have used knowledge about his paintings, so that I really came to like them after the point where I could learn anything from them, beyond a couple of general things, such as scale, primacy of wholeness, and color. It's a very big point but I didn't learn it only from him but from all the New York painters. It's nothing that Rothko didn't do too, or Pollock. Also Pollock was the first artist that I was really impressed by of that group. I'm still impressed by Pollock, but when I saw Newman's show at French & Co. in 1959, I thought the paintings were good but I was kind of critical of him because of the geometry which I think was probably the problem Barney got into with everybody in the fifties. I think people misread that geometry. I misread it too. I attributed all that geometry to Mondrian and the Europeans. Though I like Mondrian, I felt it could only be used one way and that was the end of it so I had a lot of trouble getting into it myself.

Wasn't the main objection to Mondrian's paintings that they were built up of relational elements?

The relational elements and just the quality of it, the pure and ideal. I was never interested in a pure kind of art. That was the main thing I held against geometry and primary colors and such things. Now, though, I wouldn't distinguish between pure and impure. It's a writer's cliché. But I guess, too, at French & Co., I took Barney's paintings, which I think now aren't at all like that—as sort of blown-up sections of some of Mondrian's paintings, where the stripe would be over on one edge, which Mondrian does all the time. Except Barney would have nothing but white canvas with a stripe at one edge and it looked like a section. So I kept thinking of the stripe, as in Mondrian, moving to one side rather than simply being there as it really is in his paintings.

When did you change your mind?

About 1964, that was all finished.

Do you think there are young artists today upon whom Newman had a direct influence?

I've seen a fair number of paintings around. They don't look very interesting to me. As you can probably figure out, I'm pretty skeptical about painting. But that sort of thing isn't retroactive; it doesn't apply to

Barney or Stella. I don't think anyone has come along doing interesting painting in quite a while.

What about an influence on Dan Flavin? By the way, Flavin told me that you introduced him to Newman.

We were all on a panel together. Barney, Dan and myself at the Richmond Institute in Richmond, Virginia, and somehow we got to talking about Charlottesville and Barney wanted to go there. So the next day we went to Monticello and saw the buildings on the campus. They were pretty interesting. Barney liked the pillars on the main building: the pillars as line and the space behind them. I don't know. I first saw Dan's work before he used the fluorescent tubes. In his first show he had one, two, three, four tubes and that reminded me of Barney. I see things that I'm interested in, that he was interested in too, that are closer connections than those general things. But it's in retrospect. That is, for example, pieces with narrow shapes—evenly spaced, or some of the pieces that have narrow spaces of one kind or another. They're usually part of a very broad area. That's certainly true of the stripes.

An incredible quantity of thinking went into the lines in Barney's paintings. I'm not talking so much about placing as the possibilities of the line. You know—broad, narrow and so forth. That's really amazing I think about things like that in my own work, but I'm mildly surprised that he can think so much about a relatively unmomentous matter. It's funny. It's a very philosophical matter, I guess. Presumably there are an awful lot of things to think about—it's strange to think about a single form over and over again.

Do you have a preference for any particular painting of Newman's?

I tried to buy *Shining Forth (to George)*. It's one of his best paintings but it's a personal painting, too, because of George (Newman's brother). I saw it when it was just finished in a show at the Jewish Museum. Then not too long afterward it was in the Sidney Janis Gallery. I didn't see very many Newmans after the French & Co. show so I think maybe it was one of the first big ones I'd seen since I'd changed my mind on the whole subject. And it's also a spectacular painting.

What about Who's Afraid of Red, Yellow and Blue II?

It's a very nice painting. Barney and Dan Flavin and I went down to see the big one after he'd finished it. I was very surprised by bright color and I guess, actually, the red, yellow and blue.

Vir Heroicus Sublimis is a red painting—it has plenty of red, white and off-red, a red-brown stripe—but anyway, decidedly not primary color.

I guess I was surprised by the use of primaries because of my own bias against primaries and the fact that it didn't have anything to do with that sort of use of primaries. Also, an interesting thing about the red-yellow-blue paintings, too, is that they're very flat and comparatively non-spatial, compared to his earlier paintings. They have a very mechanical surface. He was using a roller.

One thing I objected to in the French & Co. show in several of the paintings, for example, *Cathedra,* a big blue painting, was the brushwork and the airiness.

There is brushiness in Shining Forth.

Yes, but it's not used to make air or illusionistic space. It's used as the nature of the edge, the process of making the edge. That has to do with brushwork as contrasted with making space. *Cathedra* seems to go way back while the late ones are very very flat. In *Red, Yellow and Blue III* it's only one stripe that's a little spatial—the blue is glazed or something, so it's a little indeterminate but the red is just red paint.

Certainly Newman was the most successful in eliminating illusionism. For instance, compare him to Rothko.

That is pretty recent in Newman's painting. However, Rothko's whole way of working depended on a good deal of illusionism. I think it's very aerial. The whole thing is about areas floating in space. Compared to Newman there is distinctly a certain depth. But I finally thought that all painting was spatially illusionistic, even when it was flattened as much as Barney had flattened it or as I tried to in my paintings. Barney's quite a bit less illusionistic than others but they're still involved in a certain amount of space. *Shining Forth* is all about where the space occurs even though it's only canvas.

I went with Annalee [Newman] to see the paintings Barney had been working on when he died and he had a great big one finished, and some unfinished. They're like the red, yellow, and blue ones. He was using a roller on these. The big finished one had a very wide central band and two big areas on either side and all the areas were flat—rolled on.[1] It was exceedingly flat. It's really just a layer of paint. Also he had some triangles stretched that he was going to work on. So far I haven't been too interested in them. I need to think about them more. I wasn't so keen on them in the Knoedler show (in 1969) but then they were on velvet walls. Maybe in another context and more time to think about them I'd like them better.

The idea for the triangular paintings grew out of his sculpture, Broken Obelisk.

I don't like the Obelisk. I don't know what it's all about. I can't make any sense of it. I have no interest at all in obelisks. I didn't understand why he was interested in the obelisk as a form. And it didn't seem interesting to break it. Why not just do a big line or band or whatever? And the precarious perch seems tricky or cute. I like the first sculpture he did, in 1950.

Andy Warhol

Andy Warhol: The only way I knew Barney was I think Barney went to more parties than I did. I just don't know how he got around—I mean he'd go off to the next party. And it's just so unbelievable; why, I just think he's at another party. Don't you think he's just at another party? Maybe he didn't have to work a lot if he just painted one line, so he had time for parties.

And then I heard about all these studios he used to have, like fifteen studios; one for every painting. Everytime I'd go by a building they'd say, well, Barney has a studio there. He had one in Carnegie Hall and about three or four downtown. He did a painting in the studio and then he'd leave one painting up forever. Isn't that true, Fred? Didn't Barney have a studio for every painting he ever painted? That was the most mysterious thing about him—that's what I thought was so great.

Jeanne Siegel: *Was Barnett Newman a success when you first became aware of him?*

I thought he was famous ever since the first time I met him. But then somebody said he wasn't famous until just recently. I liked the thing that's down in Houston next to the Rothko Chapel. I think that's so beautiful. We used to go down to Houston so I saw it. The whole idea was so great. It was so simple near the church. I liked it in the setting.

Did you like his other, simpler sculptures, such as Here III?

Frankly, I never understood how he got away with it.

Did Newman ever come to your studio to see your work?

No, I don't think so. The last time I saw Barney it was at the Eugene Schwartzes. Do you know them? They had a Barney Newman and then they had another Barney Newman, and I thought it was a copy done by that girl who copies paintings.[2] I was going to ask him and then I didn't

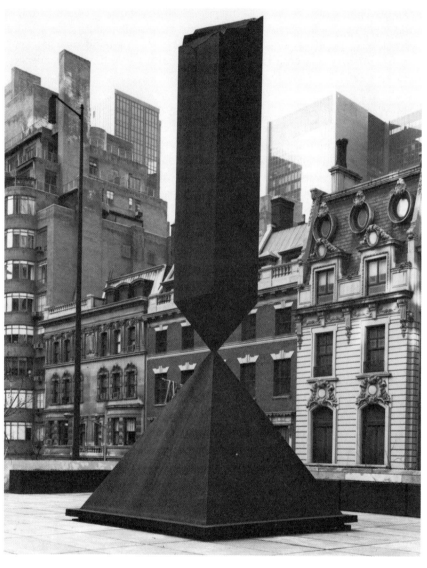

7. Barnett Newman, *Broken Obelisk* (1963-67)
Collection, The Museum of Modern Art, New York

ask him and then he was standing right next to it so it must be real. They wouldn't have hung a copy if Barney was there.

Did you talk to him?

Oh yes. He was always so sweet. He always asked me how I was. He was really kind.

Philip Wofford

Philip Wofford: I remember very strongly the 1959 show of Newman's work at French & Co. Primarily I remember a big red painting and a big blue painting and I was very impressed at how full the paintings seemed. The paintings I was interested in at the time were primarily Pollock's and the more Expressionist American painters. Newman was really a new experience and something that I didn't expect. When I stood in front of those big paintings I was very impressed at the richness of the single color, the quality of the paint application and the rightness of his edges, the narrow stripes cutting through and working in all that red and all that blue. It was the first reductive painting that I had seen that seemed like a full experience.

Then later on I saw some earlier work, smaller, rather abstract Surrealist paintings with totemic imagery, circles, and rather shaggy stripes, which related to early Rothkos and Pollocks. Those interested me very much in the sense that they were the beginnings of Newman's entry into a unique kind of American painting. I felt that this early involvement in a kind of Surrealist, symbolic imagery carried over into his later works— into the idea of a monolith, or the single stripe—his notion of "onement," the single direct statement. It was this symbolic or more expressionist than conceptual way of approaching painting that I feel made him very different from the Minimal artists of the middle and late 1960s, even though he was connected with them as a kind of precursor and influence.

I always felt his work had a very human quality: the way one big mass of color rubbed up against a stripe or against another color had a kind of friction to it, a rubbing energy that is very exciting within his refined statement.

The next paintings I saw were the "Stations of the Cross" series at the Guggenheim in 1966. They seemed to move through time—a kind of sense of the evolution of a process unfurling itself so that each individual unit within the whole reflected the whole and in order to see the whole one had to relate all the paintings together. I thought of Bach in the feeling of the separate notes working in and out of each other in a fugal way to make up a oneness again.

His *Broken Obelisk* is one of the greatest pieces of American sculpture probably because of the monolithic quality of it, but also the almost absurd obviousness of it—the combination of an obvious gesture taken to an extreme. The cutting of the obelisk and the turning it on its point is almost laughable, but at the same time, the scale and the rightness of the proportions of the form make it a classical, very serene piece. There's an ambiguity about it, an exciting bridging of comedy and drama.

Those "skinny" pictures, where he just lifted one of his stripes out of a large picture and isolated it in this very narrow stretcher, are his typical impishness coming out. It was, again, pushing something over the edge of seriousness into absurdity. I never took them seriously as paintings in themselves, but as an extension of his concerns and of the concentration on one of the elements in that. Certainly the kind of wit that was in them was, again, much more human as against mechanical or commercial.

I usually felt the presence of Newman's hand and the working out of the paint as material taking various spatial levels within a huge area of color, shifting back and forth, the light acting within like a pool of color, shifting and changing. In other words, they never looked as if they were done by a machine. So much art now, has a printed look, as if it's been stamped out rather than painted. There's a whole impulse to reduce that personal hand touch. If you move your brush a certain way, you apply the paint a certain thickness, you're going to get a certain kind of organic looseness, a flexibility that goes against the deadpan flatness that a lot of artists want.

Newman formed a kind of bridge with ideas and impulses that arose in the late 1930s and 1940s in American art, a bridge that kept expanding and extending his work into the late sixties and early seventies. He seemed to be right up front in terms of everything else that was happening.

Robert Murray

Jeanne Siegel: *When did you first meet Barnett Newman?*
Robert Murray: In 1959 Barney and Annalee Newman accepted an invitation to attend the Emma Lake Workshop up in Saskatchewan. Emma Lake is a shallow weedy little lake on the edge of the Saskatchewan "bush." The Workshops, which have been traditionally held in the last two weeks of August, following the summer art school, were an important event, particularly in the late 1950s, when few of us were able to travel outside of western Canada.

At that time Newman was perhaps the least well known of the New

York group, although he had just had his show at French & Co. Certainly the review *ARTnews* carried wasn't much to go on—it put down the paintings and attacked Newman for promoting overly "masculine" imagery in his work and what he said about it. But as it turned out, Barney came at a very critical time for many of us and the workshop was small, concentrated and, ironically enough, all men. I remember his arrival in ball cap and heavy Siwash sweater. He looked around and said something like "You guys don't need me, you need a psychiatrist." I haven't been to any of the recent workshops—a very impressive list of visiting artists and critics including [John] Ferren, Greenberg, [Herman] Cherry, Noland, Olitski, Stella, Alloway, Cage, Judd and a number of others, have gone up—but it's hard to imagine a more interesting situation than the one that existed in '59. Barney wasn't out to sell New York or a style; essentially he helped us get over our provincial paranoia and encouraged us to take ourselves seriously as artists. His life style made itself felt and was pretty infectious. He made it seem important to be an artist, which for many of us was a commitment often difficult to justify, living in small western cities, without one decent museum.

There was a period between 1951 and 1959 when Newman didn't show in New York.

That was a kind of self-imposed exile, in a way. But Barney was a force on the scene and he was painting even if he wasn't showing in galleries. The "official" art world was slow to deal with his work and he was pretty irritated with the antics of some of his colleagues. Fortunately his work remained relevant for the next generation and is now regarded as some of the most important painting this country has produced. Barney's best audience has always been other artists and, later, a few private collectors.

In what ways would you say his work has remained relevant?

We forget now what a dramatic thing it must have been to draw a line down a canvas and call it a painting. But Barney was also about color. You don't go back from Newman to Mondrian, you go back to Monet and Pissarro. The "band" was a device for activating the field of color. I remember talking about this after going to an exhibition of Yves Klein. Barney was intrigued with the paintings but I know he felt they existed more as aesthetic objects—the overall uninterrupted blue turned into, well, like material. Size and scale were also important. Some Pollocks are big and feel big. Barney too sustained this ambition for scale, grandeur and a sense of the sublime; statements that were quiet, strong, and immense. I'm thinking of paintings like *Cathedra, Vir Heroicus Sub-*

limis, Uriel, Onement VI, and *Shining Forth.* He also succeeded with another largely American pursuit and that was to make a truly abstract art. I found his work harder to get, harder to deal with than most of his generation, but almost always more sustaining as a pure painting experience and less dependent on nature, the figure, and European antecedents. In the first few weeks I was in New York I saw three of the largest paintings I had ever seen. *Guernica* hardly needs comment; it is overrated even as a political cartoon. Goya could do it; no one else has been able to handle stuff like that and make a decent painting, just as no one can do "My Lai" better than *Life*. The Pollock was terrific but bothersome. The image was vignetted to the canvas and the layers of threaded color looked suspiciously Cubist. Only *Vir Heroicus Sublimis* seemed big and pugilistically new. All that red, just barely held in check by the vertical bands seemed, well, right. Today we talk about getting vibrations—I was getting vibrations about "red," not the way Matisse "whitewashed" his *Red Studio*. It seemed pretty valid, just the way Barney laid it down. His devices were never diagrammatical or decorative, but the format was amazingly logical. The bands within the painting repeated and echoed the rectilinear shape of the canvas just as the color and forming of the bands entered into a dialogue with the open areas of color. It all happens in one arena and when you stand in front of the painting, you are in it. It's not the Impressionist window, it's not the ironed-flat Cubist room, it's not mural decoration for the walls—it's more an aura of casually punctuated color you get into through your head and gut. He continued the best aspects of Impressionist color as light and went around the architectural hang-ups of Cubist picture making.

Was there anything you would call a direct influence on your sculpture?

Barney didn't have a following the way younger painters once aligned themselves with de Kooning, but his attitudes have made a significant impression on a lot of us working today without resulting in stylistic conversions.

When I first arrived in New York I spent a great deal of time with Barney, often helping him move and stretch paintings. We also worked together on the model and drawings for a synagogue that were shown at the Jewish Museum in 1963. These were always social situations, good chances to talk and almost always ending at Sweet's or in Chinatown. Barney was terrifically generous with his time and I was glad to be whatever help I could. I was painting then and I admit it was damn hard to go back to my own work after spending several intense days with Barney and his paintings. Our interest in sculpture had somewhat more of an even footing. We had each done one good sized piece by 1960—I shifted

to bronze casting in '61 and Barney and I used to go out to the foundry in Astoria together when he cast *Here I*. When I went back to fabricated work in '63 he came to Treitel-Gratz and did two pieces in steel. We found out about this firm from Alex Liberman. In '67 I took Barney up to Lippincott's in New Haven, where *Broken Obelisk* was built. We could agree or disagree about a great many things when it came to sculpture, but it was always an event to get together when one of us finished a piece. If there was any one thing I could say came directly from Barney, it might be a desire on my part to have people experience a piece of sculpture the way I reacted to his large paintings. I have tried to get people involved with my pieces without being able to see all of them at once—to sense the nature of a piece by moving in and around it rather than looking at it.

Your total elimination of the base is a point of departure from Newman's.

I've always had pretty strong instincts that sculpture should stand freely on the ground plane as a self-supporting structure. The bronze pieces got me into bad habits. They were small and needed bases and these concerns carried over into the first few fabricated pieces I made. It was an unnecessary crutch and didn't last long because the various parts of the sculpture leaned and tilted and easily supported each other. Barney's pieces have always been much more static declarations. The bases under them tended to establish a place for the sculpture to happen. They mark off territory, like the paper margins of his lithographs. On the other hand, the slab under *Here I* and *Here II* becomes hardly visible in the *Broken Obelisk* and there is no base in *Zim Zum* (1969).

The *Obelisk* was set up on a slab in a pool of water in Houston. Perhaps that's artificial but it looks damn good and it keeps the kids off. Barney more than anyone else I know had a sense of concern for the way in which his work was exhibited. This is not to imply that some ultimate situation should exist where the work is necessarily commissioned in advance. That's another problem—and Barney wouldn't ever do commissions.

Saul Steinberg

Saul Steinberg: I have to report with alarm that my souvenirs of Barney are made of:

 A. Things I said to Barney.

 B. Things that Barney told me about myself.

It obviously reflects on my egotism but it also shows how memorable it was to listen to Barney on that subject and that his presence caused

me to—probably—say things that were better than usual or important for me.

I occasionally still monologue with Barney—but it's too easy. Or I ask myself what would Barney have said about this or that (including this letter).

Alexander Liberman

Alexander Liberman: Barney never wanted to be seen or photographed at work. This whole question of not showing one's effort has to do in a way with a classical education where emotion shouldn't show. It's the anti-Expressionist attitude, in a sense, and Barney, who was very fond of reciting Corneille and Racine, had the sense of classical nobility. So just as there was paint splattered around his canvas, and there was so much splattered that he would have to protect the walls with brown wrapping paper, the finished canvas was to show no effort. To emphasize the dignity of the human being, art has to go beyond the manual, and Barney more than anyone achieved that in the final result. And the final result is what counted. Young art students have studied photographs of studios thinking that perhaps they would reveal something about the creative process, but in Barney's case none of this mattered. It was unnecessary and even intruded, because the real creative process was spiritual and the physical means were really very factual and not visually meaningful. The clutter of Picasso's and Braque's studio—they were surrounded with their own works and artifacts. Nothing was in the studio except Barney himself. There was nothing basically to show because it was in the mind and in the soul and in the heart.

The curious thing, though, in order to achieve this final result, Barney was profoundly involved in techniques—in the actual making and mixing of paint, the using of new mediums, what would give him the mattest black, how to get rid of brush strokes. Barney would say he would have a problem with a certain varnish that would dry leaving flecks of white crystals—how could he avoid that? To take a gigantic canvas off a wall, should one roll it on a roller? Should one roll it on a stick? What are the best stretchers? Should they be two inches deep?

These are technical problems that artists can only really discuss among themselves. We used to discuss the quantity of water to put in plastic paint. It was through him that I got duck canvas. He taught me what to do and where to get it. I had started doing a lot with Liquitex and Barney at that time had done less; he was working with Duco mixed with Liquitex to obtain a richer black, so we discussed certain formulas. I'd say, "This dries better if you do it this way," and he'd say, "I tried it

8. Barnett Newman, *Midnight Blue* (1970)
 By: Alexander Liberman

and I'm having problems," so then he'd say, "Well, maybe we have to eliminate water from the brush, maybe it's water in the brush that makes the plastic paint look streaked." These were the discussions. "Should we use any tension breaker so that the plastic paint would penetrate as a first coat into the canvas?" He was against it because he always felt it had something to do with batik and he hated the principle of staining a canvas because that, to him, was, perhaps, a dangerous link with the decorative.

When Barney began to make sculpture, he went to see Treitel-Gratz and started to work with them, too; we had long discussions as to what metal to use and how to rust it. He would say he'd been using orange juice (which he had learned from a master-craftsman in Brazil) and he was getting certain rust to come quicker by using orange juice. I was trying acids. Barney was profoundly involved in all of this. I think Barney's whole technological experience has been extraordinary.

Can you connect Newman's extreme interest in techniques, for example, his choice of a particular black acrylic paint, to his metaphysical ideas?

If Barney wanted a black and he didn't want it to have traces of his hand (sometimes he did, but usually he didn't), I don't say his black represented a void—he wanted the black to be a black, and nothing, not a brushstroke, not a feeling of the hand, should interfere with the sensation of black. So then the problem is the link between the concept and the medium—how to achieve, technically, the blackest black—and the metaphysical element there is the basic decision of black black without anything distracting from it.

What did Newman mean when he spoke about the "sublime" and the "tragic"?

I always interpreted it as being the highest aspirations of man. It's not tragic in the sense of tragedy, it's not sublime like the most extraordinary beauty, but it's really, perhaps, reaching for the impossible. Going beyond the human condition and opening to other human beings a new experience of the spirit. I think, frankly, Barney was trying to put painting into the highest form of human endeavor and put it on the level of philosophy or religion. I think religion is the realm of the sublime, basically and I consider religion tragic, too. The great human experience is a religious experience. Not a denominational experience, of course, but an experience of reaching out. And I think Barney's greatness is that he was able to use the simplest means.

Do you relate scale with the tragic or the sublime?

No, not necessarily. The question of scale is really a question of monumentality and the great artist is the one who, whatever the size of

the work, keeps the scale on the same level. There's a small etching of Barney's—it's very small but it has that monumental black line. I always felt that Barney checkmated all artists because I don't think anybody can draw one line on the canvas without the image of him being there. Do you remember in *Don Giovanni* the voice of the Commander calling Don Giovanni and everything seems to stop and all the merriment stops. Suddenly there's this commanding voice putting everything in its place, into a sort of order. I always feel that Barney's line has the same kind of commanding assertion of what art is about—of what modern art should be about. Of course he loved music, but what Barney had beyond that was that he was the most civilized man I knew. He was cultured, read, involved and knowing, and he could write about Amlash, about modern art, he could introduce Kropotkin, he could talk about Spinoza, and I think for an artist it is very important to have this intellectual breadth of vision. You could not, I think, do the kind of art that Barney did if you were an uncivilized human being. His passion for Mozart, his passion for Baudelaire, all this is part of a total image of man absorbing the experience and knowledge of centuries and distilling it into a major human statement.

Clement Meadmore

Clement Meadmore: Recently I have come to regard Barnett Newman as the equal of Brancusi and David Smith as a sculptor; in fact I think he may be even more important for having gone beyond Brancusi's semi-traditional forms and Smith's semi-traditional composition. Although other sculptors in the 1960s did larger works, Newman's for me were the most monumental, by which I mean they had a feeling of scale which went beyond their actual size. This is surprising considering the use of lean forms not usually associated with monumentality. *Broken Obelisk* works in spite of, not because of, its allusions to traditional monuments. It has to do with intuitive proportioning of almost conflicting elements. *Broken Obelisk* was originally made taller so that Newman could decide the position of the break at the last minute even though he had made many different cardboard studies. My favorite Newman, *Here III,* also has this inexplicable proportioning and scale in the interaction of base of the work and the stainless steel shaft which is entirely reliant on the base for its meaning.

Dan Flavin

Dan Flavin: This is the text of a telegram of July 7, 1970, I sent to Annalee Newman in New York:

"Flying home from London, I stood up to change physical position, I looked down to see Barney's picture in the worst possible place in someone else's *Sunday Times*. Sonja and I were shocked and saddened at the borrowed obituary notice.

"Last night, I telephoned Larry Zox in Springs. He and Jean agreed in sorrow. Jean had been unable to sleep, remembering Barney. After all, as Larry said, Barney was such an impressive physical presence that it is difficult to imagine that one can no longer see and sense him. Please be well. Take comfort from our good thought. Please plan to visit with us when you want once more."

Draft of a letter, July 21-August 22, 1970:

"Douglas Davis, I noticed your 'Death of an Artist' in *Newsweek's* July 20 edition. I guess that I appreciated its appreciation mostly but the article reads as though composed by a new boy around posing as Barney's own contemporary partisan which engages me and not but I don't want to explain. However, you do present several serious observational mistakes in your fondly determined excesses but—oh so what. Well finally, to commit myself, I simply can't believe that Barney understood, as you state 'He began . . . with the notion that painting had to be about its own physical properties—color, form and texture.' That's chronologically absurd in terms of his own art history and then, too exclusive an approach to art for the Barney I heard. Why I believe that the man could have easily and assuredly concocted his own 'on the spiritual in art' if he had wanted to write that all. That 'His painting pushed abstraction as far as it could go' should never have been credited to any painter, even Barney. It's an incredibly excessive, silly, metaphorical cliché—of the destructive to reductive to minimaleast too apparently correctly 'logical' of an art-historical-critical triple ploy (as implied historically correct procedure thoroughly through so-assumed non-associative art in the 1960s)—on to all gone, out-of-sight out-of mind complete conclusive coup against apparent art—and then you simply sophistically have to conclude progressively forward to 'purer' than ever before 'Conceptual Art' circa 1970 so boorishly boringly conceited, theorized, periodicalized and catalogued by even the slightest studented mentalities just about anywhere such relentless promo-'in'-proto-art historicists haplessly convene authoritarianly avant-gardistically.

"Can't you, won't you possibly consider Barney's finally plain, however distractingly determined spiritualized paintings as ambitious, pretentious, aristocratic, mature, positive proposals sophisti-

catedly complementing past paintings by other men which he knew, admired and personally interpreted. Oh but so likely that's asking you to know as an artist with Barney and me and others instead of just as a commentator or worse just as critic which you seem to be.

"I'm sorry to belabor but I mean this communication mainly to concur with your: 'He (Barney) seemed to befriend everyone he met, especially younger artists, whose openings, he alone of the senior artists always attended.' (Exaggerated estimations but near enough to accurate.) Somewhat contrary to your opinion though, Barney seemed to play frequently with the paradox of his senses of being another one of the guys, artists, and his senior status of prospering old master. He could close to your face address you in inside artistic vernacular with oft-reiterated tales of his command of discussions long ago with noted artists and others some of whom were long dead all the while inserting and rejecting his preposterous monocle to help sustain his fervent outspoken authority then and at the moment. Most often I enjoyed the total performance. And I must not forget now that customarily dear Annalee would monitor the demonstration of Newmanisms so carefully, so considerately, so considerably as though she alone possessed some uncanny superhuman editorial capacity closely and long developed for her adjacent charge and spouse, Barney.

"I came to sense that Barney reservedly desired, obtained and enjoyed the esteem of young artists particularly from those whose arts he could respect somehow . . ."
(The letter was discontinued, never resumed and never mailed.)

The label from the Leo Castelli Gallery exhibition dedicated to Barnett Newman:
"Untitled (to Barnett Newman to commemorate his simple problem, red, yellow and blue) 1970 (signed) Dan Flavin."

Tony Smith

Tony Smith: One day, shortly after I had started to teach at N.Y.U., Barnett Newman and I were standing on the Fourth Street subway platform. He said: "The students want to love you. What you must insist upon is respect."

Before he became known as one of the great revolutionary artists of the century, I had the love for him that he said the students wanted to give their teachers. I also had the respect which he demanded.

Perhaps less personal and more important is the admiration I have for him as one of the great geniuses in the history of art.

[The interviews on Barnett Newman were published in *ARTnews* in October 1971. Christensen, Poons, Judd, Warhol, Murray and Meadmore were taped in their studios in New York. Wofford was done at his gallery in Soho. Flavin, Steinberg, and Smith were received by mail. Liberman was interviewed at *Vogue* where he was the Editorial Director.]

Notes

1. In point of fact, Newman painted with a brush all the final coats of his pictures. He sometimes used rollers to lay on the undercoats. (Ed.)

2. Elaine Sturtevant.

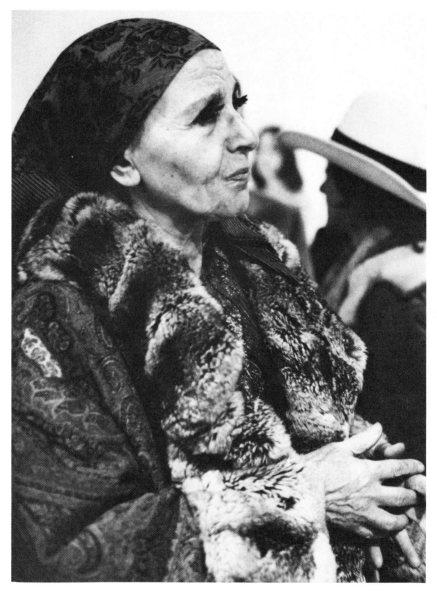

9. Louise Nevelson, ca. 1970s
By: Dorothy Beskind

Nevelson's Walls

Louise Nevelson's retrospective exhibition opened at the Whitney Museum of American Art in March 1967. At age sixty-seven she was finally beginning to receive critical and public acclaim. Included in the exhibition was a gigantic gold "wall" titled *An American Tribute to the British People,* which she had given to the Tate Museum in London.

Nevelson's discussion of her "walls," her most environmental structures, makes for an interesting comparison with the ideas of Allan Kaprow and George Segal. (See Environments and Happenings). Her awareness of the presence of a feminist sensibility and its influence on her sculpture anticipate Feminist issues in the seventies.

Jeanne Siegel: *At various times over the last twenty years your sculptures, particularly the free-standing vertical ones, have been likened to stalactites or totems while your black wall pieces have been described as monuments and altars. The boxes that comprise the whole have been called closets, chests, even coffins. In art terminology they were categorized as Neo-Dada assemblages, Cubist collages, pictorial reliefs, junk sculpture, and more recently environmental art. How would you describe them?*
Louise Nevelson: First, I'd like to say that these descriptive terms are quite contrary to what I feel about art. For example, the comparison to cupboards or caskets never entered my consciousness. Second, Neo-Dada is the furthest thing from my mind. It is all right to have people write about you in their own terminology, but it has nothing to do with me or my work.

How about the word "environment"?
I think I gave the word meaning in a visual sense, to begin with, and then the other people that followed me, naturally, they have either added or subtracted from that word. I think if we look in print, in the past, you will find that when I had my first big show, it was already considered

environment, because I was the first one to take away the furniture in the place where I exhibited.[1] The gallery at that time permitted me to take out everything. I didn't want a chair or a desk or a light to interfere with this environment. It would have been like if we got a splinter in our hand. It would have been something that would have been irritating. And I used the windows at the time as works of art by putting things in them. So I took that whole environment and did that. So I consider that I'm actually the grandmother of environment.

Do your present sculptures carry the same connotation of environment?

Once you have established that in your own being, naturally if you have learned to dance, you can move around in different positions, but basically, that is already established. I'm probably not holding as close to that but certainly those are the ingredients.

You spoke of trying to capture the indoors and the outdoors simultaneously. Could you explain that?

In our time, which I think is unique and quite magnificent for my kind of thinking, throughout the world we find that the architects are opening up all the spaces through the new materials like glass. They have trees, for instance, growing out of the living rooms. They have swimming pools within homes. So now I have come to the point where I feel that there is no longer indoor sculpture and outdoor sculpture. It is all becoming one and it's fortunate because the materials that have been given to us can make that possible. I would like to make an environment where all the walls would be bronze or metal, and then they would be part of the interior of a home. Then I would put metal sculpture, let's say, black, against that, and make a total environment which has never been done yet. I feel that it would be so timely.

Do you think of that as making art more functional?

Not at all. I consider it makes a new environment that would reflect our time in that it would encompass all the inventions that have been given to us, so that the visual eye would be moving into an environment that would mirror the times. I believe that most people are still living so much in the past and much further in the past than they will admit. Really it's status symbols when they sit back with comfort that they can buy a piece of the fourteenth century, a piece of the fifteenth century, and maybe way back to B.C. Consequently my desire is to give an environment that mirrors the present, and projects, of course, into the future.

Are your ideas about indoor/outdoor a result of your recent trip to Japan?[2]

No. I have been thinking of that for some years. When I had environments and they should have been kept as one environment, they were broken up because on earth there wasn't one person that comprehended that. Therefore, naturally at this point I feel that I want to do this again but with a difference, because we're living in a different time. And I hope that this time I will be blessed to place it as it is. Maybe I'll be rich enough to build a museum for myself and place it for myself.

What does a change in materials mean to you?

I don't consider it changing. Actually, it's using. I'm mature enough so that they're at my fingertips.

Rumor has it that many years ago you walked along the streets of New York or the beaches nearby picking up driftwood or discarded pieces of furniture. I don't believe that you are using that sort of material any more.

That is true but according to my kind of thinking there are only two lines anyway—there is the straight line and the curve. Now the curve really is a straight line. So if I choose to use those materials that I did or use the ones today, for myself there is no difference and it isn't that I have left anything. I recall when I used black. They said, "What is your next color?" Well, I never left any color, and that goes for these forms. I'm not leaving anything. I may be simplifying or complicating, like you wear a dress sometimes that's very severe, and sometimes you want a flowery thing but it's still a dress.

The fundamental unit in your work has been a box-like form and the box of course, is very old in art. It goes back to ancient Greek and Oriental art where it may have had some utilitarian purpose but its surface was often elaborately decorated.

I don't call it a box. I feel that man first has a kind of consciousness and then he has a line. That is true in literature—the line. It's strange, that's literary, but visually it's still a line. Then man has begun to encompass a space instead of staying with the line. And I've always felt that really Picasso brought back the cube to our attention—and we're not any longer saying it was just a visual thing, but there's a whole philosophy. Man has arrived at a certain place and I feel that I stem from that.

There are other sculptors who also work with cubes. For instance, Joseph Cornell deals almost exclusively with a shadow box in which he places various objects. Does your work have any affinity to his?

I'm a great admirer of Cornell. I feel Cornell really is surrealistic, and he's probably more romantic in that he uses material that suits that

surrealist pattern. I'm much more formal and much more abstract, and much more visual.

Your work shares with Cornell's a poetic quality. Certainly your direction has been toward the abstract.

I feel that they were always that way. Actually I've never made a so-called realistic piece of sculpture at any time, probably because I didn't study sculpture. You see, I didn't have a teacher. I went into sculpture. I can't conceive of myself trying to do a realistic thing. I don't like armatures. I don't like the techniques. For instance in New York there was a period after the Second World War when materials were difficult to get and everybody began to use metal and to weld. As a female it just offended me that I'd have to wear overalls and learn to put things on my eyes and start and that's when I threw myself into wood. And I think probably if we look back, it was kind of revolutionary to have a wood sculpture show.

When you place your pieces—the cones, squares and cubes that you are working with now—do you have a system or definite patterns in mind?

Yes. In the last piece I made I took a circle and made four pieces out of the circle, in other words, cut it into quarters and also moved the different parts in space. You just had to do it that way if you wanted a circle. You couldn't possibly get this without preconceiving it.

Does the same hold true for the large piece in the Whitney Annual, Shadows and Reflections?

Yes, because I thought of that as "energy," and tried to concentrate the energies in one part. There is the one line, the one column and then a counter-movement to that and so that's what I call energy. A more direct example is the enormous wall, *Homage to the World.* There it is practically one straight line. But then there's the circle off center where all the energy is. So it is controlled.

How many pieces make up Homage to the World?

It has a hundred pieces and they're enormous and very deep. After I decided to do it, it was kind of a finale of big wood walls. I had that work in one of my studios and for a year I couldn't even enter that studio. And that's not long ago. So you can see what an artist goes through. I got my work ready and had them in the studio and I became a little bit frightened of this enormous project, and so I locked the door. And if I needed something out of that studio I sent my assistant. I'd say, "Go and get this, this, this." I couldn't encompass it. And then one day after I had

done the metal, somehow I had to simplify and it gave me the key and then it was like a song. And then I thought, why did this intimidate me? I had to grow to be able to confront this.

Have you always used an assistant?

Yes, because I haven't made sketches at any time in my woods. And it would be impossible to be spontaneous and create and hammer and cut all at once, because the physical nature would mean if I put down two pieces of wood and started to pound, the other would fall off. So in the woods in order to control this I've always had to have an assistant.

A moment ago you mentioned that you turned to wood because welding offended you as a female. I suppose I think automatically of [John] Chamberlain's crushed automobile pieces as masculine, but is it valid to talk about sculpture in terms of masculine and feminine?

I like to be called a sculptor and I feel that a feminine mind certainly can move in any direction. It is no handicap from that point of view of birth concept of a mind but, nevertheless, I consider my sculpture feminine sculpture in a sense or created by a female.

What is the essence of that feminine quality?

To define it would take really writing a whole book because I think a female every moment of her life is meeting a male. She flirts. She likes to look pretty. She wants a compliment. And how she eats and what she wears. The whole pattern of her life is quite a different thing so naturally her reaction to the world is going to be different from a male's reaction.

Do you work as hard today as you did ten years ago?

Not quite as hard but I happen to have been blessed with a lot of energy. For years and years I thought nothing of getting up at six in the morning, going through the day, having a little dinner, going to sleep, getting up the next morning. I wouldn't even take time off to have pets or plants, or anything that took me away from this. I had a lot of creative energy and the only way it would be satisfied was doing just that.

Maybe subconsciously I didn't really reach out for financial success because I was pretty jealous of my total time—this is one of the things I must have been born with—I wanted my life to be totally mine. Somehow I comprehended that I didn't want to stagger the mind in any other way, so that there's a price for that, and it was difficult but I think subconsciously I chose it.

I was discouraged about life, discouraged about people being blind,

10. Louise Nevelson, *Homage to the World* (1966)
By: Ferdinand Boesch
Collection, Detroit Institute of the Arts
Courtesy Pace Gallery

but I don't think I had a day that I ever questioned creativity. There has never been a day like that.

[This interview with Louise Nevelson was broadcast on March 6, 1967 on WBAI.]

Notes

1. Martha Jackson Gallery, "The Royal Tides," April 20-May 20, 1961.
2. Nevelson had just returned from Tokyo where she was invited by the Japanese government to "inform" them about the American art world.

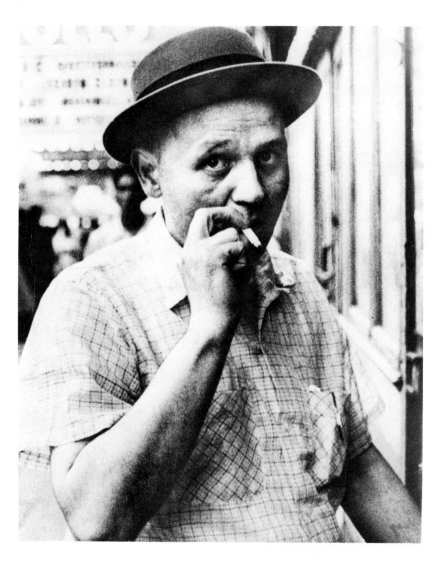

11. Romare Bearden, late 1950s

Romare Bearden: The Unknown American Negro Artists

In the mid-1960s, Romare Bearden felt it was urgent to make contemporary black artists known. He was the founder and president of Spiral, a group of black artists who banded together after the first March on Washington in 1964. The organization rented a store-front space on Christopher Street in New York City where they met regularly to discuss issues and to exhibit their work (see interview on Civil Rights). In the summer of 1967, Bearden was the art director of the exhibition *Contemporary Art of the American Negro,* which was shown on 125th Street in Harlem.

The artist was simultaneously engaged in a study of black art history. He was on the committee under the joint sponsorship of the Harlem Cultural Council and the Urban League that organized the exhibition, "Aspects of Negro Art and Culture" that took place at City College of the City University of New York in the fall of 1967.

Bearden's narration of the personal experiences and problems as well as the economic successes of some of the nineteenth-century black artists is startling; it reads like fiction. His own experiences in the thirties, his thoughts on jazz, and the problems of "identity" that still existed in the sixties are sensitively discussed.

Jeanne Siegel: *Mr. Bearden, who do you consider the most important Negro painter of the nineteenth century?*
Romare Bearden: Possibly Henry Tanner. To give you his full name, Henry Ossawa Tanner, was probably along with Duncanson, the most important Negro artist of the last century.

Where did Henry Tanner come from?
Tanner was born in Pittsburgh a couple of years before the Civil War. His father was a minister in the African Methodist Church, and Tanner's

father encouraged him in his efforts to become an artist. The family moved to Philadelphia when Tanner was about eight or nine years of age and his father had given up the ministry by this time to edit publications for the Methodist Church. Tanner was reared in Philadelphia, and, I imagine, was one of the first Negroes to go to study at the Philadelphia Academy where Eakins was that time the director. As a matter of fact, Eakins painted a portrait of Tanner that is in a collection in New York State now. One of his best-known portraits is of Tanner.

Was Tanner beset by any particular problems as a Negro?

Tanner had all the problems of racial prejudices. He speaks in some autobiographical notes that he probably would have never finished his studies at the Academy without the encouragement of a Philadelphia artist. I don't know just what happened, whether the students abused him or made fun of him. This is unclear. But after his two or three years at the Academy, he then became a photographer. He was unable to make a living as a painter and taught for a while in Georgia and then went to France through the help of some friends and remained there, except for trips to the United States, all his life. The late Stuart Davis told me that in the 1920s Tanner was here in New York City to do some commission and had a studio at Carnegie Hall. A petition was circulated among the people who had studios there at that time to have Tanner removed. Some people went around with this petition.

So you see these are just a few examples of prejudice that he had to face. But besides that, Tanner was faced with a problem of a different nature. In his early years he did paintings around genre subjects, one of his famous being *The Banjo Lesson,* which depicts an elderly Negro man instructing a little boy how to play the banjo. Then later Tanner became a religious painter, but Booker T. Washington had seen and admired *The Banjo Lesson* very much, and he visited Tanner in Europe around the turn of the century and tried to persuade him to forsake religious painting, to come back to America and do this genre painting around Negro subjects. He felt that Tanner was a great artist and had the capacity and the compassion to give the Negro the dignity that Booker T. Washington felt that he deserved and ought to have in the arts. But Tanner, while respecting Washington's point of view, told him that he was committed to a particular type of painting and felt that his development as an artist at that time lay in his remaining in Paris, which he felt was the capital of the art world.

Did he receive any acclaim by his contemporaries in Paris?

Tanner was the most acclaimed of the Negro artists in France. He was made a member of the French Legion of Honor. He won many prizes

throughout the world. He was one of the first Americans to have work purchased by the French Government. His work hung in the Jeu de Paume. It was later supposed to go to the Louvre although I'm not sure if it did, but I know the French Government has three or four of his works.

He is represented in some museums in the United States today, isn't he?

All of the big museums, the Metropolitan, the Carnegie in Pittsburgh, the Milwaukee, the Philadelphia, San Francisco, practically all of the museums have works of Tanner. However, the majority of the museums don't display them as they formerly did, but a lot of the work of that century that these museums have purchased is just relegated to the basement.

Didn't Robert Duncanson also become an expatriate?

The leading Negro artists of the nineteenth century, aside from Tanner, were Duncanson; the sculptor Edmonia Lewis; Joshua Johnston, an early engraver; Patrick Reason; two brothers, Eugene and Daniel Warbourg; and a man named Edward Bannister. With the exception of Bannister I believe all of these artists were in some form or another expatriates, either had to go over to Europe to get their training or got their training and, as in the case of Edmonia Lewis, just remained there. She remained in Rome from the time she was a young girl maybe until she died, although where she died and the date of her death are kind of a mystery.

We have to make a distinction between going to Europe to get training, which undoubtedly many artists at that particular time did, and remaining to become an expatriate.

Well, Tanner received some of his training in Europe because, as I mentioned, he went to the Philadelphia Academy and studied under Eakins and Thomas Anshutz and in Paris with Benjamin Constant and Jean Paul Lorenz who were, I guess, the Jackson Pollocks and the de Koonings of their time. And he remained, as I said, in Europe. Duncanson made frequent trips to Europe in the time when travel to Europe was a real undertaking.

How could he afford it?

This is a surprising thing. These artists that I mentioned, Duncanson, Tanner and Edmonia Lewis, made a great deal of money out of their art. I read that in 1876 Edmonia Lewis received two commissions alone and she may have received others but two commissions were for $50,000 each. Now in that time that's $100,000 with no income tax. It was a fortune.

12. Romare Bearden, *Watching the Good Train Go By* (1963)

Duncanson, when he got going, made a great deal of money. Alfred Lord Tennyson invited him to his home and felt that Duncanson was the only painter who really captured in his paintings the flavor of his poetry, that is Tennyson's poetry. He did a painting which established great fame for him in his country around *The Lotos-Eaters,* the poem of Tennyson's, and when Tennyson saw it he was enthralled with the painting and became a friend of Duncanson. A letter was written back to Cincinnati where Duncanson had come from, that said, imagine this Negro invited to the home of Alfred Lord Tennyson. Just can't imagine it.

Who commissioned Edmonia Lewis?

Recently a friend of mine has found a medallion that Edmonia Lewis did of Emerson for some purpose. She was commissioned by Harvard to do a bust of Longfellow and someone else. She did a bust of Seward, of Colonel Robert Shaw, who was the commander of the first Negro combat regiment in the Civil War, the 54th Massachusetts infantry, and many other such commissions. Now which particular commissions that she got in 1876 I don't know. A lot of her work has been lost. Two of Edmonia Lewis's pieces were found last year that had been for years in the basement of the Roxy Theatre.

What is the subject matter and style of her work?

Edmonia Lewis's work can be classified as neo-classicist. In other words, she followed in the tradition of Canova and Thorvaldsen. In fact, most of the American sculpture at the middle of the last century, men like W. .W. Story and the other American woman sculptor, Harriet Hosmer, were all in this neo-classic mode. Edmonia Lewis's talent represents a unique achievement. I just saw a photograph of Edmonia Lewis's early work that she did in 1867 after she had been in Rome a couple of years called *Forever Free,* which depicts a Negro ex-slave breaking his chain and I guess his wife or a woman praying beside him. She must have been in her early twenties at this time, and the command of carving and anatomy is phenomenal. It's not a great work of sculpture, but the knowledge that would go into that is astonishing. Where she studied and picked up this professional facility is something I must find.

From what you're telling me it doesn't seem that she ran into too many difficulties as a Negro artist.

Edmonia Lewis's mother was, I believe, a Chippewa Indian, and she recounts that her mother, when she was a young girl, would often leave and go back to her tribe and so she was left with her father. Because of this upbringing she ran rather wild. She did, I think, study at Oberlin for

four or five years and while at Oberlin, in rather bizarre circumstances she was accused of poisoning two of her classmates. And in the course of investigation, a mob took and stripped her of her clothes. It was during the winter, and they beat her and threw her in a snowbank to die. She was living with a Quaker woman who became alarmed because Edmonia usually came home from her classes. The woman didn't see her in her room and a search party went out with dogs and she was found near death. She was indicted for poisoning these two girls and was carried to the courtroom on a stretcher. She was defended by Langston Hughes's grandfather, a famous lawyer by the name of John Mercer Langston, who later became a congressman during Reconstruction times.

I think it was shortly after this that she came to Boston and through the help of Oswald Garrison Villard, who was one of the great anti-slavery people, and the widow of Colonel Shaw, and W. W. Story and his wife, she was able to get to Rome and continue her studies and function over there. I believe that she had Canova's old studio for awhile until she was able to get going and then she sold work to an amazing number of people. Hawthorne knew her. Her closest friends were Robert Browning and his wife. Disraeli bought her work and this was fantastic, this young girl in her twenties, to be thrown in kind of the jet set of her day.

Jumping over the years to the 1930s, do you feel that a great many Negro painters were given an opportunity under the WPA project?

In the nineteenth century a Negro family who could afford to send a child to school would prefer, I imagine, that child becoming a doctor or a lawyer, in some type of profession where he could make a living rather than the precarious status of artist and who would need just as much training. So you find very few Negroes going into the arts until the thirties with the WPA, which gave a Negro artist a chance, really providing him with a salary, materials, even training, to work with some freedom.

Were you on the WPA?

No, but most of my friends were and a number of the Negro artists who were rather well known at the time were like Jacob Lawrence, Charley White, Charles Alston, Norman Lewis, to name a few.

Where were you living then?

I was living in New York and I took some work down to see about getting on the projects, but I was just a student and I don't think I was developed enough to where they would have given me the status of an "easel painter" on the WPA.

Were you in art school?

I did go to art school later but I first thought that I wanted to be a doctor and got a Bachelor of Science degree and then later studied at night with George Grosz at the Art Students League and during this period was the time of the WPA. When I was making a little headway, seeing a little light as an artist, it was time to go to war.

Didn't most of the painters that you mentioned work on murals?

Alston did. I think Jake did. And an artist named Vertis Hayes. I know Jimmy Yeargan's work as an assistant with Alston and with some of the Mexican fresco painters who were here at that time in some number.

What did you paint after that period?

Most of my work at that time was around Negro subject matter. I guess you'd call it genre painting or people in the cotton fields or things that I had seen and observed in the South. The first showing of this was after the war at a gallery called the "G" Place Gallery run by Clarisse Crosby, which was a famous name at that time in the art world. I later showed with Sam Kootz, but my style had changed a bit. It was much more abstract.

But in those paintings where you retained even a semblance of an image didn't you introduce new themes?

That's right. Away from the Negro subject matter that I had been doing.

What were some of those themes?

My first show at the Kootz Gallery was around a Christ theme, "The Passion of Christ," then a show around Lorca's poem, "The Death of a Bullfighter," then the *Iliad,* the last of the thematic shows that I did.

Wasn't there one exhibition in which you and other artists in the gallery used the theme of jazz?

Oh, yes, that was where we all did impressions of jazz. At that time I believe Adolph Gottlieb, Robert Motherwell, Carl Holty, Bill Baziotes, Byron Browne—who's dead now, were all in this show. I called mine *Blue Note.*

There's a question that people always ask, which is why jazz developed as a unique artistic contribution of the Negro while no distinctive style has emerged in painting and sculpture?

The jazz musician, it is true, does have a signature and something that is completely identifiable. But the painter I believe by the nature of

his training didn't remain in isolation at first as the jazz musician did. The Negro painter had to go more towards the development and the training of western culture, and that led him often away from his folk groups. Maybe this was bad, but in the nineteenth century, Duncanson, Edmonia Lewis, and Tanner not only had to be artists but they had to prove that they were capable of functioning in the art world as able practitioners. Besides being a painter, this double burden was on them. So a man like Tanner, who was extremely talented, would move toward these academic honors rather than becoming an Impressionist painter or Neo-Impressionist or anything that might be considered vanguard at that time.

Bannister stated that he became a painter because he read an article in *The Sun* that said it was impossible for a Negro to be an artist, they didn't have this capacity. So the artists would find out what is the thing most favorite at this time, and they all worked toward that.

I think the Negro was torn from his particular geography, the Negro coming here from Africa where there was some type of a cultural heritage and put into another one. I think that when he finds his identity and time, that he might have this, or maybe the whole condition of life will make it impossible to move towards a type of integration.

Are there any problems that face the contemporary artist that didn't exist in the nineteenth century?

I think that in Tanner's life most of the problems that face a Negro artist now were at least brought into focus. After Tanner, you find a great number of Negro artists going to Europe to study and to remain. For instance, three or four years ago you might recall they had a show of twelve American Negro artists living in Copenhagen. A number of these artists still live there and, like Tanner, they remain as expatriates. So one problem of the Negro artist—should I leave this country?—obviously still faces him since you can have a whole group show of Negro artists who are living abroad. And of course there are not that many functioning professional Negro artists.

Didn't you live abroad for a period of time?

Yes, on the GI Bill, I lived in Paris.

Did the thought ever cross your mind to remain there?

It was very seductive at that time.

Why did you return?

The GI Bill was running out and after staying there a long time, as much as I might not have liked some of the things here, I realized that

my culture was here and that I wasn't part of a lot of the effects at work in Europe as much as I might admire the European art tradition.

What are some of the particular problems that face the artist in New York City?

All artists, Negro and white, have the problem of making a living, of finding a gallery or a place where they can display their work and often with the Negro artist these problems are attenuated.

But a number of Negro artists are represented in some of the leading galleries in the city.

Some Negro artists are, but the vast majority and this is true of white artists also, are without representation. This is one of the problems we used to discuss in Spiral, which was a group of Negro artists who got together to talk about common problems. We had made our meeting place on Christopher Street into a suitable gallery and we held several exhibitions there.

A number of exhibitions have been held in Harlem in the last two years. What is the thinking behind exhibiting in Harlem?

They're teaching at Haryou—they have a large art program for gifted students mostly of the high school age. Then there is a Parents Association that has a program for children who are younger, so there is a growing interest in Harlem and a growing interest among Negroes in their history and in their identity. The show of Negro artists which we put on in Harlem was well attended. We have a book in which people were asked to write their comments and you should read them. "Wonderful. Why don't you have more like this? This is what Harlem needs."

I would guess that there is room for increased knowledge among the Negroes themselves because at an Aritsts for CORE exhibition a few years ago I told James Farmer, who was then the head of CORE, that I was writing an article about Negro artists. He said, "Are there any?"

This is true.

Do you believe that the Negro painter should try to bring out any ties that he might feel with African culture?

What the Negro artist should do is what any other artist should do, that which sets him free. I could never think of dictating what an artist should or should not do as I couldn't answer that.

An exhibition is being planned called Aspects of Negro Art and Culture. *Does that imply any sort of relationship between African culture and American art?*

We planned to have the exhibit sectionalized, the opening section being devoted to the African heritage, the African sculptures and artifacts, then leading on to other painters of the eighteenth and nineteenth centuries. Then there will follow the painters of the so-called Negro renaissance—men like Aaron Douglas, Archibold Motley, Hale Woodruff, then the artists of the 1930s, of the WPA period you might say, on into contemporary work. Along with this we want to show other aspects of the Negro in American culture and we're using this in a broad sense. For instance, we will include a photograph of Dr. Williams, who was the first surgeon to operate on the heart; a man whose name I've forgotten who made a great discovery in the shoe industry that allowed the production of shoes to be increased tenfold, things like this showing the total involvement of the Negro not only in the plastic arts but in the whole fabric of American life.

Art historians become violent when they hear of an exhibition titled Negro Artists *or* Negro Art; *they object strenuously to this kind of distinction. Do you find it acceptable?*

They become almost as violent if a Negro moves next door to them.

That is not comparable. They feel that artistic divisions are not made on that basis.

While there may be some intellectual truth to this, you have to face the fact that there are differences among people. Some of the differences are very good. You have a museum in the city, Asia House, showing Oriental arts.

But the Orient is a specific geographic location that has developed a body of culture over many centuries whereas the American Negro has developed, at least for the last four hundred years, within the American milieu.

But his development has been, in many cases, tangential to that of the white culture. For instance, you've just spoken of jazz music, which was at first a particularly Negro phenomenon, and later, Benny Goodman, Jack Teagarten and other great white jazz musicians came along. It's the same thing with the Negro in the arts. A number of the Negro people are unaware of the Negro artist and a Negro is isolated in this country and the Negro artist doesn't have all the chances of showing. I don't know if there's any Negro artist in this country who is able to live on the proceeds of his art or his painting alone; they did this in the last century, as I have

pointed out. So there are many problems that still have to be faced. The Negro artist will do his greatest work when he does face his identity and knows that he sees the beauty in many respects of his life and his culture that have been neglected.

[The interview with Romare Bearden was broadcast on WBAI on October 12, 1967.]

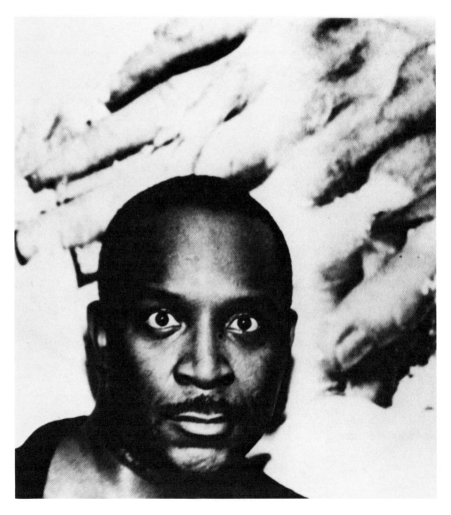

13. Al Hollingsworth, 1960s

How Effective is Social Protest Art? (Civil Rights)

Political events eroded abstraction's hold on mainstream art in the sixties. Some artists, spurred by the activism of the time, began to feel a strong need to express themselves on political and social issues. This panel included three painters, Romare Bearden, Alvin Hollingsworth, and William Majors, who were members of a group of black artists drawn together in the summer of 1963 at the time of the March on Washington to see what they could do for the Civil Rights Movement. They formed a club called Spiral and held long and heated debates in an effort to determine what their commitment should be as human beings and as artists.

Among various activities, they decided to hold a group exhibition with a theme. Initially it was to be "Mississippi 1964" but they rejected this as too pointedly "social protest." Instead, they chose an aesthetic theme, "Black and White," which referred to a limited palette. The results were extremely varied. Romare Bearden created a series of collages that revolved around memories of Harlem, the South, Jazz, Pittsburgh. His dedication to Civil Rights, however, was not a new one. In 1942 he painted *Factory Workers* for *Fortune* magazine to illustrate an article, "The Negroes' War," that exposed discrimination in industry. His efforts and affiliations continued through the years and in 1966 he was the Art Director of an exhibition of contemporary art of the American Negro on 125th Street in Harlem.

William Majors, a painter and etcher, had a portfolio of etchings from the Ecclesiastes published by the Junior Council of the Museum of Modern Art in 1965. He was one of two Americans who was represented in the Print International Exhibition held in Switzerland in 1967. He had been teaching painting, drawing, and art history at the Orange County Community College in Middletown, New York. Although an abstractionist, Majors joined Spiral because of his commitment to the Civil Rights movement to find out whether he could help in some way.

14. Al Hollingsworth, *The Feast* (on easel) and *Cry City* (on wall), ca. 1965
By: Richard Nieves

Alvin Hollingsworth, a poet, teacher, and painter, was the Director of an art program for the Harlem Parents Committee Freedom School where young students were taught commercial and fine art in preparation for professional schools or jobs. He was an authority on fluorescent paints and, like Bearden, had oscillated between a representational and a more abstract image. In the Spiral show, Hollingsworth exhibited a canvas, *Cry City,* in which he tried to capture the violence and erosive spirit of the city through its walls.

Jeanne Siegel: *In retrospect, how effective were the paintings in the Spiral Exhibition as social protest art?*

Alvin Hollingsworth: Spiral's exhibition, I believe, was one of the leading exhibitions to protest something that we felt was outrageous. What we were seeking aesthetically, we could never agree on, but I think the artist's intent and contrasting results were quite different. Consequently, in retrospect, I've gained a greater respect for the idea of the show than I had when I was actually caught up in the heated arguments of where we should place this or what should be hung.

William Majors: I felt that as protest art the exhibition was totally ineffective and not only because of aesthetics, but because of what we're dealing with here—the whole scheme of things. People try to pin it one place, others try to pin it all over. I believe that the Spiral group as a whole became closer knit through participation in the exhibition.

Siegel: *Did the switch from the initial theme of "Mississippi 1964" to "Black and White" weaken or eliminate the element of protest?*

Romare Bearden: It was eliminating the idea of protest for everybody. In other words, if we had the theme "Mississippi 1964," all of the fifteen artists of Spiral would have had to do something around that theme and which, by its very title, would have meant some aspect of protest. They were having trouble in Mississippi at that time and some of the members didn't want this. Not that they didn't feel acutely what was happening in Mississippi, but they felt that they couldn't make a certain kind of statement in their art around what had happened there. So in the black and white theme, if you wanted to do that type of thing, which a couple did, or something else completely apart, you could do that. And this is what the show turned out to be. Charles Alston had a certain kind of abstract thing having to do with Mississippi . . . a policeman or dog? It was very

abstractly designed and Hines, who was another artist in the group, had a landscape—sea breaking on a shore—which was a beautiful painting but it couldn't be, in any sense, called protest painting. Maybe Hollingsworth had a social aspect to his work. So you see, it varied.

Siegel: *Would you call your work "protest"?*

Bearden: I think that mine is definitely protest. In fact, in looking at what I did then in contrast to what I've done since, I wonder how any of them were sold, because they were so grotesque that anyone who had any conscience about the Civil Rights movement would not want the pictures looking back at them, reminding them of things they had not done. And I was so close to the show when I did see it that I thought that those colors were just beautiful, baby. It's very interesting to note I've gotten similar comments by people who had looked at the work more objectively: that it really was a sort of painting that made you feel guilty. My image was definitely a protest image, more so than I had imagined when doing it.

Siegel: *I like the inclusion of the idea of guilt as part of the definition of social protest art. Romy Bearden had mentioned to me that he thought Pop artists were working out a kind of protest art but I would not consider that protest art because there is no feeling of guilt in Pop.*

Bearden: I mentioned that Pop art seems to me a kind of a protest, but then you have all kinds of protests—like some of the Charlie Chaplin's shorts as you look back on them now. Although they were first conceived as something entirely humorous, they became a quite definite protest about the period. Pop artists pick certain symbols—a hamburger or a lemon pie—and they are using this, in a certain sense, to satirize some aspects of American culture.

Siegel: *The question is: can we distinguish between social satire, social comment and social protest?*

Bearden: Some of Bertolt Brecht's plays are wildly humorous but underneath it all is a definite protest. Protest art doesn't always have to be about a Negro being lynched.

Siegel: *I think it demands the element of change. To distinguish between protest and merely comment or satire means it's strong enough to demand some sort of change.*

Bearden: No. A great artist of protest was Goya in his *Disasters of War,* and one of the reasons that *Disasters of War* has lasted is not so much

that he was protesting what the French did to the Spaniards, but he was protesting man's injustice to man. So when you think of it now, you don't say, "Aren't these Frenchmen awful?" You say, "Well, war is something we have to eliminate." That's why he disliked war. He loved the concept of justice more than he did the concept of injustice.

Siegel: *Bill, do you agree that Goya is a great social protest painter?*

Majors: Well, it's a fact, it's history. But whether or not the artist or the public will enjoy it or constantly refer back to it, is a question. An artist of my time that comes to my mind, is Jack Levine, who painted the dogs of Mississippi *[Birmingham, 1964]*. I constantly think about these pictures and I'm reminded that no man would like to see his mistakes and feel guilt.

Now, as a painter, I would like to think of the word "universality." I deal with religious subject matter, the Old and New Testament, and in my way I attack the church, the synagogue, but these things are not accepted for trying to change the image of big white father with beard, holding sheep, walking down that fine green meadow. I do not think Levine's is a great picture. I find that the great protest picture, you cannot show. I'm located in the fur district, and if I decide to make a great monumental protest picture, I guess I would settle for a nice big, black swastika and let it go at that and see what that would do. I realize that they did away with Lincoln, they shot [John] Kennedy, and God knows what they would do to me on 7th Avenue for painting my one masterpiece.

I do not feel that enough can be said for the Civil Rights movement. But how do the painters get to the public? How do the painters deal with mass media when these things are not shown? I find that pretty good protest pictures are those composed of our alphabet. Words carry more strength in certain areas than strokes of paint.

Hollingsworth: I agree with Bill on quite a few points. I think he has implied here the idea of communication in protest art. He did abstractions which were highly personal and consequently the actual visual communication or meaning may not come across to the viewer who looks at it from a cold standpoint, not knowing the background of the artist. It may not hit them as strongly as something that is so shocking that the guilt is implied immediately. There are different levels of guilt. The painting that has a swastika immediately sets up that syndrome that makes you respond. This is a universal symbol of negation. However, in some of the Pop artists' work it may be subtler. The symbols that they are using may be pleasant symbols, although they may be nauseating symbols to them. When you look at the pictures that I had done in my *Cry City* show, there

was no getting away from the very morbid, very rough, the ugliness of the entire image that screamed at you, and this is something that is important here. I would not judge another artist. However, one thing that is definitely important in protest art is the ability of the picture itself to communicate.

Majors: Jack Levine's picture has been exhibited, publicized, and I believe CORE had it in its charity exhibition. I love it—what this man knows about dogs. I've been bitten as a child and my leg would swell, but I wonder what this man really knows about my problem as a painter, and what does he really know about protest art? What does he know about my problem and dogs? This man is not aware of me, Bill Majors, painter. He's not aware of the Negro problem as few people are, in New York, Indiana, Mississippi. The food problem. What am I to do? Should we take one of Oldenburg's papier-mâché loaves of bread and present it to the powers that be to say my people are hungry? How does a painter get to it? I feel that all of this business is nonsense. There'a a lot of talk lately about the *Guernica,* and people loving it and going to the Museum of Modern Art and standing there crying. I only relate to that picture in the beautiful way in which it is painted and yet I hear this business about war, protest. Rather, I would like for some of the historians and artists to go and look at Picasso's *Old Guitarist* and look at the sensitivity in which this artist has recognized humanity in an old man who has been neglected, who sits there. It is a beautiful example of protest art but the owners, possibly, only recognize the name Picasso. But here we're given constantly the *Guernica,* Jack Levine, Jacob Lawrence's *Migration* series. They were great pictures once, I guess, but now we need something more—collective effort from all of the artists, maybe. Maybe I need to sleep at Levine's studio to see how he handles his dogs. I've yet to see a Bearden hanging in the Met or the Guggenheim or maybe one of these color shows when the curator really touches the problem from his experience and yet aesthetically they are beautifully put together.

Bearden: I'd like to follow up on something that Bill said in defining the nature of protest. Take a Cézanne still life—a sideboard, some apples, a skull, a tablecloth. In a certain way this is a great protest painting because he has protested all of the existing values in art of the time—the Academy and all of the moribund values that it stood for. He was talking about certain universals and, in a sense, this is as much a protest in his paintings aesthetically as Daumier. But we are confusing protest here. We're thinking of it in terms of illustration. That the painting has to portray some facet as Daumier has, like a cartoon or a lithograph of third-class pas-

15. William Majors, *Big Blue #4* (1968)

sengers frozen on the train. He's definitely pointing up some of the ills of the time as a painter now might do with an airplane wreck. But Cézanne is doing something else in the nature of an aesthetic protest and I think this, as far as art is concerned, is valid too. He was destroying, in his painting, all of the artistic values and substituting new ones as a protest. He was, by nature, a very conservative man. In his art he made one of the greatest protests, in that sense, aesthetically, of all time.

We've had certain men in the last century who have undoubtedly used their art as a form of protest. Like Daumier and others, or in this century, George Grosz, who I studied with. But it seems to me art has a particular problem in each century. The problem of the Renaissance painter was to know life so you found these painters exhuming corpses, doing great and detailed studies of plant life, investigating physics, all at a great and vast encompass of knowledge. So it wasn't just painting that interested them. It was a kind of humanism; to understand man and to understand life, to come out of the dark ages. And this was a problem of putting this into painting, which is why they were so interested in the realism and perspective of drawing masses of people, all of those things that hardly any painters can do today.

Now this isn't the problem with the moving picture and the camera and many things that we know about people. Corpses have been looked at through the microscope and many other ways now so that isn't a particular problem. Maybe protest could be done better by the camera in 1967 and reach more people and have more force than the artists painting or drawing today. They have a problem other than trying to turn somebody away from something to look at it from another way.

Hollingsworth: I have to go along with Romy's point concerning the need to search for new instruments or possibly not being satisfied with what is called protest art. I think that Romy's involvement with his imagery is very important—the images of the folk of America, the contribution of the Negro that is not recognized to the degree it should be to the American culture is important. I think that Bill Major's concern with religion is very valid and a very strong protest but, as I said before, the protest is at different levels. And in some cases it does not come across to everyone.

I think a lot of the Pop protest is mainly shock. But I believe some of it is effective on a different level.

Siegel: *For instance?*

Hollingsworth: In Tom Wesselman's paintings where American commercialism is at a very high degree, where you see the very neat bathroom,

the very neat sink. You see a maid depicted there. I know Tom personally and this is his form of protest. He has a very strange way of looking at the world that I respect. It may not be at the same level of intensity that, say, a Bearden collage is, but to me, at his level, this is his form of protest.

Majors: Just today, I've been reading *Life* magazine, the mass media again, and I saw these gigantic testicles made of the American flag. I also saw a great Jasper Johns American flag—they say it's great. I wonder what the effectiveness of these two images are. I would take, just for excitement's sake, the two giant testicles rather than this flat thing with the stars and stripes painted on it. I wonder if this man is being prosecuted because he used part of the flag in that image, or if he offended some senator, or senator's daughter or if it's just the whole Vietnam thing. As I remember in the late President Kennedy's inauguration speech, he mentioned an artist, and painting protest pictures, and being aware of what is going on. Now evidently he recognized protest pictures. Possibly I recognize them but refuse to see any merit because they're not helping the Civil Rights movement, they're not helping anybody. Many so-called artists are riding the coattails of Civil Rights under the guise of "we're going to help you," "we're going to sell pictures." It just will not work.

July 4 I went to the Whitney Museum. There I saw the most beautiful protest picture I have ever seen. It is not accepted as such and I'm sure if you could call the man from the grave he would possibly take advantage of the Civil Rights movement, of Jacob Lawrence, Jack Levine, Philip Evergood, Bearden, Hollingsworth, Majors, Reinhardt, Norman Lewis, or Picasso, and this man is Kline. It's a huge thing with big, black stripes but how he's painted togetherness, how he's integrated black and white, and when I say black and white, I'm thinking of the paint industry that has helped the artist more than any other person I know, any other industry. I can go to a paint store and buy fifty whites, possibly, I can buy thirty blacks and I can go back to my studio and paint. Kline gives you all of this in this one picture. I prefer Kline's picture over the *Guernica*. I prefer Kline's picture over Jack Levine's hounds.

Hollingsworth: I'd like to make two points here. One that Bill had stated earlier, which is that a lot of people hang on the coattail of Civil Rights whereupon this may be used as a way of selling paintings or making money or being seen where they wouldn't be seen otherwise, and consequently, this is why I, in retrospect, cannot sell the Spiral show cheap. Whether or not we hit what we wanted to aesthetically is a moot question. But the fact that we sincerely wanted to do something and had a show

with this intent in mind, is important and I believe other shows have followed our lead. Possibly they were more successful but I think as a pioneer effort it was important in the idea of making a statement publicly.

Secondly, although Bill, in talking about the painting by Franz Kline, brought out the point very clearly that he is extremely involved aesthetically with the image, I unfortunately, feel the world is not ready to see a Franz Kline as a strong protest in the Civil Rights movement. I think Kline is a great painter. Some of the things I've seen by him undoubtedly have far more strength than 90 percent of the figurative protest pictures that I have seen. However, you've got to analyze the purpose of a Kline picture in contrast to the purpose of the artist's picture when he's painting a Civil Rights picture. One place you put the aesthetics first; the second place you put the message first. Now if you're a great painter (I think Romy is a great painter) aesthetics automatically fall into place. The message is clear. While in other cases you see the clumsiness of a weaker artist when he is putting across a message—when he just does not have the innate talent. What you find in protest painting is a lot of Sunday painters, a lot of folk painters, people who should never have been allowed to own a brush, but who have something to say. So the purpose here is important; the purpose that this party wanted to make this painting for, and I think this is where the differentiation comes in. I think in one case a person is going to become involved aesthetically, such as Kline with his black and white where, as I stated before, the by-product could be protest, while this person who has painted the American flag or Coke bottle or this dog biting a child, whether aesthetically wonderful or not, his purpose was to convey something to the masses that would hit them immediately.

Bearden: There is one thing that we ought to make clear—which I believe has something to do with the nature of protest. In Spiral, of course it was Civil Rights that brought the artists together but even more than that, it was the concept of exploring the identity of the Negro artist and his position in our society. I think if this Negro artist had such a concept, this would resolve so many of his problems, problems of painting, problems of protest. I think it is for this, more than the exhibition, that I'm indebted to Spiral.

Take an artist in the last century, like Tanner, and many artists who followed, who went to Europe, who lived there, who considered himself not so much a Negro artist but an artist who happened to be a Negro. There's nothing wrong with that. But I think somewhere along the line Negro artists have a different problem and different relationships to face than the white artist does and I think that the Negro artist must face this.

By not facing it, the Negro artist has often laid aside or turned from a reservoir that is very rich within his own experience and heritage that in many cases would have enhanced his art. Within this resource, or reservoir, is the possibility of doing things like Kline or doing things of the most outrageous protest. But the Negro artist should see this through his own spectacles. I'm not saying he should be a protest painter or abstractionist—whatever he wants, but I believe this problem resolves this thing—protest and the rest—as long as he finds himself and his identity as a Negro.

Majors: Certainly the Negro has problems and who realizes it more than the Negro artist? My dossier is heavy; so is yours. In a few hours Al Hollingsworth will have a Ph.D. What does it take? When and how can the artist make the public aware of what is going on? How can you paint a lasting, beautiful piece of protest art? Can you afford, as a Negro artist, to constantly say "Look sir, you've got a problem. You've done me wrong. This is how the world should be" and hang [it] in the Time & Life Building, the Metropolitan Museum, the Guggenheim, The Cleveland Museum, the museums in Mississippi.

Now certainly the artist is aware, but how can he do it just beautifully? How can you make men aware? Have a Negro do it, suddenly open the gallery opportunities to him, open housing to him, make the Negro public aware that he is alive, not to mention the whites—not to mention breaking it down by groups, geography. How many people know that Romy Bearden is a painter? How many times do I, or will the young artist, have a chance to look at your pictures?

Bearden: That brings up the point of propagandizing your work, I wasn't talking of that so much, although that is keenly important. I was saying in aesthetic terms that there is a broad base within the Negro experience. For instance, I got on the subway once at 125th Street and this man got on at the next stop—116th Street. That was about ten years ago, before the people went out in space. This was a Negro man and it was around Halloween when you dress up in costumes. He was dressed as a spaceman but he made the space costume from a radio antenna and he had red socks on, which were pulled over his pants. And the people laughed at him because he looked like he just landed from Mars. I was fascinated. It was so inventive. You know, no Surrealist, Dali or Tanguy, had done any better than this person. I looked out of my studio window many times on 125th Street, and the things that I've seen. You didn't need to look down to see if they were abstract. It was all right within the context of the experience.

That's why I don't feel that I am protest painter. The moment that you deal with your own subject matter and you put some Negro faces that are recognizable on the canvas, people think it's protest. It's like a lady at my last show. She was interviewing and called me and said she wanted some more information. Now she said, "In your show of head-hunters," I said, "Lady, headhunters are in the Solomon Islands or used to be. I think they've been converted by Christianity now." These people were from Harlem or people in the South.

Siegel: *Maybe she was thinking of the African mask images which you incorporated into a painting like* Baptism.

Bearden: All of them to her were paintings of headhunters.

Siegel: *Nevertheless, a painting of Negro heads, crowded into a small space in a scene of 125th Street, where there's hardly room to breathe, might have associations that would justify defining that picture as social protest art.*

Bearden: What I was saying is that out of these memories can come anything. It doesn't need to be social protest. A Negro painter can paint like Mondrian or like Horace Pippin, you know, the whole spectrum of effects but he must always remember something of his background.

Siegel: *Pippin was one of your best social protest artists.*

Bearden: He didn't consider himself that. Some of his early war things may be protest. But even so, Van Gogh spoke of himself as a protest artist in some of his letters. He once did a painting in a café and wrote about it, and it was full of sociology. But when you look at the painting it is so beautiful that it looks like ice cream sherbert. The colors had nothing to do with the protest, it supersedes that. It's a great study of light and color.

Hollingsworth: I think it's important to consider the fact that if Romy sits down to paint a protest painting, then he is actually defeating a feeling that he has. In other words this is a statement. If I want to be free, if this is a protesting by-product, okay; but I want to be free not to protest. I just want the same rights, the same things as everybody else. As an artist even more so.

Siegel: *I'd like to go back just for a moment and talk about what's being done today; where paintings by Negro painters are being shown; who we're trying to expose the paintings to; is any effort being made? Al, you mentioned that some of the young students you have been working with were making protest paintings. Were any worthy of being exhibited?*

Hollingsworth: I have never seen such a great deal of production as when these students had something that they were angry about. They were on this anti-poverty program where they were given the opportunity to express themselves and do the sort of thing that would show they had something to say. And it's interesting to note some of the results of this exhibit held at the Carnegie Institute . . . there were such a great deal of protest posters actually done voluntarily, which had a lot of subject matter concerning Black Power, Stokely Carmichael, scenes of Africa. They were given free reign to select what they wanted to do the most and the results were every effective, very powerful. I believe it is because they had felt this protest and consequently they had a chance to get it out of their system. Some of the students in this program won scholarships. They've gotten into the School of Visual Arts, they've gotten into Pratt. But before this you may not have even known that they were around and I think that what drew the attention to their portfolios when they took them around were the scenes of how they felt about Harlem, their feelings concerning the duty of the black man and the black woman, which were largely the subject matter. Chances are that this exhibition is probably much better than so many that I have seen in professional galleries where the intent was to shock.

Majors: I'm not concerned with students. I teach and it's been my unfortunate privilege to see students come out of school and exhibit paintings in galleries long before I could. I have a name for the anti-poverty program: relief programs, in that I don't believe they're helping anyone. When the Negroes apply to art schools, why are they not accepted? Who on the Board of Directors or the faculty says, "I don't want to be bothered. No Negroes allowed." If it takes anti-poverty programs, I'm all for this to get them in the schools but I'm wondering when are we going to realize as adults, as educators, as artists that we're going to have to get ourselves together. How do we attack the problem? The administrators in art schools are just not aware of professional Negro painters. Why should I worry about students?

Hollingsworth: It depends on the program. I think the Harlem Times Committee Program on 126th Street is a very good one. The director, Ed

Jeffrey, has made sure that the staff were competent Negro artists who wanted to do something for the kids.

Majors: I know Negro painters who don't have a dime, who do odd jobs, who have degrees but can't get teaching jobs. Closed shops: number one—Brooklyn College, City College—you name it. Are these kids being fooled?

Siegel: *Are there any Negro patrons?*

Majors: There's one that I know of and he's buried in the Middle West. He was the Head of Research, Dr. Frank Lloyd. A very fine man who helps Negro artists. I believe he bought Romy's pictures in the fifties but we're in touch now. Outside of him, I know of Dick Clark.

Bearden: But I think that this is something that will develop in time. In the July issue of *Ebony* the lead story was on Charley White. It was a very long coverage. Things like this promote interest and the Negro patron. In *Ebony* they talk about their cars, their houses, their coats, and now they have to develop in terms of life.

[This panel discussion between Bearden, Hollingsworth, and Majors was recorded and broadcast on December 14, 1967 on WBAI.]

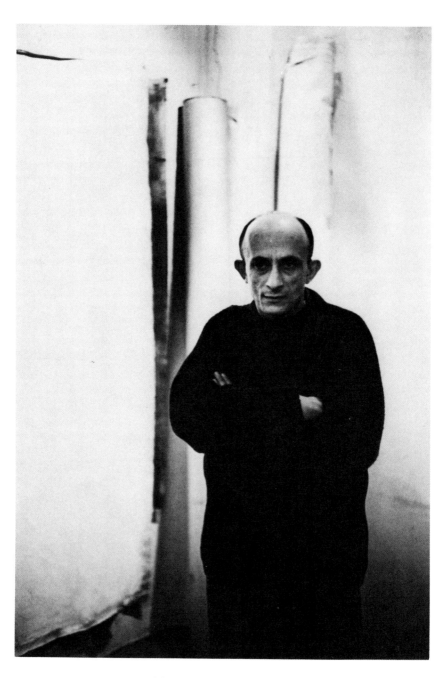

16. Leon Golub, mid-1960s

How Effective is Social Protest Art? (Vietnam)

Political crises in the sixties served as a catalyst for this panel discussion. The artists, Leon Golub, Ad Reinhardt, Allan D'Arcangelo, and Marc Morrel, had participated in the Angry Arts Against the War in Vietnam, a protest involving some 600 artists in New York that took place between January 29 and February 4, 1967. This included painting and sculpture, theater, poetry, concerts, film, and happenings. Under the aegis of the Artists and Writers Protest, a 10' high, 120' long *Collage of Indignation,* a collaboration of 150 painters and sculptors, was installed in the Loeb Student Center Gallery of New York University. The panels, each of which was 10' × 6', arrived at their final state more or less haphazardly with the artists filling any available spaces.

In addition, D'Arcangelo built a 20' long float, a giant three dimensional cartoon, a double-headed Uncle Sam/L. B. J. monster with a flaming fuselage toting a money bag. It travelled from Washington Square to the Bronx with stops for poetry readings. Golub, Reinhardt, and D'Arcangelo contributed to the portfolio of prints and anti-war poems that were devised to raise funds for the Angry Arts movement itself.

Marc Morrel donated a construction that, because it incorporated a facsimile of the American flag, was removed from Loeb Center at the time of the Collage. Because of another sculpture in which he had used a flag that hung in the window of his gallery, Morrel's dealer, Stephen Radich, was charged with violation of the penal law for publicly displaying a work which "defiled and mutilated" the flag.

Although the specifics belong to the sixties, the basic issues concerning political content in art are timeless and particularly relevant today. Reinhardt's uneasiness over the growing power of the mass media was well founded.

17. Leon Golub, *Combat II* (1968)

Jeanne Siegel: *One critic who thought the art in the Collage of indignation was not of great merit felt it was due to the estrangement from narrative and allusive art that has made the expression of anger an awkward and exceedingly worrisome problem for the artist. Leon, do you agree that the art was not of great merit?*

Leon Golub: Very possibly but it's very hard for me still at this point to disengage my feelings about the construction of the Collage, and the impact of the Collage and the merits or historical importance of the Collage. The Collage primarily existed not so much as a demonstration of art but as a demonstration of a kind of immediate and almost imperious anger that took place. It was kind of spat out so that in a certain sense our ability to recognize its merits are caught up with all kinds of things around us today.

The Collage had an immediate effect, and then of course it's falling apart and gathering dust and getting torn up and every time it's been shown it's been broken a little bit further. The art begins to fall apart even more. So it wasn't really intended as art but as demonstration. Now at some point art can become demonstration but whether actually this happened in the Collage, it is hard to say. It might have happened with individuals.

Allan D'Arcangelo: It provided a position about the war to the world. I think it was thought of more in those terms rather than in terms of creating a work of art specifically, that would be considered on an aesthetic level. I wasn't considering aesthetic problems but rather how to convey a particular feeling that I had about the war, about that situation in a way and with materials that I usually use.

Siegel: *Marc, did you feel the same way about your construction?*

Marc Morrel: My construction was a bit separated from the Collage itself. I didn't actually do a piece for that particular thing, it was another one of my pieces. The Collage I thought was very groovy. It was big and it was fun. It upset an awful lot of people and it brought the people there. N.Y.U. was mobbed from the time it was opened to the time it shut. As a matter of fact, we had to keep the people out the last night when we were closing it and they were still trying to sneak through the guards to get in and see it. I think it was very effective. You see, I judge effectiveness by the police force and the police force was there and they stopped it.

Golub: You judge effectiveness by repression?

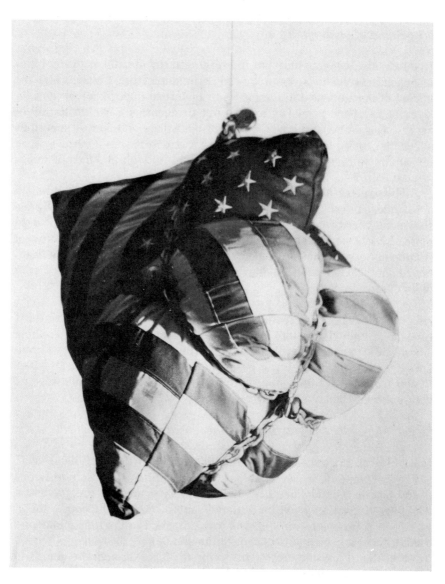

18. Marc Morrel, *Flag in Chains* (1966)

Morrel: Exactly. If it's repressed, then it's effective. You've made your statement.

Ad Reinhardt: For over thirty years I was never sure about what protest art did exactly. I know that at one point I thought that perhaps murals or public statements, signs and parades, political cartoons in newspapers, and now things that happen on TV—the publicity might do something. I'm not so sure just from a social and political point of view what protest images do and I would raise a question. I suppose this is an advertising or communications problem. In no case in recent decades has the statement of protest art had anything to do with the statement in the fine arts.

Siegel: *Would you consider this to be true of Picasso's* Guernica?

Golub: This object was made for a very specific purpose. It was made to dramatize Picasso's anger and denunciation of fascism, of great countries attacking small countries or villages. Since then, this particular painting has become an object of holy veneration and it's become a mystical thing but it's lost its effectiveness. People come and look at it and they don't even know what they're looking at in a certain sense.

Reinhardt: It might have a symbolic value, but actually it's just a Cubist, Surrealist painting of some kind.

Golub: It's a war painting.

Reinhardt: I wouldn't agree with you. It doesn't tell you anything about the Spanish War and it doesn't say anything about war. Picasso just committed himself about something like darkness and brutality. Actually I'm against interpretation anyway but the most interesting or at least the most relevant interpretation seems to be the psychoanalytic one in which Picasso reveals himself to be an open book.

Golub: You're dealing with certain universal symbols, for example, with the bull which comes down all the way from Crete. It's a Spanish symbol. Also, these things appear in Spanish apocalyptic art of the tenth century. There are manuscripts that relate to this kind of thing. When you see a horse that's disemboweled, you recognize it as a disemboweled horse. When you see a mother holding a dead child, which appears in *Guernica* you recognize it as a mother holding a dead child.

Reinhardt: They're like cartoons.

Golub: You may call them cartoons but the point is that they have rhetorical purpose.

Reinhardt: They have no effectiveness at all.

Golub: They have a tremendous effectiveness on me even today.

Reinhardt: That Spanish War was lost.

Golub: Paintings don't change wars. They show feelings about wars.

Reinhardt: It didn't explain anything about Spain to anyone.

Siegel: *Perhaps the painting doesn't explain it, but there is a narrative that always accompanies the painting that does.*

Morrel: When classes are taken around I've heard the speeches that go along with it and they're very powerful and perhaps explain the painting better than what Picasso was actually trying to say.

Golub: He knew what he was saying. He was in full command all the time.

Reinhardt: Nobody is raising a question there. It's a question of what he was trying to do and what he did do and what did happen.

Golub: But when you say that it's simply a psychoanalytic explanation, you can reduce everything to that kind of explanation, and, then of course, you have no social world whatsoever—you simply have a biological, genital organization to society.

Reinhardt: The most ironic thing was the William Gropper painting in which he satirized audiences at an opening at the Museum of Modern Art and then the Museum of Modern Art bought it and they showed it. Now it's just a question of about how effective that satire was. Gropper thought he was making a devastating statement.

Morrel: I think Ad Reinhardt had a beautiful series of protest paintings in the Modern Museum in 1963. I walked in the room and wow, it knocked me over. Everybody was looking at them and saying, "How dare this guy; how dare he do that?"

Reinhardt: It seemed dangerous because they fenced it off.

Morrel: But how dare you do that to these people as though they should designate what should be and what should not be. These to me were very valid protests. Everyone that walked in there felt like he was being put down. That was one of the most beautiful qualities.

Reinhardt: It wasn't a social or political one, but was an aesthetic one.

Morrel: Exactly. But, you see, this is another detached way of saying . . .

D'Arcangelo: This is two different things because I think the sense of the discussion involves the communication of anger or the communication at least of feelings about a particular political situation, which is quite a different thing. In the sense of the aesthetic dialogue that an artist is involved in, he's involved in that all the time. And the work may be contrary to an aesthetic position or not—that's something that's going on.

Reinhardt: Remember Jasper Johns's flags? There was something comic and satirical about that when it was first shown. I don't know whether it was camp or what and the New York World's Fair used it and they played *America the Beautiful* with it. They showed it as a straight painting of a man who painted the flag and they used it in the most patriotic way, jingoistically. There is some confusion between what the artist had in mind and what actually happened—the problem is what do these images do?

Golub: Let's say that in these flags there is a certain element of satire, of irony, of disengagement, even of nostalgia. But the threats that are involved in Jasper Johns's flags are minimal. That's why they can be used in a World's Fair and everything else. The threats that are implied by the nature of the *Guernica* are of a totally different order of things. This does not take away from the nature of what Jasper Johns is saying but when you make a reference from the *Guernica* to Jasper Johns's flags in terms of the social action of a painter, I just want to say that in the *Guernica* itself there are the kinds of things which would make it a very unlikely object to be shown in Spain today. And the fact is that the Spanish know this, because, someone told me the other night, apparently some several thousand Spanish college students had what must have been a near riot, demanding that the *Guernica* be brought into Spain. In other words, they know what the painting means, and they are demanding that the painting again engage itself in this way.

D'Arcangelo: What's happened with *Guernica* is that it's acquired the properties of a holy relic and it's functioning more that way than it is in

terms of its immediate impact as a political statement. It's more the historicity of the painting that's involved now than the actual thing itself. I agree with Ad that when you look at it you don't see a particular comment about fascism and there's no response in terms of Spain unless you read the little thing that goes alongside it. What you do deal with is human suffering.

Reinhardt: It doesn't deal with human suffering. There was an attempt to use details in a peace parade and the details from *Guernica* looked like Virgil Partch cartoons. Those funny eyes and circular lines connected. That has nothing to do with suffering.

Golub: When you go into the world and look at an object, you relate to it by what is called your body image. That is to say, that you carry within you a certain normal state of ego strength and health. Therefore, when you see a photo of a maimed child, like out of Vietnam, you related to your normal awareness that your body has.

Reinhardt: You might and you might not.

Golub: You do. Most normal people do. There's that recognition of the fact that they see something which is distorted. Now in *Guernica* you see distortions and you can make the connection.

Reinhardt: Not just *Guernica* but all issues of *Life* magazine and all photographic images everywhere, there is a question about what images mean. The image of the monk that burned himself in Saigon, that was used in I don't know how many movies, lightly, seriously. If those images are seen enough everyone accepts them and they become quite callous to them.

Golub: That's another problem. You're talking about stereotyping which happens in any kind of painting. It will happen in your painting, my painting, anybody's painting.

Reinhardt: No, it has to do with what McLuhan is talking about in communication and transportation which is that the image itself isn't what works you over, it's the medium that does.

Golub: But that's just a truism which gets away from the fact of the violence of the situation.

D'Arcangelo: No, I think what this has to do with is does any kind of visual image have and how much does it have any direct relationship to any reality situation. And I think we're swamped by images of this, and you may be moved by one of a burning child if for some reason you can make an identification. But there's even a question of the fact, is this real? Just because it's photographic—and then if you translate this into painting, you draw it further away from any reality situation so it becomes more interpretative and less immediate, less significant.

Golub: I claim that there is a basis by which one can come to this anger, these social images, in art. I would certainly agree that the art of our time has shown damned little interest in arriving at such conclusions but that doesn't mean that these conclusions cannot be achieved. The fact that the artists of the twentieth century have for one reason or another in large part felt it necessary to go away from this is something else.

Reinhardt: Even now, we have a problem of what to do against the war. It doesn't matter what you do, nothing seems to be very effective.

Siegel: *Do you consider Ben Shahn's* Sacco and Vanzetti *series effective?*

Reinhardt: That's a mockery of that event. I would never take that painting seriously in any way. It looks like a couple of dumb cartoons. The images in the painting are disgraceful. If you feel seriously about the real event, the painting is insane.

Golub: I don't feel that Shahn's has been a great, incisive, social art in the sense of what this art has been or can be. However, I think the *Sacco and Vanzetti* is by far his best work, and has a certain poignancy about it. The reason it's his best work is probably because at that point there was a pitch of something happening to him due to the event itself which translated itself through his hands on to the canvas.

Reinhardt: What would the poignancy be in the painting? In the slanty eyes or where?

Golub: These things are qualities of experience which are not that precisely and perceptibly evident. That's one of the reasons, Mr. Reinhardt, that we have art. And it's true of all kinds of painting—abstract painting or something else—if we try to get into it that way, we won't get into it either. There's no way to get into this at the aesthetic level.

19. Allan D'Arcangelo, 1984
By: Robert D'Allesandro

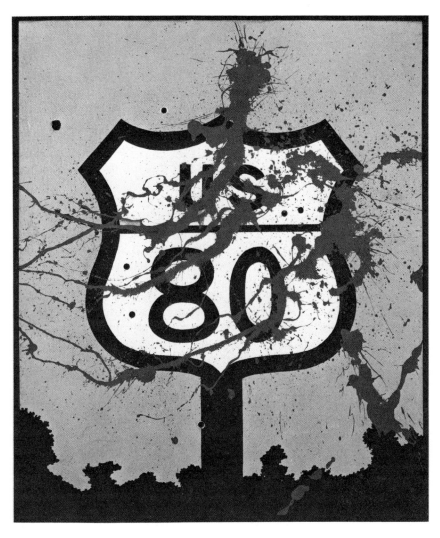

20. Allan D'Arcangelo, *U.S. 80—Mrs. Liuso* (1963–64)
 By: Nathan Rabin

Siegel: *Goya's painting,* The Third of May, 1808 *is certainly more acceptable aesthetically.*

Reinhardt: Finally, Goya is only important because of his relation to Manet.

D'Arcangelo: I don't think so. He's a maverick, I agree, but I find that painting very strong.

Morrel: We're not trying to reach people who agree with our feelings in protest art. We're trying to reach the people who may be on the other side.

Reinhardt: You can't do that. As an artist you can only reach those people who are willing to meet you more than half way. At least that's the fine artist's problem now. Another kind of artist who has techniques of communication or who wants to affect people like an advertising artist or a poster artist or somebody who wants to get a strong reaction, that's even another matter. You don't know exactly how effective that is. But those tricks and those usages—when Pop art entered the scene there was a return to the use of images. There were broken dolls with red paint spattered on them.

Golub: You've been finding that all these things are false for one reason or another. Everything that's brought up either has slanty eyes or is ineffective or it belongs in the street and doesn't really work or it's not what it seems to be. You find all of the things lacking because they presumably do not have the proper attitude. Why are they inadequate?

Reinhardt: Max Kozloff criticized the Collage and he said that somehow artists today lack the imagination to make something effective. I would object to his use of the word imagination. Imagination is the word used for an idea man in an advertising agency. You don't have imagination in the fine arts. That is one thing that's different.

Golub: What do you have in the fine arts?

Siegel: *Perhaps Allan D'Arcangelo might make this distinction because he chose to use a style for the float that was a departure from his fine art style.*

D'Arcangelo: Knowing that it was going to travel around the streets of New York and poets would read from it, I wanted to make something

that would make contact and have impact right away. I wasn't giving it any aesthetic considerations and therefore I used a giant political cartoon without any concern or reference to prior work or other work that I've been doing. It was an advertising technique in the sense that Ad described it. And it dealt with my feeling about the war, where responsibilities lay and in a sense it tried to generate anger against the war on the part of the people who would see it.

Siegel: *On the other hand, your print in the Portfolio related directly to your usual style.*

D'Arcangelo: That print is much less effective in those terms but the print was being used in a completely different way. It's a small, private, intimate thing and it reverted back to a kind of symbolism.

Reinhardt: Everyone seemed to have a problem with the Portfolio of whether to do their usual work or whether to do something with images that may have some political or social effect but it wasn't only a problem of images. There was even the problem of verbalizing or what words to put down. You could say "no napalming" or "no bombing." Those may mean something. But to say "no suffering", that's not clear in relation to this specific war. At any rate, there's a question about how effective that portfolio is.

D'Arcangelo: The impulse for the activity of an artist does not just lie in the area of formalisms or in the area of aesthetics at all. The initial impulse comes from the condition of being alive and it may manifest itself in a variety of ways. It could be in terms of political commentary or memory or even in the purist area of aesthetics.

Reinhardt: If you are saying that an artist's impulse comes from some life experience first it wouldn't be true. An artist comes from some other artist or some art experience first.

D'Arcangelo: I don't think so. The concern for another artist comes later on.

Reinhardt: Cézanne was involved in Poussin and in Impressionism—not in scenery, not in grass.

D'Arcangelo: But initially he was involved with Cézanne and then the formalistic concerns. You said something beautiful a couple of years ago,

"We all name ourselves. We call ourselves artists. Nobody asks us. Nobody says you are or you aren't."

Reinhardt: But you don't do that after you say you're a human being.

D'Arcangelo: It's an inseparable act.

Golub: The Portfolio has a number of images that attempt to be expressionist, humanist, figurative, but it also has a number of images that are very pure, extremely abstract, concrete if you want, and that are concerned with, in a certain way, what I call perfectibility. In this kind of art there is a kind of dream, a vision, whether it comes out of self experiences or comes out of the arts that sees itself as self-encased and that reaches for a certain kind of perfection. Now the attempt by the artist to break what is a self-enclosed area of perfectibility and get out in the arena, the arena where experience is actually when they hit you over the head!

Reinhardt: Artists never, never, operate in the area of experience.

Golub: But I personally think very strongly they do and I even think you do. The Portfolio is a mixed bag because today American artists, as we talked at the very beginning of this discussion, like European artists, like everyone, do not know how to cope with the totality of the experiences that are assailing them. So what they do is, so that they can have this perfection, they go back to other artists, they go forward with other artists, but if they try to get into the arena where the life is pulling at them, they're going to be in trouble, because they don't have the instruments: they don't have the brushes with which to deal with this and the Portfolio reflects this.

Siegel: *Allan do you think that you might go on with some statement that refers to the war?*

D'Arcangelo: I might, though probably only in connection with the kind of activity that it's been with in the past. It hasn't come into any work that I've been doing now.

Reinhardt: Artists have forms and devices and you're asking him to use them for some other reason than he's using them. Golub too has his traditional forms. He doesn't express anything. He doesn't express anger or humanity or anything like that. He thinks he does.

Golub: I happen to think I do actually.

Reinhardt: What was your print of?

Golub: It's called *Killed Youth.* It shows a red head and shows blood.

Reinhardt: Blood? Real blood or red ink?

Golub: Just red lithographic ink.

Reinhardt: Well, that's fake, isn't it?

Golub: But I never have claimed that art is life. Art is an attempt to get at life as a symbolic thing. No one has ever said in any era of human history that art is life. In fact, it's in the twentieth century that people got all balled up with that concept.

D'Arcangelo: I've always had the feeling that one chooses in a sense to be an artist as a means of staying away from life—that the painting, the canvas itself becomes a kind of buffer, because if we really want to get involved in this, why should we paint about it.

Golub: What do you mean? There's the novel.

D'Arcangelo: Language is different.

Golub: Language is not different. I use a language which I think is recognizable and comprehensible to others. This is a certain kind of language, a certain kind of image. I expect people to be able to resolve what this signifies. If they don't like it, that's tough, but this is the way it goes. But I don't claim this is life. When the ancient Romans or Greeks showed conflict in some of their sculpture, they didn't claim this was life. This was an attempt where the citizens of the community, of this world, could get a symbolic, condensed resolution like in the reference to *Guernica,* an apocalyptic statement about what the nature of experience is in one's time. You can get it through music in this way; you can get it through literature in this way; you can certainly get it in visual arts. Why do you wish to deny this particular area? I don't deny these other areas.

Reinhardt: But the fine art that you see anywhere, Greek or Roman, does not tell you anything about the nature of experience. I don't know where you get your information from. There are a certain group of iconogra-

phers and iconologists who are pretty wrong now, in that they treat works of art as kind of illustrative of their periods.

Golub: You comprehend it existentially. You comprehend it in the nature of the form itself.

Reinhardt: You're talking mystically now.

Golub: Not at all. What I said before, you comprehend it on the basis of your own body images, on the expectations of your society, on what is normal to your society, on what is normative, how people behave. Art always has this other aspect to it as well. It's adventurous, it challenges these things but nevertheless it's comprehended on normative bases in your society, always.

Reinhardt: Everything is in that sense.

Golub: That's right, even figurative art is.

Reinhardt: Why is the activity separate from other activities?

Golub: It has its own often limiting conditions.

Reinhardt: Why are art objects special objects or more valued objects?

Morrel: How do you look at a painting?

Reinhardt: Only as a painting, of course. I don't see how a painter can look at painting except as a painting. Then you know the artist is involved in certain tricks in colors and forms. But one artist doesn't look at another artist ever as somebody who's had some kind of experience that he's expressing other than the painting experience. That's for laymen, the idea that an artist expresses some life experience he's had.

Siegel: *Marc, you have a real-life problem of a different sort at the moment because of the fact that you incorporate real flags in your sculpture. Can you tell us about that?*

Morrel: There's federal legislation going through to make desecrating the flag, that is, to defy and defame, cast, or trample upon the flag a crime and this act is supposed to carry a five-year prison sentence. Already it's been proved in court that these are desecrated flags. Therefore I'm illegal,

my ideas and my art are illegal, and I'm a walking felon. I may have to flee. If all of a sudden they busted down my door while I am working on one of my sculptures, I'm committing a crime.[1]

Reinhardt: If you think that a flag or a cross is that meaningful then you're in the same boat as people who want to make it a sacred symbol of some kind. Why do you want to work with a real flag?

Morrel: Why do you want to work with paint and canvas?

Reinhardt: That's neutral. That's just material. We're not talking about materials. We're talking about a sign or a symbol. What kind of a symbol is it? Most of the time if you use it, it's a patriotic symbol.

Morrel: Exactly. Therefore the patriarchs are very upset. I felt that this was the one symbol that could reach people other than a burnt or bloody doll or a draft card. This is a very sacred image to some people—the very people we're fighting, intellectually, not physically, yet.

Reinhardt: If it's a good idea then maybe everybody should do that. Anyone who wants to make a statement about the war, make some kind of gesture.

Golub: You have an a priori position about Marc, because you feel that using the flag is impossible as art. Going from that assumption, then you deny that he can have an art. Isn't that true?

Reinhardt: I just wondered about what the flag was. Johns painted out a flag. It looked like he slashed it up if you want to be literal with it, in a kind of abstract expressionist action technique. What was all that about?

Siegel: *In the process of painting out the image of the flag, Johns was primarily concerned with the relationships between a real object and the act of painting. By making it less visible, he forced the viewer to look more closely.*

Reinhardt: It's pretty unpatriotic, isn't it?

Golub: Everybody knows the way he did it is not unpatriotic.

D'Arcangelo: I don't think it's a statement that goes much beyond the notion of introducing another heretofore unused object as subject matter in painting.

Golub: The thing becomes obscure to some extent anyway. Then the public has trouble reaching it, and a certain few may understand it. They become very involved in the meaning of these paintings but at that level it's obscure. But what Marc does—has the quality of the directness and impact of the work. His work is not obscure in that sense and therefore people get upset. When you make a phallus out of an American flag, you are going to upset a lot of people.

Morrel: The most upsetting piece, and the piece that confused our case more than anything was one where the element of sex was brought into it. In this piece a papal flag was the main staff of a cross. And the Christian flag and Episcopal flag were there. Attached to the cross's lower section was what everyone assumed to be a penis.

Reinhardt: If you can get publicity, then you can be effective. For example, you can have a five-man picket line and if the television camera's there then that five-man line is much more effective than if you have 50,000 and they don't make the television news. Then you're talking about publicity, not about the actual object or the sign or the symbol or whatever you're using.

Golub: But you cannot hold his art or anybody else's art responsible for the lack or for the success that it achieves in the public sense.

Reinhardt: But in most cases it's an anti-art position, which is all right.

Golub: I think art involves an anti-art position, and you think art does not involve anti-art positions and that's where we disagree.

Reinhardt: The thing that bothers me is that you have the mass media that is trying to influence all kinds of people, and there are tests about how effective things are. As an individual you might have illusions about your effectiveness. If you're involved in an area where they check your responses, say, in advertising you had to sell something and convince somebody of something, then there are ways of checking that.

Golub: That's not the way protest art works because protest art starts in a milieu where it is not liked, where it has to fight against convention, where it has to fight perhaps against the bourgeoisie, where it does not have support, but over a long time through intellectuals and artists, over generations . . .

Reinhardt: It dies out. The Mexican influence has died out.

Golub: There is always that kind of necessary development from isolated singular positions into a group thing so that the effectiveness of this thing is not so much determined by the fact that 100,000 people will change their vote. Obviously it will not have that kind of effect, as it will by the kind of fury, the kind of furor, the kind of excitement, the court case even, the kind of legal landmark it might become, the general effect it will have upon opinion in the United States, and, also, which is very important, in Europe. That's how the effect works.

Reinhardt: Well you know what happened to all the Social Realists in the 1930s? They became artist war correspondents for *Life* magazine in the early forties and then you never heard of them again. Who remains? Evergood? Shahn became a poster artist. I remember in the CIO in the early organizing stages, Ben Shahn made some posters for the newspaper and the posters came in and they were done by Ben Shahn, that made them culture, you see, he was a fine artist. Then the CIO Committee was bothered because these faces, they said, looked foreign and ratty, these union people he represented. So they asked me. What could I say? They looked ratty and foreign. In a union recruiting drive you can't recruit on the basis of posters like that.

[The panel discussion with Golub, D'Arcangelo, Reinhardt, and Morrel, which I moderated, was broadcast on August 10, 1967 on WBAI.]

Notes

1. Radich was convicted for "casting contempt upon the flag" but after a series of court appeals which took more than seven years to settle, the original decision was declared invalid. The case was won finally on the grounds of the First Amendment. By this time Radich had ceased to be an art dealer and Morrel had fled to Europe.

21. The first demonstration at the Museum of Modern Art,
 Takis with removed *Telesculpture*
 New York, January 3, 1969
 By: Mehdi Khonsari

The Artists' Protest against the Museum of Modern Art

The sculptor Takis and some of his friends removed his *Telesculpture,* 1960, from the Machine Show at the Museum of Modern Art. They took this action because the work was exhibited against the artist's express consent. On January 28, 1969, the group presented to the director of the Museum of Modern Art, Bates Lowry, a list of thirteen demands, the first of which was that the Museum should hold a public hearing in February on the topic, "The Museum's relationship to artists and to society." Mr. Lowry answered their letter on February 14, stating that he was sympathetic to the issues that had been raised but felt that a public hearing would not be in order. Instead, he recommended that a special committee on artists' relations be appointed for the purpose of investigation and discussion of these issues. The artists felt that this response totally ignored their demands and, since that time, there have been a number of demonstrations at the Museum of Modern Art.

The panel brought together artists who have been part of this protest since its inception: Carl Andre, Hans Haacke, Tsai, and Farman. Unfortunately, Takis was unable to attend, but his recorded statement, broadcast before the discussion began, is quoted below:

> Artworkers, let's hope that our unanimous decision, January 1, 1969, to remove my work from the Machine exhibition of the Museum of Modern Art, will be just the first in a series of acts against the stagnant policies of art museums all over the world. Let us unite artists with scientists, students with workers, to change those anachronistic institutions in the information centers for all artists' activities, and in this way create a time when art can be enjoyed freely by each individual. This has been made January 3, 1969. Since then our group has become much bigger and taken the name of the Art Workers Coalition. Artworkers! The time came to demystify the elite of the art rulers, directors of museums, and trustees.

Jeanne Siegel: *Could you tell us why Takis didn't want that particular work in the exhibition?*

Farman: The fact was that when the exhibition was being put together, Pontus Hulten, who was the Curator, had talked to Takis in Paris and he had told him that Takis would be having three pieces in the show, including two larger ones that were not to be seen in the exhibition because later Hulten realized that they couldn't finance the show the way they had designed it, probably, and he decided to cut some corners. Therefore, he decided to just put in the show a small sculpture by Takis, which he had made, in fact, maybe ten years ago and which he felt wasn't representative of his work. So at that point of the game, Takis wrote to them that he'd rather not have this one piece than be misrepresented, because it really was too small, compared to all of his contemporaries that have been working with him all along these years and some of whom were given a lot more space.

And also, the fact is that in terms of taste and in terms of involvement, they cater to the Board of Trustees and their friends. Trustees give them a piece of art, they'll take it and put it in their gallery, and like it was the case with Takis, after the correspondence between Takis and Hulten, finally Hulten decided that the Trustee who had given this *Telesculpture* to the museum should have his way and that the telesculpture should be in the museum's Machine Show exhibition, although Takis has written that he didn't want it to be in that show.

So, in a way, they will listen to the Trustees and pamper the Trustees and not follow the artist's wishes.

Siegel: *The first demand called for a public hearing. Why was that important?*

Carl Andre: In a sense, I think the problem that we as artists have is not the Museum of Modern Art at all. The problem is we ourselves. I think artists in our society are unnecessarily and unwarrantedly isolated from each other and are encouraged to remain isolated. And a public hearing is a way of artists getting together and exchanging views and finding the common ground that they share in gaining some influence on their own destiny as artists.

Siegel: *If it is just a matter of artists getting together to express their views and getting to know each other better, there doesn't seem to be a necessity for participation on the part of museums.*

Andre: For that matter, museums can come and present their views—it's a public hearing to gain a sense of community. It has to be for some purpose. In other words, the reason for the artists to gain a sense of community is so that in dealing with the institutions of our society, the artist cannot have the single, separate fight or the single negotiation. Certain rights, duties, and responsibilites on the part of the artist will be recognized as something that's shared by all of them in their views dealing with museums and institutions.

Siegel: *What was Mr. Lowry's response?*

Andre: His response was to recommend to the Board of Trustees—not to the artists—but to the Board of Trustees of the Museum, that a special committee, he referred to it in one of his letters as "our committee," meaning very much a committee within the structure of the Museum, would be formed of people that the Museum felt were representative of the art community to hear testimony, you might say, about the Museum's relationship to artists in the community. This special committee, the artists felt was a fine organ for the Museum to express its own views, but was not the proper organ or the proper forum with which to examine the Museum's policies itself.

Siegel: *Did anybody ask Mr. Lowry who would be on that committee?*

Andre: He pointed out that the Museum would pick the people.

Farman: But none of them have been revealed by the Museum yet. They are in the process of picking, I suppose, some individuals from the museum's Board of Trustees and Directors and employees. 'Fair-minded people', he said in his letter.

Siegel: *Don't you think that if the artists pointed out that they wanted to have some artists on this committee, that he would be willing to do that?*

Hans Haacke: Supposedly, there will be artists on this committee. But these artists will be chosen by the Museum.

Tsai: I would like to add to this question of why we want to have a public hearing. What Carl Andre said represents one viewpoint. We have other viewpoints. Originally, when we started this demand, we felt that since we listed certain points that by no means represent all the artistic communities—it only represents a minority—a few of us who sat together

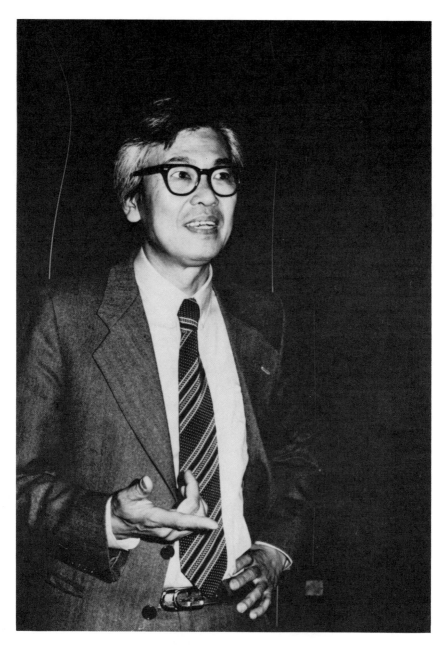

22. Tsai (at Isetan Museum of Art, Tokyo, 1980)

and listed all these points we considered pertinent. Therefore, we consider this public hearing absolutely necessary in order to have a broad viewpoint presented and from which we could go further to see what kind of improvement could be made by listing all of these other viewpoints, which we could incorporate with our original points, and we will go on to negotiate or talk or whatever things command in later days.

Andre: Yes. A public hearing has been arranged by the artists. It will be held on April 10th at 209 East 23rd Street between 6 and 10 P.M. at the School of Visual Arts. We as a group wish to encourage this wide group of persons, including all people who feel that they are engaged actively in the art community, to come to that address.

Siegel: *Will there be any other events between now and this public hearing?*

Farman: There will be a demonstration that will take place on Sunday, March 30, to extend our field of activity in bringing in more people and having an occasion to exchange ideas just as it is done in demonstrations about any problem. We are not sure exactly of the size of the attendance—and that's another reason why we are having this demonstration—to find out, in fact, what kind of people, how many are interested in forming groups of artists with common points of view, which will strengthen them when dealing with institutions. I am personally very much in favor of having all people dealing with institutions to have a voice and to be organized and be able to talk with the directors and the trustees and the stockholders of these institutions. That is like the consumer having a right in what is happening.

Andre: There is a general demand on the part of people all around the world to be in a reciprocal relationship to the institutions that determine the course of their lives, and we know that the Museum of Modern Art has a very great influence on the course of the career of an artist, and artists should have some influence on the Museum's policy. Other artists also see a gallery/museum nexus so that artists who choose not to be represented by private galleries are in a great disadvantage in showing in the Museum because of the close connection between staff and trustees at the Museum and the staff and owners of private galleries. That's an inevitable relationship but I don't think it should be as influential as it is now in the present art scene.

Siegel: *What about the financial issue? I see that at least two of your demands are specifically involved with that question. Demand No. 5 says that the Museum should be open on two evenings until midnight and admission should be free at all times.*

Farman: I have read some of the figures—the Museum's five year statement of income. There are some figures from 1963, some figures from 1967. I suspected this and I was, in fact, pleased to find it in these figures printed by the Museum. It has to do with the admission; basically what runs the Museum, next to the admissions, is the contributions to the Museum, and if you read these figures you will find out that between 1963 and 1967, admissions have gone up over $194,689. They have made more money from admissions while the contributions by the trustees and friends, as they call them, have gone down by $114,277. Now, what I believe this means, is that the Museum caters to the rich. It's a syndrome that exists in all of the country now, and this is part of it. The Museum caters to the rich and maintains their level of taste but makes the public pay for it. Because, in fact, if they need to keep the kind of luxurious and chichi organization that they have going, they should ask their trustees and their friends to give them the money. If they say that they're an institution that is dealing with a large public, they should not raise their prices in order to compensate for the lack of contributions. That is one of my main points of contention here with the Museum. Of course, we have received leaflets from the Museum in which they say there are many groups of people who can enjoy reduced admission charges, etc. That is true, but somewhat irrelevant in my mind to the policy that a Board of Directors should follow. These directors should make an effort to get the money if they want to retain the level of gala openings and luxury galas that they maintain.

Andre: My personal thought on the free admission issue is that the admission cost should be voluntary on the part of the person going into the Museum. And, of course, I'm immediately told by people associated with museums that people would not pay the dollar and fifty that many people pay who go there now. The irony of that statement, I find, is that the poor cannot go to the Museum, although I have spoken to people at the Museum and they cannot conceive of a person who does not have $1.50 that he can spend on a museum. And I know many people who were in that position, and I myself for most of the time that I was in New York was in that position. But they say that the people who now can afford to get into a museum will cheat on it, and that the people who have the affluence to spend $1.50 are the ones who will duck in, so to speak. I'm not worried about their morals—I'm worried about people who simply don't have

$1.50 to get in. I think people who present themselves at the gate to enter the museum should have the right to get in. I don't think we should encourage new college girls and the middle-aged salesmen and their families to duck it. But I can't be responsible for the morals of the affluent— I'm much more worried about the deprivation of the poor.

[This panel with Andre, Farman, Haacke, and Tsai was recorded and broadcast on WBAI on April 29, 1969. The transcription is incomplete as a portion of the tape was destroyed.]

23. Carl Andre
 By: Gianfranco Gorgoni

Carl Andre: Artworker

Carl Andre was a generative force in the formation of the Art Workers Coalition. The Coalition was formed officially on April 10, 1969, when three hundred artists met for an open public hearing at the School of Visual Arts on the subject of what should be the program of the Artworkers regarding museum reform, and to establish the program for an open Art Workers Coalition.

Andre, like Reinhardt, favors the separation of art and politics. Unlike the latter, however, he feels strongly that his Minimal art has been directly influenced by his life experience, seeing the art world politic as a microcosm of the larger world.

Jeanne Siegel: *It seems to be a moment in history when the artist, after twenty-five years of withdrawal, is once again thinking about himself in close relationship to society with the same demands and desires as other human beings.*
Carl Andre: I don't meet too many artists who have the kind of social pretensions of the good solid bourgeoisie or who lead neat Cadillac-driven lives, and most of the artists that I've met have had great social concerns. I remember talking to David Smith and he said that he considered himself redder than Mao. He had a very intense social and political concern. The art was considered hermetic in a sense, and withdrawn from society. It was placed aside from the concerns of society not so much by the artist but by the critics and the curators and the art establishment. They made a big thing out of the ordinary man in the street not being able to understand and probably disliking it because of having had no exposure to it and used this in a kind of elitist way.

Certainly the artist is taking a more active public role today, for instance, your participation in the Art Workers Coalition.[1] Why do you feel the need for that?
I think the Art Workers Coalition has been the most significant art movement in New York in the last two years. It's the first time that artists

have gotten together in my experience without any art problems. Art simply is not discussed at these meetings. The trouble is artists I've been involved with before have always had a more or less tacit assumption that we approved of each other's art, but the Art Workers Coalition has nothing to do with what your art is like, but it has a great deal to do with keeping the springs and origins of art, which I think are essentially the same for everybody, open and as fertile and as productive as possible. And this is done by artists being able to get together, talk about the common social, economic, and political problems and having the right to get up and speak your mind because you consider yourself an artist. Actually an artworker, I should say, because, as you know, I like the term artworker, not because it's any kind of camp Marxism, but it includes everybody who has a contribution to make in the art world. A collector can consider himself an artworker, in fact, anybody connected with art would be considered an artworker if he makes a productive contribution to art. I make art works by doing art work but I think the work itself is never truly completed until somebody comes along and does artwork himself with that artwork. In other words, the perceptive viewer or museum-goer who's got some kind of stimulus from the work is also doing artwork, so that broadens the term out to a ridiculous extent; but I think it should be as broad as possible because I never liked the idea of an art political, economic, social organization which is limited to artists, because that's just returning to another kind of elitism.

What issues or demands made by the Coalition have especially concerned you?

This immediate thing that concerns the museum has to do with what we've come to call the dictatorship of the bourgeoisie, which in a sense must end. The museums of the country are run by boards of trustees which are self-perpetuating. They're there strictly because they're wealthy and that is a dictatorship by a very small minority of the country over the rest of the country. This is anti-democratic (of course, it reflects exactly the kind of corporate structure of the country). The Museum of Modern Art states very firmly that they will never have an artist on the Board of Trustees unless an artist was immensely wealthy. Mr. Hightower[2] has said, quite generously, that he considers everyone an artist, so that he has a board of directors of artists, essentially. That's a lot of hokum, of course, because not everyone is a banker just because they have money in their pockets.

It also has to be quite clear that I think the economic and political interests of artists are very much in contradiction to those of Nelson Rockefeller.[3] So it's very bad having his man, Hightower, trying to rep-

resent artists, because we have different class interests. One of the reasons, I suppose, that I like to be in Art Workers Coalition is because I consciously do not identify much more with a producing, literally, working class. I remember when I worked on the railroad, it amused me because on the switching locomotives we used to work with there'd be a plate riveted onto the side of the engine saying "This engine is the property of the Chase Manhattan Bank" or "The Manufacturers Trust Co." which was socially absolutely untrue. That locomotive belonged to the people who used it while they were working and when nobody was using it, nobody owned it, literally.

And what I've seen of the people who buy art is that I'd rather not spend a great deal of time with them. There was a woman who evidently had bought the meteor crater of Arizona and wanted me to do some great scheme defacing it. I refused to do it because I once wrote a twenty-five-word novel and the twenty-five words went "Manuel corrupted money. He bought the Leaning Tower of Pisa and straightened it." So somebody buys the meteor crater of Arizona and puts an amusement park in it. That's what we're in the grip of in the world today.

But you have no objection to your sculpture being purchased by these same people?

I've never minded people buying works at all. My social position really, in the classic Marxist analysis, is I'm an artisan. That is a worker who employs himself essentially as his own tool to produce goods and he exchanges for other people's goods. This is different from a worker who is employed by somebody else. So technically, the artist's position in our society is that of an artisan and so to exchange my goods that I produce for other people for their goods is my economic function. So this business about the art object being corrupt or uncorrupt is simply not an issue.

And your personal relationships with museums and galleries have been good, haven't they?

I am represented by a gallery and I've had a good relationship to galleries, the Tibor De Nagy gallery which I was with formerly and the Dwan Gallery which I am with now. I have never received any aesthetic, political, economic pressure at all. I have not had much to do with museums in America, but what I've had to do with them as an artist has not been unsatisfactory. So I could not say that I would be opposed to museums or galleries as such, but I just think we need much greater resources to be used. An artist should not be required to go to a gallery to be able to sustain himself as an artist. There should be, for instance, a social welfare system to which they can turn. I would like to see a system

for medical and dental and pension insurance for artists and also an artists' registry and perhaps even a royalties bureau to collect royalties on reproductions of art works, or uses of essential art motifs, which now is an enormous area of potential income for artists. I think the motifs of artists are used or stolen outright by commercial artists, and without paying any royalties to us whatsoever. Royalties should be paid for work, where it can be shown to be a plain derivation from a 'fine artist's' work.

Museums should be far more open to artists than they are now. There is not in New York, for instance, a Kunsthalle, a kind of museum which is very common in Europe and every town in Germany has one, which is a museum with no permanent collection and where a show of art may be up for two weeks and another will replace it quickly, so that in the course of a year you can have hundreds of artists showing their work without the preconditioning thought that they all must have this, what I consider, fascist lie of quality. I've always found this is utterly distasteful to me because museums and galleries to my mind are not full of splendid art. Most of the art that I see in every period that's in the museums and galleries is of no interest to me whatsoever. I'm not trying to say that the art that I'm interested in has quality. I'm just saying that only a small number of art works move me deeply. But that's not quality, that's a statement about myself. It reflects my own experience in the world. So the idea that galleries and museums show art because of the quality of the art is not true. Once a work has been shown in a gallery or museum, it has a quality that was conveyed to the work by the splendor of the museum or the prestige of the gallery. What the museum is really interested in is not quality but commodity—Ma Bell's princess telephone and Carl Andre's sculpture are now in the permanent collection of the Museum of Modern Art because they have reached the level of a commodity.

Why did you and other members of the New York Art Strike[4] *decide to sit-in and close the Metropolitan Museum? Wasn't that a self-defeating act?*

It is the pretense of the museum that they are an apolitical organization. And yet the people who run them, the people who are responsible for their operation and decide their policies, the boards of trustees, are exactly the same people who devised the American foreign policy over the last twenty-five years—man for man they are the same. Actually I think the boards of trustees of these museums favor the war, they devised the war in the first place and wish to see the war continued, indefinitely. The war in Vietnam is not a war for resources, it is a demonstration to the people of the world that they had better not wish to change things radically because if they do the United States will send an occupying punishing force. It is a war of punitive oppression. And they wish to run

these quiet apolitical institutions like museums and universities suppress-
ing politics among artists, among students, among professors. They don't
wish people to have broader and more general considerations. They'd
rather have artists who do nothing but art, musicians who do nothing but
music, and athletes who do nothing but their sport.

What's coming now, I think, in the world in every respect you might
say is the crisis of freedom. If freedom has to be at the expense of other
people's lives, it isn't worth having at all. In China the artist is not free
to do as he likes but the Chinese aren't the people who are killing people
in Vietnam to maintain that oppression—we are killing people ostensibly
to maintain the rationale of artistic freedom.

*Didn't Mr. Hightower suggest to the artists that if the Museum of Modern
Art was to politicize itself, the artists should politicize their art?*

The artists made it clear to Mr. Hightower that they were not poli-
ticizing the art but themselves. One suggestion was that artists serve as
docents and give tours in the museum to talk about the works of the
museum collection—what the artists were most deeply moved by and
most influenced them. At the same time they could explain the connection
between politics and their art and between the art of the artist and their
view of the world and their objections to the war in Vietnam, sexism and
racism. (The art world itself is one of the most thoroughly segregated
communities in New York. Unconscious racism even exists within the
Art Workers Coalition. For a long time there have been requests that we
meet up in Harlem, for instance, and people won't go. They would rather
leave the Art Workers Coalition than go up to Harlem on a Sunday after-
noon.) I have felt for a long time that museums should use artists this
way. I wouldn't put the artist in front of the works of art to explain them
but to explain his position in the society. What I'm thinking of is not so
much integrating the artwork itself into the sensibility of the people, but
integrating artists in the sociology, which is a much more important
problem.

*What do you think is the relationship between the artist's position in society
and the work of art?*

I've proposed a model which described the making of any art work,
not accurately but metaphorically and I call this the three-vector model,
the vector merely being a geometrical representation of a line of force
having length and slope. The first vector would be the subjective vector
which represents one's personal history, one's talents, one's skills, the
accidents of one's life—genetic and environmental influences—the whole
thing that composes the individual human being. The second vector I

would call the objective vector, that is the properties and qualities of the materials of the world. The third is the economic vector which is a kind of intermediary or compromise between the subjective and the objective. It's the availability of the materials of the world at one time to do a work. Now if these vectors have three points of intersection there's a contained triangle in the center—there I would say was when the work of art came about.

It's been my experience that the vector that seems most vexing is the economic one. Between 1959 and 1964 I could never get together the $250 necessary to make the works which would have made a complete gallery show and I asked dealers and people for the money and they couldn't put the money together either. So at the time I despaired. But now I am in a position where I can command quite generous resources but the point is that I've also come to the realization that commanding resources shouldn't be what makes possible the work of art. You must be able to make a work of art even if you have no money. But now I cannot say to a person who has no money, you don't need money to do work. That would be sinful. I mean that's like a rich man saying to a poor man, 'Don't you see, you don't need money to be happy.' The only thing I can do is to confront the problem myself and say, Look, make work with a zero-zero vector, that is, make work as if you were poor. The recent small wire pieces, nail, rusting steel pieces that were picked up in the streets have to do with trying to make a zero-zero economic vector. And I think it's good to have an aspect of one's art that is not so super-precious—kind of ephemeral works. I don't intend them to be ephemeral but I think it's good to always make works which are not so precious they can't just almost literally blow away.

Do you feel that your political attitudes are reflected in your sculpture?
 I have been subject to politics as long as I've been alive, thirty-five years, starting with the New Deal, going into the Second World War, the Cold War, Korea, the whole thing. So I've been affected by it and hence since I've made my art, my art must reflect my political experience. I could not possibly separate them, I mean, art for art's sake is ridiculous. Art is for the sake of one's needs and I don't think one has a distinct art need; rather art is an intersection of many human needs. My art will reflect not necessarily conscious politics but the unanalyzed politics of my life. Matter as matter rather than matter as symbol is a conscious political position, essentially Marxist.

Did your experience as a railroad worker for four years influence your sculpture in any concrete way?
 Very, very much. Concretely the railroads have all to do with linear masses and a railroad train is a mass of particles and the job that I had

in the railroad as a freight brakeman, and later a freight conductor, had very largely to do with taking trains that had come in from the West into New Jersey and classifying them, that is, directing the cars to different tracks. So I was continually shifting cars around and making new strings of material. And of course there are the steel rails going on for miles and ties, and just all the industrial material—coal, coke, iron ore, scrap metals—all the materials going through there are raw materials that I was tremendously interested in too.

Are there other reasons for your consistent, intense interest in particles?

One of the reasons certainly I am interested in particles is that my grandfather was a bricklayer and the whole theory of masonry is in being able to make large structures by using small units. I've only done one work in my life where I could not manipulate the particles of the piece myself, and that was *Fall* in the *Art of the Real* show at the Museum of Modern Art, because those pieces weighed six hundred pounds each. In other work, I've always been able to put the elements in place myself, which is the theory of masonry.

In an attempt to relate contemporary American artists' choices of materials and forms to what she considered an inbred American taste for individualism and humbleness, Barbara Rose said ". . . one might go so far as to interpret the current widespread use of standard units self-sufficient, non-relational forms, and non-hierarchical arrangements of the form members, as a metaphor for relationships in an ideally levelled, non-stratified democratic society." [5] *Do you agree?*

I think it had more to do with the mechanics than with democracy or that kind of leveling. That strikes me as the kind of idea that comes to a critic because a critic tries to impose upon an artwork linguistically intellectual propositions, but art works at their best spring from physical, erotic propositions. So Barbara Rose was thinking of what artists think about when artists make works of art. But I don't think artists think that way at all, at least, I don't. I think in terms of a physical reality, a direct physical hefting of matter. The one art sense that I have of my own work is that I do not visualize works and I do not draw works and the only sense I have running through my mind of the work is almost a physical lifting of it. I can almost feel the weight of it and something running through my mind either has the right weight or it doesn't have the right weight. But I don't even visualize it—I number it sort of—something like sixty-four pieces of steel and I can have a sense of the mass of it but it's not a visual sense, it's a physical sense—almost a sense of pushing against the door and opening it.

My work has a certain nature and I want that to remain clear. I

24. Carl Andre, *64 Pieces of Copper*, 1969
By: Robert E. Mates and Paul Katz
Courtesy The Solomon R. Guggenheim Museum

believe an artist has to be responsible not only for what he has done himself as the art work, he must also guard the methods of propaganda, the methods of merchandising, the methods of distribution of the work. Otherwise, it can fall into channels that totally misrepresent it. People have tried to pass off my work as assemblage, because assemblage has been a merchandised thing before. People have tried to pass off my work as being like Andy Warhol's soup cans, and more recently as ecological works, associations which to me are completely false. Now artists must do the culture as well as the art. That is how we have become politicized.

Does the element of participation in your sculptures contain any political or social comment?

I don't consider the fact that a lot of my pieces—you can walk in the middle of them—metal pieces particularly or some of the long wooden pieces you can walk along—as participation, but rather I think there's a demand made on the tactile sense of the viewer, forcing the viewer to be sensitive to the properties of the material. Also by walking on them they make different sounds, they have different textures, you can feel the difference. It's a way of entering the art, non-architecturally. There's one aspect of participation that I like and that is that my works lend themselves to installation, and I mean building and taking down very readily, so people can put them out when they want to and put them away when they want to.

In a way you remind me of Ad Reinhardt—a certain dualism, perhaps. In his paintings there was the same pervasive interest in juxtaposing rect- angular forms and he too was politically involved although he made a cause célèbre out of keeping it out of his art. Do you feel any affinity to him?

I lived with a Reinhardt painting in 1960. Frank Stella bought or traded one of the black paintings from Ad and it was in my apartment when I was living on Grand Street. Reinhardt was quite an influence; I think it was through his painting that the idea of the spectators doing artwork in order to recover the nature of the painting came about, because with a Reinhardt even I today have to work to see it, which I've found is very rewarding. I did meet him at the time that the Dwan 10 show was being put together. I think his various doctrines about what art is not about, all those "no's," were very helpful and essentially very true be- cause art doesn't carry messages that way—mine doesn't, but I wouldn't make an issue out of it. To Reinhardt, it was a very important issue because art hadn't been stripped down. I mean he stripped down the cultural assumptions about art and I think that was a very important

work. I will perhaps betray his memory to say that I didn't keep the rigidity that he did.

Do you think the artist's affiliating himself in a public way politically is an outgrowth of a development that started with artists, like Don Judd, assuming the role of critics?

No, in my own case it was a matter of meeting and talking to students here and abroad. One is always asked political questions so I think in a sense the students have done a great deal to help the artists clarify their own political position. I think it was the students first, concretely, who used, as Godard says in his movie *Pravda,* "concrete analysis for concrete situation." Students saw that they were being exploited by people who were not responsible to them whatsoever and then they decided to do something about it.

Can you conceive of the revolution as eventually affecting your art, to move toward some form of direct social comment?

I certainly don't think we are in a time of revolution now in America—perhaps the time of Civil War but not of revolution. We as artists are not authentically revolutionary because we have not emerged from revolutionary conditions. So it's not just a question of people making bourgeois decadent abstract art or making representational art or vice versa, because we're not even in a state where we can decide. At least, I'm not. As Che pointed out, even in Cuba there is no ultimate single kind of art that can be justified because the only ultimate single kind of art would be a revolutionary art. And since the revolutionary man has not yet appeared, we don't know what that art is.

[This interview with Carl Andre was published in *Studio International* in November 1970.]

Notes

1. The Art Workers Coalition, an amorphous, fluctuating group with a steady membership of about 100, came into being when Takis made his gesture of removing his Telesculpture from the Machine Show at the Museum of Modern Art on January 3, 1969. Although it belonged to the Museum, he had forbidden them to use it because he thought the work was no longer representative and that to include it in the show would misrepresent his contribution to machine art. About a dozen artists, critics, and writers joined him.

2. John Hightower, formerly Executive Director of the New York Council on the Arts, who on May 1, 1970, replaced Bates Lowry as Director of the Museum of Modern Art,

had been conducting the negotiations with Art Workers Coalition and the New York Art Strike.

3. Nelson Rockefeller was a Trustee of the Museum of Modern Art.

4. The New York Art Strike constituted a larger group, made up of former Art Workers Coalition, museum and gallery people who didn't want to be identified with AWC, more militant groups such as the Guerrilla Art Action and Art Workers United. It was originally formed as a result of a suggestion by the Faculty of the School of Visual Arts to strike on May 22, 1970, to protest War, Racism, and Repression. About five hundred artists, students, teachers, dealers, critics, sat in on the steps of the Metropolitan Museum for ten hours.

5. Barbara Rose, "Problems of Criticism V: The Politics of Art, Part II," *Artforum*, January 1969, p. 45.

Kinetic Sculpture: George Rickey

By 1967, George Rickey who began as a painter, was devoting himself exclusively to kinetic sculpture. He had been given a large exhibition at the Corcoran Gallery in Washington, D.C., and the Walker Art Center in Minneapolis the year before. Having just published a comprehensive book titled *Constructivism, Origins and Evolution,* he was considered America's leading theorist on kinetic art.

It's interesting to hear how Rickey distinguishes his sculpture from other kinetic sculptors. Not mentioned is the fact that Rickey's sculpture is part of the sixties history of static modernist objects evolving into movement. Similar to the minimalists, Rickey employs geometric shapes and emphasizes the experiential and environmental. He is also part of a group exploring the potential of nature. A younger artist, Hans Haacke, continues this interest in natural elements, shifting it to other areas. (See Haacke interview).

Jeanne Siegel: *George, what do you mean when you say that you design with motion the way a painter uses color?*

George Rickey: Motion, which we are all sensitive to, which we are all capable of observing without having to be taught, is a sensation that appeals to the senses just as color does. It has an equivalent of the spectrum, different kinds of types of motion. I think that one can, to a very considerable extent, isolate motion as a visual component and design with that. And this I would consider fundamentally quite different from designing objects to which motion is then added.

Do you visualize the entire motion in your mind before you start making a piece?

Sometimes. But the same would be true of color. An artist might have a painting completely conceived in terms of color beforehand. Another artist might develop the color in a kind of organic way as he went

along. The same thing could happen with motion. Sometimes it can be designed in a completely preconceived way. Other times, with other circumstances, one might develop the relation of the motion the way one kind of motion relates to another within the work.

If you equate motion as a component with color, does the use of motion negate the idea of using color?

No, because one has to use material of some sort in order to establish the motion. There has to be something to be seen, and that visual part of the material itself can, of course, be black, white, or some color. And the parts could, in turn, be related in color. However, if the emphasis is on the relations of color, it takes emphasis off the movement. And I think there are some artists who have difficulty with this, who are designing in terms of motion and color at the same time and perhaps get confused.

There are a few occasions where you do use color.

I occasionally use color now, and in the past, when I was in a way closer to my experience as a painter. Because I painted for twenty years, I used color much more. And I thought at that time very much in terms of kinetic paintings where the parts, the colored elements in the painting, moved in relation to each other. But the color, of course, was itself fixed. There are other artists who work with color and motion where the color changes as well as the shapes of the colors.

When did you shift from making kinetic paintings to kinetic sculpture?

I started working with motion in sculpture in 1949. Before that I had made a few trial runs out of curiosity. But in 1949 I made a number of quite serious pieces and I began exhibiting kinetic works in 1950. However, some were with color and some without. The last pieces I made in which I had color relations as an important part were eight or nine years ago.

How is the motion conceived?

Perhaps I have several systems, several ways of getting into it. Sometimes it is an attempt to emphasize certain relations of vertical elements. I could do that in a very complicated way or I could try and reduce the elements to their simplest possible essence. And it is that which has led me into using linear forms, to try to eliminate everything that is not contributing to the movement. And, of course, one doesn't want machinery under these circumstances. A motor would immediately be something else, something extraneous to the movement, and I wouldn't want to be involved with any elaborate or expressive designs in the components to

reduce them so that only the movement was what was important in what the observer perceived.

The simplest might be a single moving line—if one combines that with a second moving line there is immediately a relationship in time. They would move together or they would move at different speeds; the directions in which they move, whether they cut each other, the question of the space that they enclose between them—all these become part of the design.

Usually your pieces barely pass each other without touching.

This comes out of an attempt to compress the action into as shallow or narrow a space as possible, so that the parts are brought into very close relation as they move. But I'm also interested in designing parts so that they come so close it appears as though a collision were inevitable, and then it doesn't take place, because that introduces a factor of tension. As they approach, and with the possibility of their making contact, and then failing to make contact, and then pulling away again, is perhaps an intensifier. It intensifies the effect and any kind of suspense of this sort also tends to make the observer more sensitive because he's paying closer attention.

If you are not interested in using any form of machinery, what are your methods for producing motion?

So far, I have used almost exclusively the movement of air, which means I have to make the components light enough and sufficiently low in friction so that the draft in a room or the movement of people around the room or breezes from outside are adequate to bring about the motion.

Are people supposed to touch them?

I occasionally make pieces that are meant to be touched, but in general I have considered that air was the motive power rather than the hand. I have deliberately made some hand-operated pieces, but, in general, if they're made to be moved by air, the hand, especially the untrained hand, is too heavy, and they won't produce the right kind of motion.

I've watched the blades move many times and I seem unable to remember from one passing to another long enough to assume that it's repeating itself.

I'm glad. Repetition soon can become boredom. I'm quite concerned that the motion should be sufficiently irregular, random, unpredictable, so that configurations do not repeat.

It's a very controlled kind of random.

The way in which the random action can take place is controlled, but within that it's left to chance. Chance is an important factor.

I am particularly interested in the reaction of the observer. Doesn't motion have a mesmerizing effect?

I am not trying to mesmerize. In fact, I remain rather indifferent to how the observer responds. And I wouldn't alter a piece in order to make it get at the observer better. I'm not studying the response of the spectator. I'm studying what happens in the piece.

What about the question of time?

As soon as movement enters in, as soon as the parts are no longer static, the element of time has to appear. And it is quite a positive, measurable component and it can be set up in infinitely different ways. You can make a single element go faster or slower, and there is no limit in faster except the mechanical limit of your means, and in slower your limit is when it becomes static again.

What limits do you set up in your pieces?

I'm interested in movement that is quite slow, because I'm concerned with relations of movement. And if the parts that are moving differently go too fast, the possibility of discerning the relationship diminishes, and when the movement is quite long, quite slow, then it is possible, to adjust, in a way, to design, to compose the movement in a more satisfactory way. If the movement is very fast, it becomes vibration and it almost turns into something else.

What kinds of movements do you employ?

I use the movements of the pendulum a great deal. I use rotary movements quite a lot, the equivalent of a spinning top or a wheel that's pivoted. I use a kind of see-saw motion quite a lot. I sometimes have devices that convert one into the other. It is possible to have a pendulum motion that will start something else rotating. And I'm quite interested in this relationship. But actually I use a rather small gamut of movements. And I find that there is a tremendous amount of potential in a very small number of different movements. It's not easily exhausted.

Is all this planned? Do you make drawings?

I make drawings. I plan a great deal. I think if possible I will draw almost a complete work as far as the idea is concerned. But the drawing is limited because it's only in three dimensions and I can't, without some

very complicated notations, draw what will happen when the movement has started. It's very difficult to draw where a component will go when it starts moving in relation to other components that are moving. It's easier then to make a model and actually move the pieces. It's much easier than to try and anticipate that in drawing. So I'll carry the drawing up to a certain point and then make a model that is in itself a kind of drawing in three or four dimensions.

Then you follow the model mostly.

Yes, often I will try to make the model very fast, so that I'm not wasting time at all on finished workmanship. Sometimes it's terribly flimsy and virtually held together with putty, but it will permit me to study how to make it and get the movement I am looking for.

Do you use any help?

All the help I can get! I need it. If I work, for example, on very large pieces where the components are too heavy to lift, I have to have somebody to help me lift them. On smaller pieces I assemble a great many identical elements. If I can get help in fabricating those identical elements, then I am left with more free time for designing how those elements go together.

I notice that you mark the surface of the stainless steel. For what purpose?

The steel when it comes from the factory, has been rolled into sheets and the surface is just a dull gray, lifeless surface. And as soon as you scratch that surface, it reflects light in its own particular way and it begins to become more interesting. So what I do, in effect, is simply to scratch up the surface with abrasives in a random way so that the surface, instead of being a dull uniform gray, has a haphazard quality of reflecting the light that falls on it. But the design that appears on the surface is not significant. I don't care how unsystematic it is. I want to avoid any systematic treatment of the surface. I just want to break through that uniform gray and have it become more lively in relation to light.

Are there any limits of size that become unworkable?

The problem is space. I've got a studio where I can put a component about 35 feet long from corner to corner, so that I get a limit of size on that account. Also there's a limit of size in what I can lift without machinery, even if I have help. But apart from those limits, one could go on up and up. The largest piece I've made so far has been a little under 40 feet high. I suppose one could quite readily make something double that

size, but the means for making it would have to change, and I would need lifting machinery to lift the parts and putting the parts together would become different because they'd simply be so heavy.

In your most recent sculpture you're working with planes rather than lines. Are there new principles involved in the planes?
 The principles are much the same and a line has a relation to a plane. If you move a straight line sideways you get a plane. It's a natural geometrical extension. And the lines, these narrow strips of steel, respond to air and move quite readily, but if one broadens the surface, the response is much more sensitive. One gets more movement with stiller air. So I've been interested partly on account of the use of broader surfaces, but also to explore the possibilities with surface where the space instead of being cut is pressed and squeezed.
 It's a different relation to space when one uses flat surfaces.

Calder suddenly comes to mind. He uses flat surfaces. Also both you and Calder have felt strongly about not using machines. Where do the differences lie in your work and his?
 At the very beginning he had motor-driven pieces. I don't know exactly why he gave that up. But rather early in his work with movement he hit on the mobiles, which were very responsive to natural movement of air, and he had no need of motors. I'm not sure that he ever abandoned motors. I think he simply found something that responded better.
 I feel that with motors there is danger—with a motor-driven construction there is danger of giving a rather obvious repetition of the movement—and then boredom. I'm interested in this randomness which is quite difficult if not impossible to develop with a motor-driven piece. But a lot of people have made a construction of some sort and then hitched a motor to it and it just cranks away at a constant speed and very soon it's repeating itself.
 I really have nothing against motors except that they tend to destroy randomness. There are some artists who have been very ingenious in the use of motors and keeping randomness as well. One of those is Pol Bury who uses motors, but has in a way interposed between the motor, the driving power and the kinetic result, devices, which introduce large elements of chance.

Also Bury keeps the motion down to such a slow pace that one almost feels that there is no machine. It's a little deceptive.
 It seems organic. They are motor-driven but he has devices that allow a lot of slippage between the motor and what is finally driven. And

25. George Rickey, *Two Planes Vertical Horizontal II* (1970)
By: Roxanne Everett, Lippincott, Inc.

the amount of slippage at any given place or given time is something that's indeterminate.

I felt a similarity of quite a different order; one we might call emotional. In Pol Bury's there is a certain creepiness, and your large blades strike a menacing note.

Your responses are yours. I've no desire to produce any kind of mood whatsoever. And I know that the shapes appear to many people to resemble aggressive shapes such as swords or knives. But I think it's just as plausible to consider that they resemble blades of grass or wheat or reeds. I can't control that. I have no symbolic intention whatsoever. And I don't think Bury has, but Bury did start as a Surrealist. And I think that he has probably a special affinity with this kind of creepy movement.

What about the childlike quality that one senses in Calder? When you first started, there was some of that contained in your work, and you seem to have moved away from that completely. Have you consciously tried to eliminate a toy-like quality?

I think Calder has something very playful in his nature. His playfulness is genuine and important; it comes out in his work. I'm not as playful, you see. Maybe I'm too serious, but that eventually comes out too, and I think that Calder suffered a little from being thought a maker of toys. Now his work is taken very seriously in spite of the playful character, but to begin with it was accepted for its playfulness only.

Do you consider your kinetic sculpture antithetical to Tinguely's?

These comparisons are difficult. He has a great sense of humor. He also has a sharp critical and satirical talent. And he can make machines that mock. They mock society; in a way, they mock themselves. He can take a machine and in a way make it ridiculous, and this is a gift. Tinguely is really an extraordinarily gifted artist but sometimes he is not devoting his talent, at its best. But he's young and very energetic and I think a great deal more will come from Tinguely.

But my own taste is not for a kind of rock-and-roll rhythm and the combination of movement with loud noise and firebells and pounding and banging. This is very far from what I'm involved with. But I don't think that that means that his work is not legitimate. It's simply a different part of the spectrum that he's working in.

Are there many young kinetic sculptors working in the United States today? It's my impression that the kinetic sculpture movement is primarily a European one.

Of course Calder, the great master, was American, but recognized rather early in Europe. And he lived in Europe. His antecedents were

Gabo and Marcel Duchamp. They were in it thirty or forty years ago. After Calder, around 1950, there began to be in Europe only a handful of artists working. It was the same here—only three or four people until maybe five years ago. A lot of the development is really rather recent.

There was a very large exhibition in Europe in 1961, first in Amsterdam, then in Stockholm, and then near Copenhagen. And in that exhibition I would say that the European kinetic artists probably outnumbered the Americans ten to one.

I know that you felt as late as two years ago that kinetic explorations were really in their infancy.

I still think that.

In New York in the last year there have been a number of explorations in other areas such as the use of water and light. I am bracketing all of these under the heading of kinetic art.

If there is movement, it is kinetic. That's the generic term. And I think there's an immense range of means available and of materials. I use steel, but I think that to use water is wonderful. I've dreamed a little of waterworks of various kinds but that is a very broad study in itself.

[After a visit to George Rickey's studio in East Chatham, New York, in May, this interview was conducted and broadcast on WBAI on July 5, 1967. It was one in the series "The Artist and New Media."]

26. Robert Rauschenberg, 1960s
Courtesy Leo Castelli Gallery

Multi-Media: Painting, Sculpture, Sound

This panel was the first in a series that signaled the new interest in the sixties in combining mediums that had, heretofore, been clearly demarcated. In 1964, two years before this discussion took place, Robert Rauschenberg showed his Combine Paintings at the Venice Biennale and shocked the art world by winning the gold medal—the only American ever to do so. Sven Lukin was included in a show, "The Shaped Canvas," held at the Guggenheim Museum in the same year. In 1965 Larry Rivers had a retrospective exhibition at the Jewish Museum in New York. Dr. Irma Jaffe, a former Whitney Museum Curator, was Chairman of the Art History Department at Fordham University.

What becomes clear are the artists' divergent positions. Rauschenberg articulates, in an especially perceptive way, the dissatisfactions of the artist with painting as an isolated activity and his personal struggle for new solutions.

Jeanne Siegel: *Bob, in your work titled* Bed *you attached an actual pillow and patchwork quilt to a board, which gave the painting the projection of a relief. Then you overlayed this with multicolored paint drips and splotches. What is the relationship between the real elements and the paint? Why didn't you just paint a bed?*

Robert Rauschenberg: It wasn't programmed to be a bed painting. I was simply using the patterns that were already in the quilt as some sort of a challenge or threat—seeing what would happen working against or with them. And I wasn't doing very well. The quilt had so many nostalgic connotations that it remained much more direct than any of my actions so I thought the only thing to do is go along with that. So I added a pillow. Then that turned it into a neutral surface and it worked for me as a painting from then on.

27. Robert Rauschenberg, *Bed* (1955)
By: Rudolph Burckhardt
Courtesy Leo Castelli Gallery

Larry Rivers: When you did that, I was wondering if you were as interested in the bed or was it like you were changing what to paint on. A lot of times I thought that, for instance, perhaps you were given a table or someone said "Here's a radio, Bob, work on it."

Rauschenberg: It was what to paint on mostly. I didn't find it too different from when I went from all black paintings into colored paintings. I used to size my canvas with funny papers so that I'd have a live surface there already and this was in an attempt to recognize the painting from the very beginning as an object, as opposed to the theory that you began with an open surface ready to receive whatever you do to it. I consider that the painting begins with the stretchers or possibly even walking across the room to start it.

Siegel: *Does the same hold true for the constructions?*

Rauschenberg: More or less. I called them all Combines. I had to coin that word because I got so bored with arguments. I was interested in people seeing my work. When someone would come up and I really wanted to know what they thought of it or wanted to sense the exposure, there was always this screen that they could get behind which was, if I said "It is painting," they would say, "That's not painting, it's sculpture." And they thought this was very interesting or else it was a very good way to get around the question of looking. It gets a little complicated now because now when I do drawings people call them Combine drawings and the word "combine" really refers to those things that somehow exceed the traditional or the former definition of a painting.

Siegel: *Larry, you use sculptural elements in your paintings also, but you hold them to the level of a relief. Can you explain the difference between your use of these elements and Bob's?*

Rivers: You mean that, in other words, anything away from the flat surface would be called sculpture and if you don't go more than six inches it can be called relief? I did sculpture before I began introducing sculptural elements into my paintings.

Rauschenberg: You did sculpture before painting?

Rivers: No, I mean I did them separately and then as the years went on, I realized that one of the things I liked when I got into sculpture was that it took longer. It sounds silly to say but it used to take more of my day

and I'd work at night when I did sculpture. And when I think that as the years went on it just struck me that I'd like the idea that it was more complicated.

Siegel: *Sometimes you use the same theme for both a sculpture and a painting. In which one does it appear first?*

Rivers: It's just a certain preoccupation. At any given point you don't have too many ideas. I would keep changing the way I would do things, like in the *Webster Cigar* piece. I knew certain elements of this work that would be a kind of gateway with the word Webster on it like things over graveyards or very expensive estates. When you come up to them, they have that kind of arch. There was that element. And then there was a man. And then there were some flowers. I would just keep working them in different ways. I think that the theme thing is very old in modern art.

Irma Jaffe: It seems that both you and Bob arrived at the forms or images that you're making in rather a pragmatic way—that you had certain images that you wanted to express but that you arrived at them through almost a trial and error system of using materials. In general, from an art historical point of view, we would connect your work with the beginning of this century—with the Futurist manifesto—where they said we should forget about marble and bronze and paint and anything can be put together to make art. Would you say that consciousness of this concept as it was enunciated by the Futurists had played any part or would you say that you had never heard of this?

Rivers: Certain things are in the world in so many different ways that you didn't have to read it—you're just sort of aware of it.

Rauschenberg: I came at it quite negatively and that's through a lack of being able to be converted to the wonders of paint. I found myself looking for other materials or not being able to get involved in the self-indulgent mysticism—in self-expressive qualities that paint, per se, had. Or it may have been out of a clumsiness and inability to use paint that way. Nearly everything I did looked like a splash, a smear or a drip, you know, a brush mark. I was unable to divorce paint, as it was traditionally, from the fact that it was just another material. Paint has a character, a quality, it has a physical, recognizable body and I just couldn't cultivate in myself that other kind of illusionary quality that I would have had to have believed in in order to have gone in a different direction. I had the same trouble with canvas. I stretched the canvas—I knew what it was—it's a piece of

cloth. And after you recognize that the canvas you're painting on is simply another rag then it doesn't matter whether you use stuffed chickens or electric light bulbs or pure forms.

Siegel: *Were you inspired by Duchamp?*

Rauschenberg: I'm inspired by the man and I have a natural affinity for objects so that I think that we have that in common. I appreciated his punning and humor but actually a lot of his works are extremely literary and my personal appetite doesn't go for literary works. But I like it in *his* work.

Rivers: I don't think you are like Duchamp at all. You work very hard, don't sit around thinking of one idea and living fifty years on it.

Rauschenberg: Duchamp is a thinker whereas, actually, I am distrustful of any single thought that I might have and so I have to do them in order to see if that's an idea—like taking five canvases and taking exactly the same material and making five different pictures out of it.

Sven Lukin: Duchamp's are really singular things. Every object is perfectly displaced and very much by itself.

Siegel: *What about Picasso's constructions?*

Rauschenberg: I didn't see Schwitter's or Picasso's until I actually had started working the way I did. I don't mind admitting I had a few setbacks because you get the creeps when you see something and you look at it and it was done a year before you were born. You think, well, there are other jobs I could get.

Siegel: *Sven, your recent work has been referred to as a Shaped Canvas. Exactly what does that mean?*

Lukin: It means that the canvas, rather than just being flat, is shaped. It is stretched over an armature or in other cases I have introduced other elements that project out from it. For instance, in a few of the pieces the point was to have the projection come out of the canvas and involve the floor and in that way involve the whole space. And the canvas itself actually becomes like a kind of environment.

28. Larry Rivers, 1980
By: Dorothy Beskind

Siegel: *What is the difference between these paintings in which elements that hang from the surface on the wall extend to the floor and a Combine like Bob's where a chair hangs from the canvas and also rests on the floor?*

Lukin: There are similarities in the fact that these are three-dimensional elements that we use. Mine is, in a sense, a Combine because it does have these different parts to it and I actually combine them. The difference is that Robert uses random elements, found objects, while I make mine. My work seems to be much more lonely than his because he can engage in the whole environment and use anything.

Rauschenberg: Yours is a lot more dramatic with your pure use of color and of simple forms.

Lukin: What I, in fact, do, is I just design in color, whereas I think when you choose objects at random, you have so many more possibilities of making a piece.

Rivers: I think the important part is that you want to be more perfect. You'll take one little part and carry it out almost as if you're interested in the detail and you concentrate on that detail until you finally have it exactly the way you want it. It wouldn't just be enough to be there the way Bob puts it in. You'd have to trim the edges, make sure that it goes from one point to another in a certain flat color. When you make it turn you make it turn on all sides.

Siegel: *Isn't one of the important distinctions that Bob differentiates between or contrasts the paint and the object whereas Sven's is a continuation of a similar form.*

Lukin: I think of my things as being very articulate, in the sense of the object as an image. It's an immediate image, and the fact that it's three-dimensional is very important, but it could have been a flat image, but the thing is that it evolves from that flatness into this.

Jaffe: The question here is the difference between the integration of all elements subordinated to a single image which is what you do, Sven, and the other concept, which is relatedness instead of integration. In other words, Bob and Larry make their images of parts that are related to each other but keep their own identities and remain themselves at all times.

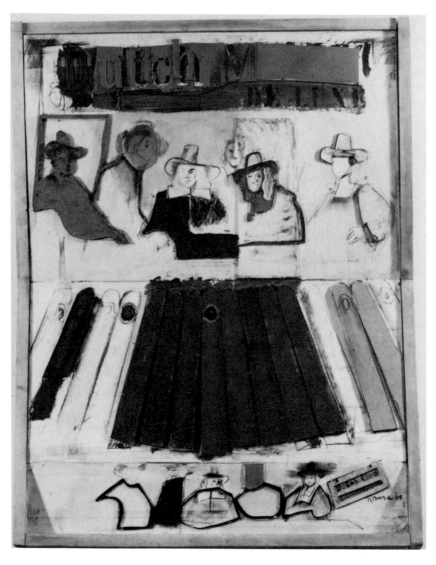

29. Larry Rivers, *Dutch Masters*, ca. 1960s
Courtesy of the artist
Collection of William Dorr

Rauschenberg: Actually, it is apt to work the other way. I'm more apt to use two elements taking advantage of the fact that they don't have a relationship except in that work. I mean that the relationship is not known.

Jaffe: But that is still random.

Rauschenberg: Not completely random, because it's a matter of opinion too about whether they're related and you are dealing with either your own personal experience or an assumption about other people's thinking.

Rivers: My images are more stories in the sense that in subject matter you're not surprised by what you see there. Say, for example, in *Russian Revolution,* you would think that what you see there would go with the thing called the Russian Revolution.

Rauschenberg: There are very few absolutely arbitrary decisions there.

Jaffe: That is not exactly what I meant by relating this, although it's a factor in it. What I mean is even what I find when I look at Bob's work. In other words, two objects that have no relationship in real life, have been brought into relationship with each other by your act, therefore they are related but their relationship does not entail any integration. You haven't altered the pieces by bringing them into relationship, whereas Sven's image depends on the whole image being grasped as a sum total in which the whole is greater than its individual parts.

Lukin: I think that also has a great deal to do with the kind of process that is involved. When I make a piece it all happens in the drawing stages really and then it's just a matter of making it and blowing it up.

Rauschenberg: He works inside whereas I work outside.

Lukin: Your work is much more biographical in that sense than mine. Larry can put himself in the picture and so can you.

Rauschenberg: But I think you and I have more in common with our use of sculpture in painting than Larry because both of us are involved in an open disbelief in illusion.

Rivers: Or you allow other people's illusion. You'll introduce illusion as long as you don't make it. For instance, you'll include a photograph of oranges—that's an illusion of oranges. I knew that they're oranges.

30. Sven Lukin, late 1960s

Rauschenberg: But that's a well-known illusion.

Siegel: *Larry, in your new* Don't Fall *series you apply pieces of metal and plexiglass—layers of plexiglass that denote the dimensions of the face and the cheek and the hair—one is actually on top of the other, are they not?*

Rivers: Yes, like forced perspective. In other words, your nose is in front of your cheeks so if I made your nose, I would bring it in front of your cheeks as if it were like I was making a painting of a nose, but I would be aided by the fact that physically it was more forward than your cheek.

Rauschenberg: What's interesting for me is the fact that those two actions have contradicted each other. You painted as though you were painting three dimensionally—as though you're painting it on a flat surface to insist that it be read as a nose and, in fact, you've done another act which is to put it on that plane literally.

Rivers: So that it's double. It's certainly going to be in front of the cheeks, even if you painted it wrong. What comes up is there are all sorts of combinations. The nose can become part of the forehead. You get a piece of plexiglass and you do the nose and then this part of the forehead. Now, should the hair be a piece that's in back of the forehead or forward? Actually, it's still in the back of the nose, so if you put the hair on another layer, what have you done? In other words, where is it? I don't know. I find that the combination of these problems seems interesting.

Lukin: So you think of it as a three-dimensional element and also a painterly illusion of the thing at the same time.

Rivers: You two have something in common in that you have this object but somehow it has to have a home base. You just don't put the object—you attach it to this picture like you crept slowly out of the picture.

Lukin: With me it has to do completely with giving it a home. It is its environment and whatever projects from it is naturally scaled to that thing.

Rivers: But in one more step you would be in the thing like Tony Caro, wouldn't you? If you took away the part that it comes out of—it would be just like free-standing sculpture.

Lukin: That was the first step after I made the first shaped canvases, and the first ones I still improvised with, because I really didn't know anything about carpentry.

I didn't even know canvas could be stretched like that, but once I did that the next step was to make a painting on legs, which I did. That's the only time the Whitney asked me to show at the Annual, which was a sculpture *Annual,* but I never thought about it as a sculpture.

Rauschenberg: Have you done things that you call sculpture?

Lukin: No, I think of them as both and neither. I think of them as sculptings.

Siegel: *You call yourself a painter.*

Rivers: Because you began as a painter. To me all those things are silly.

Rauschenberg: Bob Morris is a sculptor and I most often refer to him as a painter. But it doesn't matter. You may as well just call somebody what they would like to be called.

Siegel: *Speaking of being called . . . Larry, you were a jazz musician before you were a painter. Have you ever used sound in any of your work?*

Rivers: Very rarely. I feel like a crotchety old man but actually, I don't like sound in that situation. There's always sound. The only time I've used sound are in my collaborations with Tinguely because he makes pieces that move.

Rauschenberg: In *Oracle* I used sound as a sculptural element. I thought of the sound as moving out from the different pieces, being a continuation of them—each voice, like the voice that each piece had, was distorted and affected by the shape it was in and the way it was installed. It was directional. You could close your eyes and walk around the room and you would know when you had just run into one of the pieces, without touching it. In *Broadcast* I used sound as a painting element, not as a sculptural element.

Rivers: What do you mean?

Rauschenberg: I used the sound to bring in more content. It was like a sound collage, so that as you were confronted with this flat surface—I

don't know, I just think it was a difference in thinking about it and I think it works that way: when you were confronted with the piece, that the sound here, changing from one corner of the painting to the other, draws your attention to that area and then it's switched off to someplace else and it is also affected. The particular sound you have heard has affected the way you have read whatever image or color that you were looking at when you heard these words. And I really thought of it then as completely painterly.

Rivers: I was thinking it would be an interesting experiment to take some-one else's work and do a version of it.

Rauschenberg: You mean like Elaine Sturtevant?

Rivers: No, I was thinking this: let's say you did most of the work. You said you saw the sound as a painting; I was thinking immediately that if I did sound, I would have what you're listening to—it had something to do with what you saw, you see. But you're not interested in that—you always have them flipping off. The same with Tinguely. The radio thing never would be long enough for you to be able to follow any kind of sequence.

Rauschenberg: Well, you're a thematic, mood type.

Rivers: Thematic, if I understand the word.

Siegel: *Have any of you been involved in filmmaking?*

Rivers: I'm dying to make a film but I can't seem to get it done. I'm doing one called *The Bronx Zoo* with my son. It's, again, autobiographical be-cause I lived a few blocks from the Zoo most of my life and I used to go there every single day.

Rauschenberg: I took some travelogues and reworked them to use, not for making a movie but to use as material in some of the dance/theater pieces I've made. But talking about theater, I think that I got very frus-trated—it's been building up—about the fact that painting seemed so static to me. I'm sure that's why I came out all over the room and I forced it back and worked on some sculpture and . . .

Lukin: It's really an extension of your work. It's almost like activating one of your paintings.

Rauschenberg: My interest in it is that. I'm not interested in just changing mediums or doing that. I just feel more comfortable until I can figure out how to get the kind of flexibility and the lack of staticness in a work— which would be a painting or sculpture combination, or neither, something closer to that than theater. I feel like this is a learning process; the very natural condition that I am working in.

Rivers: Maybe you can't be alone. You are unable to be alone until you are safe. I don't know how old you are.

Rauschenberg: Actually my paintings have always been very sociable. They always related just as much to what was going on in the street as readily as they did to my ideas about it. I have a real fear of an ivory tower type situation. And I think when you are an artist the dangers of falling into that are really quite great. You would spend most of your time dealing with abstractions, as though they are natural live facts for you. And also the role of a painter, socially, at least historically, produces a climate which would make it very easy for you to be excluded from ordinary type activity. I find painting a very ordinary kind of thing to do.

Rivers: What do you mean? What the average man on the street thinks?

Rauschenberg: You find two extremes usually as clichés. One is that, "Oh, you're a painter? Isn't that wonderful. You're sensitive. You've got all these wonderful, beautiful thoughts" and the other is, "You're a little crazy, aren't you?"

Siegel: *Could you conceive of moving on to another medium and not returning to painting?*

Rauschenberg: I think it could happen but I couldn't program it. I really couldn't, truthfully.

[This panel with Lukin, Rauschenberg, and Rivers was conducted and broadcast on November 21, 1966 on WBAI.]

32. George Segal with his *The Gas Station* (detail) (1963).
By: Nancy Astor
Courtesy Sidney Janis Gallery, New York

Environments and Happenings

The artists on this panel—Allan Kaprow and George Segal—began their careers as painters. By 1958 Kaprow had created his first Happening. Segal, who like Kaprow first showed at the Hansa Gallery in New York, was exhibiting his plaster figures at the Green Gallery in 1960.

By the time this discussion took place, Kaprow had made Happenings his "chosen area" and he would later become known as its founder. Segal had staked out "environmental" space but was questioning the kind of active participation on the part of the viewer that is to permeate a great deal of the art of the seventies.

Jeanne Siegel: *So many painters and sculptors have performed in Happenings, Allan, how did that come about?*

Allan Kaprow: It's very simple. We knew nobody else and so it was a rather natural thing that each artist who wanted to become involved in performance of some kind should himself do it and ask those of his closest friends to help him out and it actually happened just that way.

George Segal: I performed in one of Allan's Happenings several years ago in Philadelphia. This was a Happening close and dear to my heart. It was one involved with chickens. I'm only incidentally a performer in Happenings, and only because Kaprow and I have had a long friendship—about thirteen years. We spoke and argued a lot and both of us, in a sense, were at an impasse in our own work. I was incredibly dissatisfied with my own painting. I was wide open for a complete change in attack.

Siegel: *How did you arrive at this impasse?*

Segal: I painted for a long time. My teachers were the Abstract Expressionists and I had a very schizophrenic attitude, I suppose, toward the

whole thing. I was enormously impressed with the vitality of abstract painting, really enjoyed the personality of these men, but I found that I couldn't quite swallow, in practice, things that were being told to me. I was painting large canvases and they looked rather abstract but I kept insisting on a figural element. I was painting life-sized figures. Some of them were dense and modelled as you would see in a Renaissance painting. They looked like they weighed three thousand pounds. Other figures floated, wafer thin, in the air because I was trying to obey some kind of injunction about preserving the pristine purity of flat space. Here I was trying to paint, and I was delivered certain recipes. Keep the integrity of the flatness of the surface, somebody said. But then somebody else said, oh, regard the tension, the implied psychological tension between the two and three dimensional. Every time you make two marks on a flat surface you can read it three dimensionally.

So I said, what the devil is the whole big deal about. Is it about the implication in reading it? And Cubism. Cubism, I really admired, for instance. And what struck me about Cubism was somebody picked up a cup, turned it around in his hand and read all the planes and translated them, for some arbitrary reason, into flat, almost transparent planes and put them down. And nobody ever mentioned Cézanne's magic. What was the formal magic that accounted for his stretching out a nude ten feet long and making the river half a mile away look like it was three inches deep. Why did Cézanne do all that shuffling? Nobody ever explained that. And it began to dawn on me that all these men were very stubbornly looking at the world their own way and that fancy word style had to do with a strong-minded guy deciding this is how he wanted to look at the world. I decided that I didn't understand anything about flat versus three dimensional space and why not use real space, and if a Cubist painter was picking up his mandolin or his cup and turning it around in his hand, I could walk around an object and examine it and see it from many points of view. So I went into sculpture and I deal very intensively with environment, total environment.

Siegel: *Allan, you went from Environments to Happenings. How did that occur?*

Kaprow: What happened was that a fairly simple growth took place from the collage to the giant action collage to the use of denser and denser material until it became a giant assemblage that grew and grew until it filled the room. Naturally people had to move within the parts in order to experience it. And as they did that, it became apparent to me that they were components, whether they knew it or not. I hadn't figured on them,

of course, and in order, now, to acknowledge their presence as integrals of the thing I began to score parts for people in such a way as to provide a maximum of flexibility, from almost passivity to a great deal of responsible activity. So there you have, in a capsule form, the growth of the Happening from collage or from action painting actually, to an emphasis on action without the painting, but it passed through the collage idea.

The word "environment" is something that no one can lay claim to as a style. I began using it in the fifties in regard to my own work after I had read critiques of Pollock and others mentioning their work as essentially environmental in scope.

Siegel: *This notion of people moving* within *the parts appears to be a shared idea between you. But Allan carries the idea of spectator participation the furthest.*

Kaprow: My concern from the very start of what I consider my chosen area is to absolutely put aside the whole concept of spectatorship. And maybe in the end by encouraging an optimum of participation on different kinds of levels by all who wish to be involved in my work, I can then look to that part of participation which is indeed naturally onlooking, that is to say which is really an act of spectatorship, in a new way.

What I'm referring to is that as I began to sense it, perhaps rather exaggeratedly because of the way I am, everything that developed in contemporary painting and sculpture induced a greater and greater degree of passivity on the observer's part. It either overwhelmed him in the form of great big paintings of the Abstract Expressionist era or it immobilized him by an extraordinary degree of intellectual demands as, for example, in a whole line of work from Mondrian on, which I admired equally well. So I was torn between desiring to engage in the action of Action painting, without any painting left over, and a desire also to be immersed in this kind of abstruse and, perhaps, almost mystical mental activity of the puristic thing. Now this is sort of schizoid, but you can't have your cake and eat it. So I decided that I could move faster than I could think, so I began to move. And yet I realized that the more I moved, the more I encouraged others to play, in effect, a game with me of movement, the more necessary moments of rest became and moments in which one could look at movement and things being done around one. So this was, perhaps, spectatorship on a more necessary plane. It wasn't being spoon fed. It wasn't passive spectatorship. So I tried to work into my thinking moments of rise and fall, of quietude and activity, where the same person who is looking at one moment would then find it possible to act and then return to looking, rather than having it only one way.

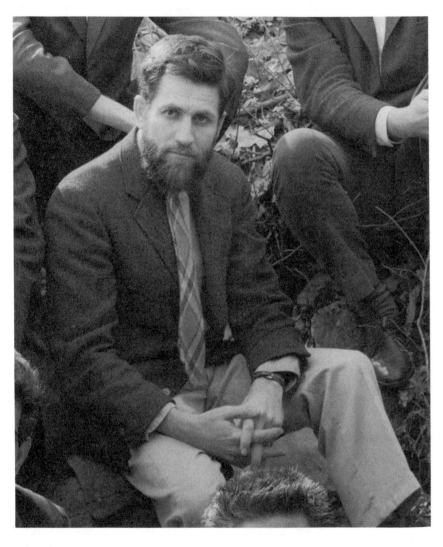

33. Allan Kaprow Surrounded by Friends, 1963
By: Hans Namuth

Now this may have been disillusion to my being attracted to two different kinds of awareness. So if we are going to compare George and me, I suppose I'm attracted to his work in precisely those terms that I was attracted to meditative stuff in the first place—that I can rest from my own activities very comfortably in his environment, while feeling perfectly free to move into my own in the next moment. And he's participated in my work, I suppose, with something of that kind of freedom to act and not at another moment.

Siegel: *Participation is inevitably bound up with chance, and yet, common to you seems to be a strong element of control. For instance, George, your sculptural groups appear to be very carefully placed, measured very closely in terms of distance.*

Segal: Absolutely yes. This whole idea of what you call spectator involvement or say, the way Allan wants to do a Happening, where he wants the people participating in the work and then he would give them a chance to stand back and contemplate; I am much more intensely interested in contemplation. I am much more interested in an intensification of an interior state of mind. Leave people free to wander through and see it from many different points of view. But I don't have the religious kind of faith that every man is an artist, or that every movement or gesture is beautiful. I have seen people behave very nastily and become ugly at Happenings, swayed by their own hangups perhaps. And I'm going to sound very retardataire but I'd like to be able to carry my own work to as concentrated a point as I can and offer as rich a gift as I can for people to enter. And they are free to stay as long as they want, wander around, get what they can. I don't want to interfere with their free willed movement.

Siegel: *But in a certain way you do in many of the pieces. The figures are often attached physically to an object or piece of furniture that is fastened to or near a wall. In this instance one cannot walk around the entire work. In that sense the spectator is restricted. If not that, there is something in the very nature of the image that acts as a psychological barrier.*

Segal: I try to compose all the space around and within the piece. That means the character of the empty air as well as the character and texture of the solids. You may call it abstract play if you want. I'm more interested in weaving as many levels together as possible. If they're attached to the wall, and pieces project, people can still walk in. I don't generally allow people to rearrange things after I step in. I like to set the pieces, their distances, and relationships.

Siegel: *It appears that in a Happening improvisation plays a large role.*

Kaprow: I've never made much of improvisation at all. I define a param-
eter of activities, usually in terms of imagery, such as it's raining and you
get wet. I might add to this set of images further limitations such as it's
raining in the country or it's raining in the city or it's a cloudburst or it's
a sunshower. What you are required to do in that circumstance usually
isn't further defined. So that the aggregate of images is as simple as all
that. Now the control doesn't consist in allowing more or less improvi-
sation on a theme or role, but rather the control which is arrived at in
many different ways. Some of them, chance methods which I use fre-
quently, consist in defining how many activities there shall be out of a
number and define further when, over how many days or hours or months
and where. Beyond that, I leave it pretty free. Now, this is a heck of a
lot of control. It's selection in the long run no matter what method I use,
whether it's my taste or a method that seems apart from it. And so I only
ask that whatever is the final rule of the game, that it be pursued and
followed devotedly.

Somebody else can control things in a different way, and it can strike
us socially or psychologically quite strongly in that different way. You
can see control as a whipping of people into line if it's carried in a certain
social manner. In other senses, it feels as though the work itself demands
a certain respect and that control is okay. We are willing then to step into
line with it. To some extent it's almost a worshipful state and we feel
thankful that such demands are made on us.

Many of the arguments that go on in the art world now are in the
area of control. Should it be? And if so, how and in what way? There are
those who try to get rid of controls in the spirit of democracy. Then often,
as George said before, in the process, people become ugly because they
get mad at the artist for having left them hanging without anything and
unconsciously they start hitting back in the work which they become
part of or its environment—sometimes to such a point that they destroy
things. Or it brings out the worst in them and they get mad at the artist
for having been placed in such an embarrassing state that their worst side
comes out. Often I've seen a kind of reversal in tactic take place when
an artist will set up extremely limited circumstances so that won't happen
again, and he might become dissatisfied with working in such a small
range and open it up to try it out once more, and this vacillation between
letting go and holding back seems to be a pervasive kind of interest in the
environment which after all, includes people.

Siegel: *Are the conditions that you have just described true of all Happenings?*

Kaprow: No. Of the three major types of Happenings, the first is the theater type that is different from theater only in its materials and content, but where its locale is the same as the theater and the set up of an audience and stage is usually consistent with conventional theater. It follows a range from very very intimate cellar-type affairs like cock fights to extravaganzas such as we'll probably be seeing in the armory shortly.[1]

The second category is what I call "idea" Happenings, that is, they don't have to be though they may be performed, and they're usually of a very miniscule kind, though you have to get to them by virtue of either reading about or hearing about them, something like an extension of the emperor's clothes. To my mind the best of this kind of happener is George Brecht who sends little printed cards to his friends from time to time on which there are only a few words. For example, in one called *three aqueous events* the title was written in small letters in the center of this little card and was followed by a dot saying, Water. And next, underneath, it said Ice, and the last dot was followed by Steam. Now you can muse on this, think it entirely in your mind, sitting on a chair or walking along the street. You can think about glaciers, you can think about drinking tea and the kettle steaming on the stove, about pouring water from the tap, or you can actually go out and buy a hunk of ice and chop it up and make cool drinks and go up north to the edge of a glacier somewhere and do it there. In other words, the extent of possibilities here is enormous. Most of the time, however, it seems that they are simply thought about.

The third kind, the one that I'm involved in, is what I would call a "participation" Happening. It has a number of forms, like the Pied Piper form in which people are led through cities and all kinds of places, cellars, or elevators, by a kind of guide to events that are scattered over a number of locales and times, extending for several weeks or months, in scope. And the implication there is that you could have a lifelong Happening. But all the participants know about the plan in the rough form that I have described beforehand and they agree to participate, mixing the events in and out of their life. Well, these three, of course, spill in to each other. And they have lots of variants all around. And those variants have become apparent to me in the last few years, when I have begun to correspond with people all over the world who have come to the Happening form very often quite spontaneously and without knowing about others.

So if you've got, from the original New York group, many who have briefly involved themselves and gone on to their form of painting or sculp-

ture again, having been renewed in that probably through this interlude, you've got countless others who have come into the movement since.

Segal: Isn't it true that a lot of the impulse behind certain kinds of Happenings has to do with some kind of wish to transform the nature of the person whom you bring in as participant? There's a lot of mixture of social messiah, of religious transformation, satori insight, and like all these things that go on in the stated wishes and dreams of the people who make Happenings. I think that if somebody has an impulse to be an artist, he is primarily an image maker. That's the one thing that should precede all the talk of a means.

This enormous permission to utilize any and all material of the real world—now that can be used any blasted way any artist chooses. No two artists are going to choose the same kind of materials. Ideas of collage, using fragments, the whole idea of multiplicity, interchangeable parts—all that stuff has been incorporated so that it depends on the vision of the guy incorporating it. But again, what's the quality of the image? I still think that there is this ruthless hunt for quality, and artists still somehow, in one way or another, are image makers, whether they are static, kinetic or they take place over a period of time as in Happenings. Happenings are difficult as the devil to photograph because very often the cameraman was not a good enough artist. Or was the artist not strong enough to make that image apparent?

Kaprow: In relation to the point that you brought up of taking advantage of the environment, which in this case is the spectator or other person, I remember very vividly the first environment, in fact, I think it was the first work of Bob Morris's that I had ever seen, which was done in Yvonne's[2] loft where I recall we were sent an invitation to come up to see his work and I climbed the stairs of this loft building, floor after floor, and ended up way up there near the roof. And the big metal door, painted battleship grey, was ajar, and I thought that was unusual since most of the time when I came up to a performance there I had to knock. So I opened it rather quietly and I saw to my utter surprise that the loft wasn't there any more. Instead there was a tunnel which was conforming to the actual size of the door and it turned around to the right suddenly and it was like in Alice in Wonderland when Alice went through a little door into another world and so I became enchanted with this. I didn't hear anybody. I said, "Hello," and nobody answered. And I decided, I'd follow the part that was also battleship grey and I turned to the right and the passageway got smaller and smaller and smaller very quickly as though the specter suddenly was rushing at me rather than receding until I ended

up squeezed in between the wall, seeing the thing finally disappear a few feet to the right of me into infinity.

Now I was delighted with that constriction of my movements. I felt that there was something very mysterious and kind of childlike about it that really moved me. It could, however, be construed quite differently by someone else, and, in fact, my friend of the evening who came along had a tizzy of a fit. He said, "How dare this guy do that? What kind of a leg is he pulling? He's just taking advantage of people."

Siegel: *It would seem that silence is very important to both you and George. The use of sound has been rare in your environments, hasn't it George?*

Segal: I've been avoiding sound, but in one particular piece a girl was literally lying on a mattress in an alcove that was an attic corner and she was listening to music with a real hi-fi set and a chosen record. The form of the music, by the way, this obscure Vivaldi oratorio, which sounded like Gregorian chanting, had, in my mind, something to do with the extreme whiteness of the entire piece. And the underlying implications of sensuousness were strong, and the music walked right into that. So the sound was there, but I couldn't separate the sound from the meaning of the entire piece so I used it.

I'm working on a movie marquee now with 288 light bulbs that blink in a certain sequence and the electric control that I rigged out of second-hand parts from Canal Street makes a sort of terrible clatter and I don't like the sound. I'll either have to muffle it or get a new control. I am very concerned with the quality of sound, either having it or not having it or exactly what's there. I think it depends on the specific piece I'm working on.

Kaprow: Maybe Jeanne was referring to the effect of the work of silence rather than the presence or absence of actual sound.

Segal: Quite so but there are many works in the plastic arts field which have no literal sound but are awfully noisy. I'm not talking psychologically—I'm talking literally. I'm talking about literal sound. You can say that the color red feels like a trumpet blast—but even that's not true. If you want a trumpet blast—use a trumpet blast because everybody reads everything differently.

Siegel: *Allan, what is the connection between the various sounds in a Happening? For instance, in* Gas[3], *on one morning we heard the pounding of oil drums while in the afternoon we listened to rock and roll.*

Kaprow: In this particular set of events there were six in all of which two occurred on the day that you mentioned. They were interchangeable,

actually, and were set up on the days that they were merely for the convenience of us all. And each of these days had a limited number of images so that the sounds were produced mostly because of the activity. That is, I never thought that a sound would necessarily illustrate a mood or reinforce an idea and therefore I never sought a sound to go with an action that had no sound. I simply let the action make the sound that it normally makes. So if we had a parade of oil drums, then turning them over, end over end, constantly produced a lot of racket. And that suited me fine. If I had some other elements to make more racket that I could have gotten hold of easily, I would have done that too. I like lots of noise and that seemed a perfectly nice way to make it.

The rock and roll band was supposed to have been actually balanced by another rock and roll band. It was supposed to have been consistent with noisemaking only in that the two bands were scheduled to play on the beach by a time score that they made themselves respecting not one another but simply their own score or whatever repertory of pieces they had. They didn't all play the same piece at the same time and they were supposed to turn their amplifiers up as loud as they could, to mix in with the waves and the kids screaming and dancing and everything else that could have gone on naturally there. As it turned out one band had a fluke in its electrical circuit and couldn't play. This made it, from my point of view, somewhat more musical than I had in mind. Yet I enjoyed it. So the consistency is not so much a formal beat that you get by turning barrels over and over or the beat in rock and roll but rather of lots of loud noise on one day and that's what the day demanded. And don't for a moment suppose that the waves didn't contribute to that too.

Any thematic relationship of a formal kind or of an idea kind or an emotional kind can be seen in these things, I suppose, after the fact. I can analyze them as having a cohesive structure in older art terms, but I never set out for that. I'm easily disappointed when I see that sort of thing, and I try as hard as I can to get rid of it next time.

Nevertheless, in formal terms, haven't you drawn a parallel between the structuring of a Happening into compartments that function simultaneously and the kind of divisions or compartments you might find in a painting by Bob Rauschenberg?

Kaprow: There's probably a similarity. It seems to be a pervasive taste juxtaposed, without trying to interrelate too much. The general tendency seems to be almost a mid-twentieth-century style. It's a thinking process that is natural or not.

Segal: That's assuming that there's a mid-twentieth-century style that comes out of collage or that that's the only way to look at the world. When you use the collage method, you've got a piece of this next to a piece of that and you juggle the sizes and you relate them visually but you wipe out any literary or psychological knowledge. You stick yourself up here in the air and look down at the earth, pick up all the fragments, like there's that busy earth going around. It's as if when something happened, somebody would say, "Come to the window," and you see the lights flashing and a horn honking down there. You collect all these fragments that all happen at the same second in time, but they all have their own coherence. That light is flashing because somebody has a parking garage and he paid a lot of money to put up that light to attract the customers. Somebody got cut off by a taxi and is mad as hell at the taxi driver and is blasting his horn—that's why the horn blew.

So that even the famous mid-twentieth-century collage method is open to question as a way of looking at things. It's not entirely necessary to use only juxtaposition. In my work I try to weave another kind of totality from internal landscape—the inner attitude of a person. There is an entire inward concern which I try to weave together into a social concern. What's the relationship of two people to each other and then what does the whole thing mean?

Kaprow: Obviously the collage method is not the only way to look at things because there is an equally strong tendency to, instead of juxtaposing a variety of different kinds of elements that may or may not have personal meaning to the artist as he knows it, extend essentially unmodulated fields or unmodulated forms as far and as long as they can. Now this induces a whole different sensibility and thought process and I'm sure there are probably different motivations for doing it amongst the people who do. I imagine Bob Morris would have a good deal to say about this. Dan Flavin seems to me awfully Christian in his blank light, and that's very uncollagey.

Siegel: Certainly many artists think that collage is one of the modes that are available to them which is almost like a piece of material now. But it seems like both collage's juxtaposition and minimalism's extension are certainly possible. It doesn't seem to me in any way unusual that both of these things are going along simultaneously.

[The panel discussion among Kaprow, Segal, and me as moderator, was conducted and broadcast on WBAI on December 13, 1966.]

Notes

1. Kaprow is referring to "9 Evenings: Theatre and Engineering" that took place at the 25th Street Armory, N.Y.C., in October 1966.

2. Yvonne Rainier, dancer and choreographer.

3. A Happening that took place in Easthampton, Long Island, on August 6, 7, and 8, 1966.

34. Claes Oldenburg
Courtesy Leo Castelli Gallery

Claes Oldenburg: How To Keep Sculpture Alive In and Out of a Museum

Claes Oldenburg's ten-year Retrospective opened at the Museum of Modern Art on September 25, 1969. In this discussion of the show, his statement about what he is really interested in—to make tangible the "expression of what it feels like to be alive"—has multiple meanings. Not only has he been obsessed by the infusion of the human form into his sculptures but, since he set up a store in which to display and sell his works, he has been thinking about how to keep sculptures "alive." Oldenburg's Expressionist style, evident in the early Store Day pieces, serves as a bridge to recent Neo-Expressionist painting and relief.

From the start of the seventies, Oldenburg has been preoccupied with realizing his large-scale public sculptures. The monuments are unique in that they introduce a figurative element into a Minimal style. The outrageousness of choosing banal objects to memorialize has not lessened with time.

Jeanne Siegel: *Claes, the exhibition includes sculpture from when you started making it ten years ago. Do you feel that your attitudes have changed sharply over that period of time?*
Claes Oldenburg: No, I think there hasn't been so much a development as a kind of spreading out and taking like, well, a big piece of pie, taking one segment at a time because it really amounts to a kind of whole vision of nature. And you're supposed to see the things all together, which is why I would have had this kind of show somewhere.

So the developments have come pretty much in terms of materials. There's been a development from very cheap, simple materials, through a little bit more expensive, through very expensive like vinyls and steel. It's been really a development of opportunity but the ideas have basically been all in a box and I've just taken them out one at a time.

But what I would like to have the show look like is not so much a view of my work as a view of a period, because along with developing opportunities, I have developed suggestions that other artists have provided, which is the nice thing about having a congested art climate like we have in New York—whatever anyone comes up with someone else can use and I think there's an awful lot of collaboration in the work in the sense that I've just very freely borrowed ideas from other people too. And so I would prefer it if the work had almost sort of originated by itself as a result of this period, which was a very exciting period in New York art history.

Did you choose the works for the exhibition?

In a sense I did. The work is there and what I did was to make what someone called an information retrieval system. I cut out cards and I put the names of every sculpture and construction I had ever made on a wall and I copied them all down and sent them off to the museum. I mean it was quite a job remembering all the things because there were a lot of them. So in that sense I helped by suggesting, and then I more or less turned it over to the museum because I felt there is a matter of space that I'm not familiar with. I let them do the choosing from that which I approved.

Were you satisfied with their final selections?

I think almost everyone agreed on the pieces that should be shown. They're quite well known so there wasn't any real problem there. The work breaks down into certain areas and in each area there are certain major pieces and certain minor pieces and certain pieces that fill in. It is almost as if I had planned each area as a show in itself even though I made the things at different times—there's a unity to each area and it kind of organizes itself. For example, in the Store Period everyone would certainly agree that the *Giant Hamburger, Ice Cream Cone,* and *Cake* should be in. Those are the largest pieces. When I made them they were arranged in categories of size and concern so that it's almost like it was mapped out in advance. It's quite organic, each period.

What were some of the other periods?

I began making constructions in 1959 with the period I called The Street. That period had a certain consistency because all the materials were found on the street and they were the neutral colors of the street and there was an emphasis on line which is sort of a street effect. There were two shows of that period—one was at the Judson and the other was

at the Reuben Gallery, and if you bring those shows back to mind you more or less see the organization of that part of the exhibition.

That was just before The Store. The Store dealt more with color and I used plaster painted with enamel, and that lasted until about the middle of '63 when I moved to Los Angeles and began an area about The Home— about the kind of volume effects of the home which would be expressed in furniture and in all kinds of accessories in the home. That period has organized itself around the bedroom, the bathroom, the toilet and so on and then there's the kitchen appliances—as I say, it's all quite organized.

Did you designate the various period names yourself?

Yes, it was kind of arbitrary—you see, I had in mind to explore first the area of line which was The Street and then the area of color which was The Store and then the area of mass or volume which was The Home and after that I became interested in scale. In between was the interest in softening the machine which was focused on the Airflow car.

When you concluded the Store Period that focused on color were you through then with the idea of color altogether?

The question of indulgence in color wears itself out. The Home Period that follows is restricted to black and white and blue with some red but very little red so that it's a very cool and reserved period as far as color is concerned. I think it's just a matter of exhausting a sensation— that's the way I work. I fall in love with something and drive it to an extreme and I just lose contact with it and start some other thing. However, there has been a consistency of drawing through all the periods where I let myself have full freedom in the drawing to use color or not.

You've remained consistently interested in the object, haven't you?

Yes, I've expressed myself consistently in objects with reference to human beings rather than through human beings. The human beings in my work are more or less the spectators.

Haven't qualities such as softness and hardness continued to preoccupy you?

Yes, but I wish there was some way I could describe exactly what I am interested in. I think what I'm interested in are conditions and, for example, the relation of hardness to softness—conditions which express my experience of nature. I think the objects are more or less chosen as excuses or tangible things that I can hang my expression of what it feels like to be alive on. Thus, I would take a hard object like a telephone and make a soft version of it which would remind you of the hard version and

kind of set you thinking or feeling about the contrast between hard and soft in nature. And the same way with scale—a little tiny watercolor which shows a very large thing would kind of throw you off and make you think about large things and small things and the relationships of scale or almost the indefinability of scale. So it's a continuous interest on my part in what it feels like to be in nature or to be in an exchange between the body and nature. And I think it's a more abstract concern than appears. People talk about the subject entirely too much. The subject is chosen because it enables me to demonstrate something about the physical condition of nature.

What are some of the other conditions of nature that concern you?
 Well, for example, dryness and wetness or smooth surfaces versus textured surfaces. I guess I was very struck once by reading Roget's *Thesaurus* with all the opposites; I formulated an expression of nature in terms of opposites, which I don't exactly believe in. It's a way of expressing nature like the sun shines or it doesn't shine or it's day or it's night and a little part of night in day. For the purposes of representation I think of things more or less in opposites. Almost any opposition that I can think of is very stimulating to me.

You seem to have been interested in fragmenting certain objects right from the start.
 Fragments have always interested me. I think one of the big differences between an artist's vision and, if there is such a thing, a normal person's vision, is that artists tend to see in fragments. They tend to take a part of the lamp, a part of the telephone, a part of an ashtray and make a whole out of that and ignore the rest. They tend to be very partial in their looking. What I wanted to do in the early fragments, for example, in The Store, which has a lot of fragments from advertisements, was to limit the subject matter to the things that interested me and that I could compose into a new whole. So I always thought of seeing as basically a fragmentary activity. If I walked down the street I would only see certain things and I wanted to be true to that vision.
 Fragments are also good because they suggest what's between, and so a little piece of something suggests the whole of it. But lately I've also become interested in the changes that happen to things physically when they fragment such as when you drop a plate. I had one colossal monument planned for Grant Park in Chicago which would be as if an enormous plate full of scrambled eggs had been dropped on the park. It would be reconstructed so that you'd come across one piece here, one piece there, and each time you did the thing, it would be something in itself and

it would also make you aware of the space of the whole park because you'd know the other parts were there too.

You mentioned earlier that in your sculptures human beings are the spectators—do you consider their physical reaction as a starting point for the conception of a work?

Not in any deliberate way. I think it's very difficult to plan your audience in that sense. I could have some general idea that if I use soft material people are going to want to touch it or if I use a functional object like the toilet which people have all kinds of notions about, pro and con, that people are going to have a mental reaction to it. I know they are going to be engaged by it physically, but I don't know exactly how they're going to be engaged. If you make food you certainly are going to stimulate them to think about eating and the use of the mouth. And if you're going to make a chair you're going to stimulate the thought of sitting and the use of the back and behind. And if you make a gun or if you make a pair of scissors you're going to stimulate the use of the hand. So I think there are objects for each part of the body and, in a general sense, I plan this and I also act it out. For example, I once made a piece with a banana showing the banana being eaten, and what I did was cast the piece in canvas and I cut the canvas and peeled it and I had five bananas and I ate each banana down to a certain point so that I was sort of acting out the thing that would be acted out in the imagination by the spectator. And the plaster tasted terrible—I would spit it out. But the act was a theatrical action which communicated. So in that sense, I do plan some of them.

You can also frustrate expectations. The bed, for example, can't be slept in—you can't get inside the covers and it's rather hard. And the food, of course, can't really be eaten so that it's an imaginary activity which emphasizes the fact that it is, after all, not real—that it's art, whatever that strange thing is of doing something only for itself rather than for function.

With your recent focus on monuments, hasn't "function" become a prerequisite for you?

Yes, it is true, the fact that the *Lipstick* just built for Yale was a subscription by students made me very happy because the best feeling I have is when a monument has a function and is not just a piece of art set out to edify the masses but it is asked for and it's taken care of and used in that way and so, in this case, I was asked to do it and I submitted some ideas and they selected from the ideas and it was also a pleasure to donate my services. The whole thing was rather a collective act which produced a functional sculpture. The function of it is not yet exhausted, which is

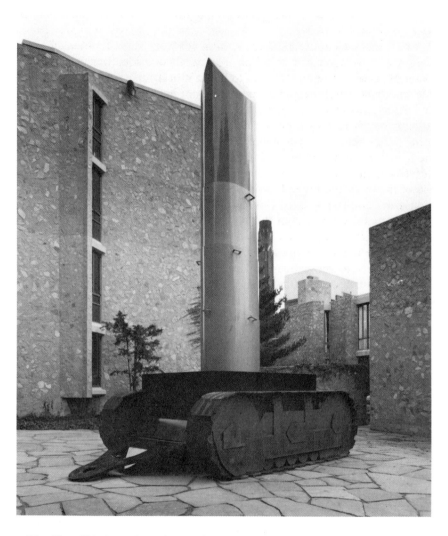

35. Claes Oldenburg, *Lipstick Ascending on Caterpillar Tracks* (1969, reworked 1974)
Collection: Yale University Art Gallery

nice because that postpones its going into a museum phase, which is the fate of all works of art. Any work of art has a phase where it's alive and then it has to almost pass into a museum phase, which is when people have exhausted its function or can't see any new use for it and don't exactly want to throw it away because it's worth money or it's sentimental or something. Then they put it in the back room of a museum, or they put it in the front room as the case may be. But the thing loses its sting, and what I had in mind was ideally to create something that would always function and inspire or produce action in the people who saw it or experienced it. But I realised after a while that that was an impossible dream, so now I'll settle for maybe a short period or so before it gets retired.

The Yale *Lipstick* has a kind of built-in continuity in that if the Yale Corporation rejects it—and they have to accept it on the terms that it must be located in the site where it's placed—it's taken away and given to another University at a predetermined site. One could see this sculpture moving from site to site, each time forceably installed and rejected, so that it could kind of move through the whole country and eventually make its way to the West Coast if we could stand that, if we could go along with all that. It might take years. But that was the original concept of it, in other words, to try to plan some way to keep a sculpture alive. There are so many monuments all over the country that people pay no attention to—they're just like trees.

Was the Lipstick *the first monument to be realized?*

That's the first thing realized on a very large scale and it made me very happy. It was like a leap into an entirely new thing because for the last four years I've made proposals that have been almost deliberately impossible or anyway would have to wait for superior technology like the *Thames Ball,* which is a huge copper ball that was made as a substitute sun for London to rise and fall with the tide.

Didn't you really believe they could be carried out?

It would be impossible to make a proposal without believing in it. As far as the practicality of it is concerned, that would involve many millions of dollars not to say property value and the consent of the people who are going to occupy it. It is a proposal on a huge scale, which is always difficult. My scale now with 24 feet, which is the *Lipstick,* is quite reduced compared to the 850 feet I visualized, say, for *The Clothespin.*

Do you have any new monuments in mind?

I've just come back from the West Coast where I'm working on a large ice bag which is to be manufactured by the workshops at Walt

Disney's under the Art and Technology contract that the Los Angeles County Museum has set up. This would be an ice bag with a revolving cap on the scale of 24 feet across which would be quite big, and that would be pink and made of some kind of rubberized material which would follow the cap around. The cap would be a big stainless steel mirror that would circulate and draw the folds of the bag with it. I say "ice bag" because then you can put it in your mind—you can see what I am talking about but I think it would be, on that scale, very abstract. Then I'm working on a giant screw for a park in Los Angeles which would spiral up, release oil, and then spiral down again, and that I hope to finish this year too. So I am just looking for sites, property, and investment, you know, one way or another to get these things up. I have a lot of ideas.

What inspired you to make a piece that imitates the monument by Picasso in Chicago?

That particular sculpture was commissioned in order to figure in a law suit against the city of Chicago for violation of copyright because the city had copyrighted the Picasso and was selling rights to reproduction and some lawyers in Chicago felt that this was a violation of the original gift by Picasso. So they wanted some excuse to file suit and so they commissioned me to make a replica. I chose to make a soft replica, which turned out nice because the thing itself is nice. It's a piece that functions largely in a sense because it's involved in this lawsuit and will have a kind of historical reason for being.

[The interview with Claes Oldenburg was recorded in June and broadcast on October 5, 1969 on WBAI. It was published in *Arts* in October 1969.]

36. Roy Lichtenstein, late 1960s
 Courtesy of the artist

Roy Lichtenstein: Thoughts on the "Modern" Period

Roy Lichtenstein's interest in Art Deco, on which this interview focuses, coincided with a popular revival of the thirties style in the late sixties. The interview reveals how articulate and astute the artist is in matters of art history. His culling from both high and low art sources (architecture and craft, in this instance) establishes him as a recent precursor of the "image appropriators" of the eighties.

Lichtenstein's broad, good humor is characteristic of most Pop artists.

Jeanne Siegel: *The fact that you use the content of art as subject becomes more and more apparent. For example, the new sculptures seem to refer both to the shapes of the thirties and the more current Minimal art. Was this your intention?*
Roy Lichtenstein: Yes, both of these styles are embodied in the work. I think the similarity between the art of the thirties and much of the sculpture being done today is that they are both very conceptual. For instance, the shape that finally evolves in a work is to a degree understood to begin with. In a boxlike structure the rear of the box is evident from the front. You can conceive of and understand what the work will be all the way around from a glance. It is also conceptual in the sense that the artist knew what he was going to do to begin with, and this is true of much thirties architecture.

It's the thirties architecture that I'm really familiar with and not the art, most of which I think doesn't really exist as painting. It exists as architectural decor, as jewelry design, and interiors—things like that. The architects and designers of the thirties apparently—and I'm second guessing them—believed in the logic of geometry and in simplicity. Their art is composed of repeated forms, zigzag marks, repeated lines in a row, or decreasing or increasing spaces, and arcs described by a compass. It

seems that the compass, T-square, and triangle dictated their art. It was an art of the plan, circles are bisected exactly in the middle, the page is exactly divided diagonally, and there's all this insane kind of logic—insane because it has no particular place in sensually determined art. There's no reason why it can't be geometric, but there's almost no reason why it should. And there's not much precedent for it, except in the architecture of the past. So it's mostly the conceptual aspects and the simplicity of the two arts that interests me.

Wasn't one sculpture derived from a Bambara sculpture?
I think the thirties style was influenced by primitive art. There's the influence of American Indian art in the zigzag, but it becomes more geometricized and turned into something else. In the same way the influence of African sculpture on Cubism carries over into the twenties and thirties art.

Do you assume that the viewer is aware of these references?
I think it may not be completely evident looking at any one piece but I hope it is evident because otherwise I don't know what they would be looking at exactly. Otherwise you read it as pure form, which is part of it, but I think that much of the reason for its existence depends on your understanding what it's about. I think it is true of all art, really. But I think six or seven years ago, we really thought we were doing pure art form, and the final appearance that it had was an outgrowth of our own personality and not about some other thing; I think we forget that we were symbolizing, in a way, what we were doing. In other words, Abstract Expressionism is symbolic of itself—it's symbolic of interaction and of order. It's symbolic of trying to do an art which is of yourself entirely. But we hated to use the word symbolic.

When you said that your sources for the design came from thirties architectural decor, do you mean you actually go out and look at architecture?
Yes, but I think when I first started I didn't. I got the first inkling, I suppose, from a poster I did, *This Must be The Place,* which was supposed to be Buck Rogers architecture, or that's what it meant to me. Then, when looking at it, it began to look very thirties. Later I did a poster for the Lincoln Center Film Festival and I wanted something about the movies, just as a design, and the thirties occurred to me; that's how I got into it. I started looking at actual objects of the thirties—architecture, jewelry, furniture, and found a lot of material. I found that much of the best of it was French, for some reason. Theirs was very elegant. It became a little more hokey in the United States.

Did they develop in the two countries at the same time?

I think the United States is a bit later. I think it really came from the Bauhaus and Kandinsky and Léger, too, in a way. And then I suppose the idea became subverted. The obvious things, the simplicity and the geometry and all that, became influenced by Cézanne's statement about the cube, cylinder, and the cone, and if you just take that and try to make art out of it, it becomes nonsense. And that's what seemed to happen, I guess, in the thirties to the art of the Bauhaus. The concepts they laid down became the purpose of their art. Or perhaps the concepts rationalize the art itself, which is generated from something else anyway, some kind of feeling or sense of what would be right. And then you say why and you write that down, as I'm doing now, and that maybe becomes a thing other people will take as real and work from.

Do both the new paintings and the sculptures relate to the art of the thirties in the same way?

Somehow the sculptures become more like real architectural details than the paintings. The paintings are more about the thirties in a sense— well, so are the sculptures, but they seem more to be like thirties *things*.

What things?

I'm thinking about portals, doorways, bannisters, and things which they really obviously look like. And I like the idea, of course, of employing marble and brass, there's nothing unusual about that. First of all, marble is such a traditional medium for sculpture and brass and bronze have been used forever, but, of course, the way I'm using it isn't particularly traditional. Possibly the unusual thing is it looks like something I found in the lobby.

Aren't the colors in the new paintings the same colors that you have always used?

It's the same color and the same technique. I think that's *me* at this moment whether I do comics, brushstrokes, a Picasso, Mondrian, Cézanne, a landscape, or whatever, and now this. What you are probably asking is where does it fit in? What have cartoons got to do with the thirties? I do think of the thirties as a sort of a cartoon era in a funny way. Another thing is the Benday dots were blown up, and they meant at first, of course, reproduced material, but I think they also may mean the image is ersatz or fake. The dots indicate a fake brushstroke in my brushstroke paintings. In this case, it means fake twenties or thirties. You know, it's a stamp of not being the real thing. That may be part of why I work that way. I just feel that the same painting technique, color, same way of

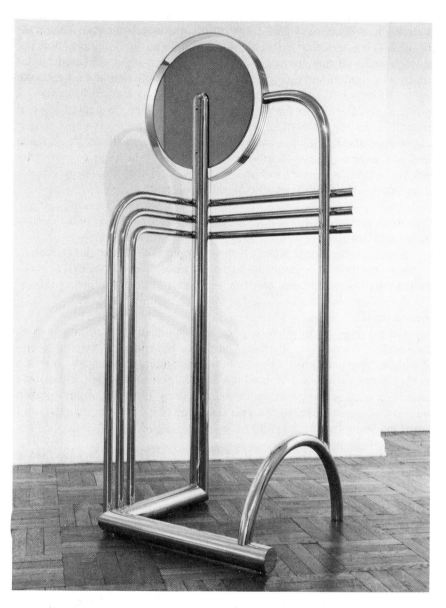

37. Roy Lichtenstein, *Modern Sculpture* (1967)
 By: Rudolph Burckhardt
 Courtesy Leo Castelli Gallery

going about it, work for the thirties images and I don't know why. The forms are different, but they relate very much to the Picassos I did, because the Picassos were cliché Picassos, over-simplified Picassos. And of course, this art is actually oversimplified, and probably comes from Picasso in the bargain, or comes from Cubism, which is almost the same thing. It's almost what I was doing when I made the Picasso painting.

Some of the latest "modern" paintings make a reference to the classical style. How do they differ from the others?

Well, I think that Art Deco, went from completely abstract art to kind of a neoclassical, heroic art which I think, for instance, the statue in front of Radio City or Rockefeller Center might be something close to in style. The image became geometricized muscle—fellows with huge necks, small heads and enormous shoulders. It was like a very simplified "animal cracker" classical art, which I guess was a way of employing geometry—which everybody seemed to like—toward a public message or statement that could be used in a mural fashion.

How would you characterize the spirit of the thirties?

I think they were very optimistic. Either they were optimistic or they figured we were all in this depression together. It developed before the depression, probably around 1923. It was very evident in the Paris Exposition of 1925, and it's been used since then, I suppose, until something like 1938—that's from the good times right through the depression and onward. My history may be wrong, but it's a little hard to understand how the same style or something like the same style, persisted through the great boom and a bust and continued on. But there was a feeling that man could work with a machine to obtain a better living and a great future. I think thirties art is optimistic. The moving pictures of that time also have a kind of optimism about them. Maybe the optimism was in contrast to real life. But there was, I think, a real feeling, of man working with the machine that is really diametrically opposed to Art Nouveau, which tried to get handicrafts back into the machine production by the use of natural forms, tree shapes, and so forth. It is as if the machine had done away with beauty and let's try to get beauty back into our manufacture.

The thirties style is the opposite—it's the complete acceptance of the machine and the making of designs simple enough to be carried out by machines. I think that the Cubist aesthetic has always worked well with the economies believed necessary in architecture, engineering, and machinery. Expressionism, except for a little salute to Gaudí once in a while, almost never got into anything that architects could use. There was a real

practicality about the Cubist aesthetic that lends itself to design, which more fluid kinds of form don't. I mean there was really no reason why in the thirties you couldn't have thrown chicken wire around and sprayed concrete on it to make architecture—forms which, in a way, would be stronger and perhaps easier to produce than Cubist ones. I don't really know why Cubism had such a strong influence, but I guess I know in a way—it makes more sense and people love to make sense. And it's the business of making sense that I think I'm really having more fun with now. It may be the essence of what I'm about, if anything is. Thirties art made so much sense and that kind of sense is absurd in art.

[The interview was conducted in Roy Lichtenstein's studio on the Bowery in October and broadcast on December 13, 1967 on WBAI, following an exhibition of new works at the Leo Castelli Gallery. The interview was published in *Roy Lichtenstein,* (New York: Praeger, 1972).]

38. James Rosenquist
 By: Bob Adelman
 Courtesy Leo Castelli Gallery

An Interview with James Rosenquist

A major Retrospective of James Rosenquist's work opened at the Whitney Museum of American Art in April 1972. Rosenquist, although always included in the category of Pop, was, as this interview demonstrates, something of a maverick. His interiorized vision and use of Surrealist stylistic devices have made him interesting to younger figurative artists.

The interview also illuminates Rosenquist's strength as a sculptor, which had been overlooked. His attitude towards political events elucidated in his discussion of *F-111* (1965), is important. The specter of aggression and the preemption of nature by technology, issues inherent to *F-111*, have continued to absorb Rosenquist to the present time.

Jeanne Siegel: *One of the statements repeatedly made about Pop art was that Pop artists have always accepted anything that was part of our society rather than registering some sort of protest. This was considered a basic difference between Dada and Pop. Lawrence Alloway phrased it "to live with the culture one has grown up with."*
James Rosenquist: That idea of accepting the banal for the beautiful doesn't really have anything to do with anything. That's like trying to figure from the glint on the grass what kind of sun in the morning is going to activate how you are going to act for the rest of the day. Of course, I hate smog and, of course, I react to this and that, but it doesn't have much to do with anything.

Your first paintings in 1960, 1961, and 1962 however, because of their banal imagery did put you into the "Pop" bag. Take Necktie, *for instance.*
At that time I was trying to find an empty area to work in that wasn't popular, wasn't contemporary looking. It's so funny that the people have gotten into Pop art. . . . In my case it wasn't meant to be no image, nothing image, nowhere. It's like a beat generation person riding around in a five-year-old car. It's not an antique and it's not new. *Necktie* is

supposed to be hung in the very corner of a room, it's like a person can't stand it in the room and he's trying to get out to the corner. It's like being stuck at a cocktail party. It's that idea.

In the so-called billboard paintings, like Silver Skies, *the images are sharper.*

Silver Skies has to do with bringing scale and feelings of scale, altitude, color, and imagery into a room. It had something to do with an exhilaration that I've had while working on a billboard. Being reduced to the size of a fly on a piece of paper does things. I've often wished in the past that I could bring people to the back of the Astor Theater and have them look out the window of the sign into Times Square to let them see the color and the feeling. So the simplest and the cheapest thing I could do would be to make an oil painting of the illusion on canvas and try to give the feeling of this numbness that I felt when being immersed in painting large imagery. The imagery was expendable to me but it was the color and texture that I was interested in, for instance, if I thought I felt like painting red I might have painted a great big tomato. I had these possibilities working for Artkraft Strauss—there'd be a desk in the front office with imagery there that I could pick out and do something with. It was a place to learn and I had an opportunity to paint a lot of gallons of paint and drop a lot of it.

Nevertheless, certain images are recurrent, for example, body fragments— particularly hands, automobiles, and food. Why did you choose them?

Hands for me have always been sort of an offering, a suggestion saying two cents off, buy this, try a new steam iron. They had to do with advertising, and advertising, as I said before, was like the power on the street that a lot of money was poured into, to make something bright and flashy, to make something go. And that was a powerful gesture that people would recognize, so if I put them in a painting, they would see them and they couldn't mistake them for a crucifix because it would be a hand offering something. I used that imagery so it wouldn't be mistaken for something else.

As for automobiles and car parts, I was brought up with automobiles in the Midwest and I used to know the names of all of them. I came here and spent some time in New York and I didn't know anything that was stylish. I found myself standing on the corner, and things going by, and I couldn't recognize anything and that wasn't only automobiles. There were a lot of other things and I began to feel that what was precious to my thing was what I could remember.

Perhaps car parts appealed to you because of their simple geometric shapes.

It's like you're born with your own living-room furniture, and in Russia they're born with another set of living-room furniture. This has to do with whether you like the shape of an automobile or a shape of horses and a wagon. As they say in Eastern philosophy, energy turns to ethics, and to me a human being is tied to some kind of humanism and that has to do with ethics and I could think of ethics of a stone or feelings towards a stone. And I like to ask the question—are people really part of the living-room furniture of their own community or aren't they? It's the idea for a film I'm making now.

The light bulb seemed to be a particular favorite. A real light bulb appeared in one of your first pieces, Floor Plan, *and it was reborn in the form of a GE label in later paintings and prints.*

Floor Plan came from knowing an ex-convict who, when I visited him in his home, used to wander around the house looking out the curtains and knocking over the furniture and going from room to room turning on and off the lights—he was very nervous and watching out for people. So I tried to invent a randomness machine like a tilting pinball table that would light up in sequence and then go off again, but I always came up with a sequence that would return very quickly, so it ended up as a painted floor plan with light bulbs hanging from it like a chandelier.

In the later paintings and prints I was interested in why a person's eye is like a camera and do things happen in a camera the same way they do in the eye. When you look into the sun with a camera you see a phenomenon called "circles of confusion," which are little balls of color that start moving around or the aperture is reflected inside the camera into a circle, the same way in your eye—there's a reflection in your eye that causes strange things to happen. And it was like trying to find something while looking at a light bulb. Also it was trying to see something while a person was looking into a vacant area like straight up into the sky, at a plain white wall, meditating. What happens if you look and look and look—you see spots in front of your eyes.

You had a special way of fragmenting images, cutting them into large sharply angled, irregular shapes and then fitting them together in a way that simulated collage. Why did you do that?

That has to do with identifying a shape of something that you're looking at. For instance, if you're looking at something at a long distance, say, over the plains in the West, you might think that's all trees there but it might be blue smoke. Or you might think you're seeing two people walking, but you're only seeing one person with an umbrella in the wind.

So if you take an image and you fragment it—let's say you take a beautiful, straight-on photograph of somebody's face and you cut out a section of this face, you could change the character of the feeling of part of that person by the edge of the shape. If you take two ideas and you connect them and you identify a part of the two ideas, you might unleash what the other part of it is instead of disguising something.

Or say it's raining and two people are standing on the street and they're embracing each other—let's say it's two people in raincoats, and there's a fragment of them that's identifiable. You might find out that it's something more than what you think that it is. And it may not be two people embracing each other. It has to do with the edges of what you're seeing. The shape of what you see can suggest one thing and you're still— right in your face—shown something else and it becomes a very peculiar mind bender.

I began to get interested in that when I painted figures for movies like *South Pacific* and there would be an actor kneeling on the ground with France Nuyen or Suzy Wong embracing one of them, and I was to paint the photograph of these two people. Someone would take a scissors and just cut out the shape and sometimes their shape would look like a whale or a sea otter or something else and I thought, here I am painting two kneeling figures embracing for *South Pacific* but they really look like whales. Now on the other hand, two faces looking like two whales would really look like people. It gets very, very peculiar. I'm not into mystical things or mystery. I'm only interested in how you see things. So it gets to be how and what things look like. Like the shape of things to come. It has to do with what shape are your ideas going to take and that's very peculiar and I hope that my ideas don't take any shape like anything before. Being a painter I would like them to be completely something else.

In The Lines Were Etched Deeply on Her Face, *the images float more freely.*

I set things in planes in space to be identified at a certain rate of speed so you can probably identify the pants first, the typewriter second, the hot dog third, and then you recognize her face as the last thing be- cause her chin and face are very large. What I was involved in was the rate of identification of imagery.

Also, the closer things are to you the harder it is to recognize them. Like if you are getting mugged by a mugger, you don't know who the mugger is if he's got his hand on your head. If something is being thrust at you, say, here have a drink—like that—you can't even recognize it. So in a very old-fashioned optical manner I was thinking of that numbness

39. James Rosenquist, *The Lines Were Deeply Etched on Her Face* (1962)
By: Rudolph Burckhardt
Courtesy Leo Castelli Gallery

that exists beyond the brutality of an enlarged image. So one of my first paintings was called *Hey, Let's Go for a Ride*. It was someone with a beer bottle and just the middle part of a face thrust at you. I could have done hundreds of paintings like that—I still could. Because what seems so strange to me is that I still feel young in things that I know aren't developed yet.

You have stressed your experience as a billboard painter as a great influence on your ideas about scale. On the other hand, when you read any of the art historical literature from around this time, reference is always made to artists like Barnett Newman and the Abstract Expressionists, all of whom were using large scale. Were you aware of what they had done?

I heard rumors in the Midwest of a painter called Jack the Dripper in '48 and '49 but I saw his paintings much later. I guess consciously, a lot of things add up to what I think about the space, but I still think about a space that's put on me by radio commercials, television commercials, because I'm a child of that age. Things, billboard signs, everything thrust at me, and when I came to New York I used to live on Columbus Circle in rooming houses and there was spit in the hallway and tobacco juice and dirty and brown looking things. I couldn't stand it. And I thought the only way I could stand it was by saying, "Oh, doesn't that hallway have a beautiful green patina." And so with all kinds of advertisements, in the numbness that occurred, I thought that something could be done in that numbness, that power. I had heard that John Marin and Stieglitz and someone else had a show on Madison Avenue in the 1930s when there were horses on the streets and they were trying to do the most fantastic show in that gallery and one of them looked out the window and said "Look, it's more exciting out there than it is in here," meaning the muscles of the horses galloping up the street. There was more throb, more action, and I begin to think there was more power and more massive things in advertising than there was in the intellect of a person making a painting in a studio. Also I saw soap boxes being designed in advertising agencies and they used to pin the soap boxes on the walls to see who would look at them the most and I thought there's more visual things worked out there than there is in an artist's studio working singularly, so I thought of imagery spilling from my billboard experience—imagery spilling off the picture plane—and then after you see that imagery what's behind it. It's like a thought or a feeling.

You painted some of this same imagery on clear mylar that you cut in thin strips. How did the change in material alter the meaning of the images?

The material was oil paint stippled on clear polyester plastic and it was .005 millimeters thick and it was imagery that could be recognized.

The largest image in the show was an armored car larger than life-size being sawed in two by a large hacksaw and two hands. The armored car image was on one plane and the hacksaw was on another plane so that they intersected. The mylar was cut in thin strips so that you could walk through it like a hanging curtain. What I hoped for was that when people came into the gallery that they would see these configurations and they would think that they had to take a certain path through the room, but actually they could walk directly through the images.

I started doing that in the winter of 1966, but in April 1968 I showed a whole room of these hanging mylar paintings at Ileana Sonnabend in Paris. In the recent Whitney exhibition only a few fragments were shown because the owner wouldn't lend the bulk of the pieces.

In the mid-sixties you made a group of paintings, like Growth Plan, *that do not seem to have a direct bearing on your billboard experience, or your other paintings, and which strike a rather sinister note.*

I can tell you about that. I saw someone murdered down in lower Manhattan and I had to identify four murderers. Afterwards I went through a lot of strange events and I made this painting and that's why it was called *Growth Plan*. I wished I hadn't sold it—I'd like to have kept it.

Why?

Because I don't think I want to show it. I don't want to be known as a contributor to the revival of realistic painting. I've been written about as a precursor of New Realism, like Ivan Karp has downtown. I hate that.

Your sculptures look quite different from all of the work we have discussed. What caused the shift in style?

I can tell you the things that made me do them. *Soap Box Tree*, which is now destroyed, is a nostalgic thing about seeing a soap box put into a tree in a housing project somewhere during World War II. I took a small sapling tree and cut it down the middle and wedged in between an enlarged AD soap box label. *Catwalk* had to do with the metal structure above the Latin Quarter in Times Square and the Canadian Club sign. One time I was working up there and there was a girl in the back yard of a building sunbathing in the nude and I was leaning off the edge of this thing looking at her and two workmen dumped about two hundred light bulbs down on my head from about five stories and I thought it was bullets—they popped off and went down my neck and everything else. *Catwalk* is merely an idea of walking across a place with lights shining through underneath and it's supposed to be at a high altitude but of

course, it's only like a little puddle or a little thing. *Tumbleweed* is about seeing a huge tumbleweed (in Texas it's a small bush that breaks up and the wind moves it along and it scatters its seeds as it gets blown about and the tumbleweeds stick together) which was as big as a house coming towards me as I was driving in a car and the way it looked later on I thought of chrome-plated barbwire as a barricade and a piece of neon light going through like a rabbit going through a barricade. And another thing I saw were animals and grasses hung up on barbwire fences in North Dakota after floods in the spring. And then I thought of East Germany and the Berlin Wall and chrome-plated and barbwire and it being in the middle of a bustling economy and there was something very ridiculous about being next to something that was tough but trying to live with it like an urban thing.

Does the barbwire function in the same way in Toaster*?*

That's just to make it spiky—it's like waking up in the morning. This is a small cube, the size of a toaster and its two saw blades—I had those left over in my studio—and it's like two pieces of toast are like waking up tough and trying to put your teeth on two sawblades.

But whatever I say made me do these sculptures—they could look fantastic or they could look terrible—and my visual thing which appears later, I hope, carries through an idea and I hope it's successful because of that. I say this because it's not style that's carrying me on, it's idea. It's idea that translates into form instead of something less. Most people involved in art history think of visual influences but it doesn't really work that way, in other words, a hard-edge school doesn't have to influence hard-edge art. A substance or feeling will probably influence me in a way that is not so recognizable.

Although the sculptures differ, as a group they have a look of process. For instance, in Tumbleweed, *the way in which the barbwire twists and encircles the wood and the crudeness of the wood with its drips and splatters of paint makes the viewer more conscious of the material creating the work.*

I'm not concerned with process at all because being concerned with process is being self-conscious of how to make it. I'm interested in short-cuts. In the past years, I seem to be interested in things up to a point and then I don't go on with it. In a lot of my work all through the years I try something and only go so far and a lot of times I find myself in a frustrated position and after that feeling happens I leave it and try something else.

Probably the strangest sculpture/painting you have made to date is 5Ups.

I did this painting that looked like a big pants-pressing machine and I thought that it would be a strong piece with the edges of the stapled canvas sticking right at your eye at eye level. That would be a very tough painting. The idea of it is this: both canvases, sitting there horizontally, are painted different colors and when they reflect the color on one another you really don't know what color each one is because of the color reflection between the two flat canvases being thrust out into the room horizontally. The present title is misleading—the original title was *Towards Earth's Center,* which means if you're making something in color and you had a rheostat on the light or if the sun goes down the colors change and earth creeps in.

Would you say that you have become increasingly interested in color since you started to paint in 1961? After all, your first paintings were monochromatic.

Yes, I started painting really in grays. Occasionally adding a color but usually in gray because I didn't want my paintings to be gorgeous. It had to do, like my choice of imagery, with not wanting to look contemporary.

One of the first in color was *Rainbow* in which there was a real window and on the window was a fork painted stabbing into the house and color was flowing out the window over the sides of the clapboard and the side of the house.

It would appear that you arrived at the greatest clarity of imagery with the mural, F-111, *in 1965, and then the gradual transition toward the elimination of all imagery took place through the subsequent environmental paintings,* Horse Blinders, Area Code, Flamingo Capsule, Slush Thrust, *and* Horizon Home Sweet Home.

There wasn't any imagery, there was just color and paint in *Slush Thrust.* But in *Horse Blinders* and in *F-111* I started out without any imagery at all. I started *Horse Blinders* in the beginning of 1968 and I had a new studio and I felt good and I started working and as that year passed we had a number of assassinations and the Democratic Convention and my feelings got heavier and heavier and I began to have this feeling then that I was putting a chain around my ankle and being a worker again. It wasn't fun, I was seriously embroiled in work, and people would say "Well, how can you let that happen to yourself"? Life and politics are a very real part of one's existence and it's very, very difficult to expend the energy to put it down and not be embroiled in it and if it comes into my work, it comes into my work. It doesn't make my work less or any

more. I'm not trying to do my art with a capital A, in other words, I was very angry too at that time and with *F-111* and with *Horse Blinders* anger came into my mind.

The progression is probably correct, but I have new ideas about it. I'm doing a film now about this room and the walls falling over that I can do with imagery or without imagery. The imagery really doesn't have that much to do with it.

You've spoken of the problem of peripheral vision in connection with F-111.

The idea there is to walk into an enclosure and to more or less try to just look at it. You get a reaction whether it's exciting or boring or whatever. What happens is that the peripheral vision that occurs from setting up a sequence, from say looking at one thing and saying, that's what it is, that is only it, that is the thing, but then the eye, the senses are filled from the side with other colors so they make whatever you look at more or less interesting, depending on what the peripheral vision is. I like the idea of questioning what I see by what I set up on the side. I've been involved in a lot of things having to do with billboard painting where I would lower myself down on a high wall, 300 feet wide and 58 feet tall and after snapping a horizontal line I would begin painting the top area red and the bottom cream color. From the bridge of my nose the edges of my vision stretched way out while looking straight ahead. I could still see the space except when I turned around and looked down into Times Square.

Marcel Duchamp did a door that opens in different ways in a corner and in this room I had corners that I was dealing with. One corner of the *F-111* paintings was largely very bright, soft, fluorescent colors and it's very strange to put brilliant fluorescent paintings in a corner shape because it makes the corner disappear. It makes that corner rounded. So there are an amazing number of experiments and feelings that have never been dealt with as far as perception goes.

There seems to be some confusion about your original intention. Did you intend to have the fifty-one panels that constitute the mural sold as separate units?

Yes, the whole thing was actually sold in pieces for about $54,000 but Bob Scull came along and bought it all, thinking he was saving it so that it wouldn't get scattered to the winds.

I heard a lecture on Marcel Duchamp at the Guggenheim Museum by Richard Hamilton and he gave a detailed explanation of metaphors of Duchamp's glass piece, *The Bride Stripped Bare by her Bachelors, Even*. I was impressed by the laborious thing that Richard Hamilton was doing

in the explanation. The function of each thing in this piece had nothing to do with what it looked like but the visual form looked strangely modern. I thought, I'm going to do a painting and divide it up into panels so that each panel isolated might look like something. Each piece would be only a fragment that would be scattered about and then later some piece might assume an identity of style. You should have seen some of the pieces—some were color, lines here and lines up there and a diagonal and something else, and that is all. And I thought people might look at them on the walls and say, look what I've got. And that would become a form. Actually it was humor. And then, if the painting was ever to be shown again, people would have to get together and lend them and they could be shown as one piece again. But I thought originally that, like Duchamp, the look of it would be or could be the form of the future, of the fragments—not of the complete whole.

Another feeling that was the basis of the beginning of this was that I used to collect cornices from old buildings in Manhattan (that's how I met Ivan Karp)—gargoyles and heads and so forth, and as I collected them I thought what are these going to be replaced with—rectangles or aluminum? And who's going to go home with those? And I began to think that when a soldier dies in battle and he reaches in his pocket, is he going to look at a picture of his mother or at a piece of aluminum. That's why I thought of the new idea of nostalgia and this was a carry on. I didn't know if those fragments would be of any value—value to look at, value to feel, value as a style (nothing to do with money), valueless.

I was concerned with the vacuum of my feelings and the position of my mind trying to fit into society while I worked on the painting. I kept thinking of Cellini at that time—Cellini making something beautiful and offering it up to society. A person making something beautiful and precious in this society seemed ridiculous according to everything that was going on about me. I wanted to make a big, vast emptiness or extravagance and see what would happen then. And something happened. I sold the *F-111* painting to someone who had probably bought the real thing many times by paying income taxes. There was this joke that if you made an anti-war painting Lyndon Johnson was really going to stay up all night now and walk the floor of the White House—and it was a dim joke, a dark joke.

I'd like to return to this question of peripheral vision in connection with Slush Thrust.

This room was entirely covered with vertical strips of painted colored horizons, interspersed with reflecting mylar panels of the same size and fog on the floor. It was supposed to have an open sky ceiling up above.

If you looked directly at one panel what you saw was either more or less according to the other colors that jumped into the side of one's eye. I tried to set the color all the way around so that everything would be as exciting as possible. It was called *Slush Thrust* (slush is a name from my sign-painting days of all leftover paint in a bucket and that paint would usually come up sort of a brown or purple). The reflecting mylar would reflect color across the room—an illusion almost like mirrors in a fun house. The floor was eliminated and made opaque by fog so the floor could be as shallow or as deep as you felt like it. I thought of the fog as a white drawing. When I was in it my arches felt like they were falling but my knees felt soft, like—Geez—I can't see my knees. And people could lie down and not be seen. And the white fog going up to the colored panels would make a vertical feeling, and the white fog going up the mirror carried the illusion into the mirror, which at that point was a vertical and you know there was something vertical going down below that. And the vertical parts of the painting were a series of slices of sky horizons, atmospheric horizons.

When I was working for Artkraft Strauss on walls there were experiences that are nothing, but I think about them. There were a lot of devices we used. We would take a gallon can and tie a string on it to form a chalk line, and drop it down about four stories and snap a vertical line that went out of sight. You know there's a line down there somewhere but you couldn't see it. I'm making an environmental film where a person can walk into a room with four empty walls and the walls would appear to fall over in slow motion revealing each wall a different color like the petals on a flower. After the walls optically fall over, a landscape of the jungle on all four walls is seen, and you realize that you're still inside a space. I'm interested in something exhilarating, something colorful, the vantage point, but by being presented with the explanation of it at the same time I may get to feel something else.

[This interview was conducted in James Rosenquist's Soho studio in Spring 1972 and appeared in *Artforum* in June of the same year.]

Hans Haacke: Systems Aesthetics

The Guggenheim Museum made a startling decision in May 1971, to cancel Hans Haacke's scheduled one-man exhibition on the grounds of "muckraking." Among the works to be shown, the most troublesome investigated the economic structures of New York real estate holdings. The closing of Haacke's show pinpointed issues on artists' freedom of expression, an issue that makes for interesting comparison to the earlier panel discussion on the effectiveness of Social Protest Art.

In this interview, which preceded the Guggenheim show, Haacke discusses a political work that laid the groundwork for his sociopolitical systems. And although Haacke has been pursuing political issues in his art since the Guggenheim fiasco, he attempts to place the content of his entire *oeuvre* in a broader categorical context—a world system which unites a seemingly disparate range of work. Haacke's understanding of the intellectual concerns of art places him among those conceptual artists who, in the early seventies, were moving away from the object.

Jeanne Siegel: *You have been called a naturalist because of your extensive interest in physical elements as well as grass, birds, ants, and animals.*
Hans Haacke: I don't consider myself a naturalist, nor for that matter a conceptualist or a kineticist, an earth artist, elementalist, minimalist, a marriage broker for art and technology, or the proud carrier of any other button that has been offered over the years. I closed my little statement of 1965 with "articulate something Natural." That has an intended double meaning. It refers to "nature," and it means something selfunderstood, ordinary, uncontrived, normal, something of an everyday quality. When people see the wind stuff or the things I have done with animals, they call me a "naturalist." Then they get confused or feel cheated when they discover, for example, my interest in using a computer to conduct a demographic survey. This is inconsistent only for those with a naive understanding of nature—nature being the blue sky, the Rockies, Smokey the

Bear. The difference between "nature" and "technology" is only that the latter is man-made. The functioning of either one can be described by the same conceptual models, and they both obviously follow the same rules of operation. It also seems that the way social organizations behave is not much different. The world does not break up into neat university departments. It is one supersystem with a myriad of subsystems, each one more or less affected by all the others.

If you take a grand view, you can divide the world into three or four categories—the physical, biological, the social and behavioral—each of them having interrelations with the others at one point or another. There is no hierarchy. All of them are important for the upkeep of the total system. It could be that there are times when one of these categories interests you more than another. So, for example, I now spend more thought on things in the social field, but simultaneously I am preparing a large water-cycle for the Guggenheim show that uses the peculiarities of the building.

When did you first become aware of systems theory?

Sometime in '65 or '66 I was introduced to the concept of systems. I heard about systems analysis, and the related fields of operational research, cybernetics, etc. The concepts used in these fields seemed to apply to what I had been doing and there was a useful terminology that seemed to describe it much more succinctly than the terminology that I and other people had been using until then, so I adopted it. But using a new terminology doesn't mean that the work described has changed. A new term is nothing holy, so it can't serve as a union label. On the other hand, a clear terminology can help to stimulate thinking.

Jack Burnham has had a lot to say about systems and sculpture, yours in particular. When did you first meet him?

I met Jack in 1962 when we were both isolated from people interested in what we were doing. Since then we have been in contact and have had a very fruitful exchange of ideas. It was Jack who introduced me to systems analysis.

What is your definition of a system that is also a work of art?

A system is most generally defined as a grouping of elements subject to a common plan and purpose. These elements or components interact so as to arrive at a joint goal. To separate the elements would be to destroy the system. The term was originally used in the natural sciences for understanding the behavior of physically interdependent processes. It explained phenomena of directional change, recycling, and equilibrium.

I believe the term system should be reserved for sculptures in which a transfer of energy, material, or information occurs, and which do not depend on perceptual interpretation.

I use the word "systems" exclusively for things that are not systems in terms of perception, but are physical, biological, or social entities which, I believe, are more real than perceptual titillation.

Do you originate systems? Do you demonstrate existing systems?

Both, but not for didactic reasons. Let me give you an example. Take the *Cycle,* water trickling out of holes in a hose, which I laid out around the periphery of the roof of my studio building. The water was following the uneven surface of the roof, down to a central pool from which it was pumped back into the hose. This is a system which I originated. On the other hand, the invitation to come to the same roof on a given day and view the weather was a demonstration of the meteorological system. This was later complemented by that day's weather chart and the weather statistics of the month.

When did you first break away from the object?

Reflective pieces that I made in 1961 evaded being an object. You had a hard time seeing what was actually there, namely, the laminated material. The reflected environment obliterated the objecthood. One of these pieces was made of two half-cylinders covered with aluminum-foil laminations. A part of the left half-cylinder is reflected in part of the right half-cylinder, and vice versa. So you have something like feedback—the two halves of the piece are optically interdependent, they are "environments" for each other. Then, of course, they also respond to the environmental conditions of light and color in the display space.

Many of the works that immediately followed—the waterboxes, the Ice Stick, *and others—visually resemble Minimal sculptures.*

I was concerned with having a space that didn't impose itself as something important. The shape is primarily determined by technical factors; the material comes in plates or rods or tubes, in other words, in a form that mass production and versatility of commercial uses impose. The overriding requirement, however, is that I allow the process to have its way. I have to provide an appropriate container for the water, for example, or create a condition in which what I am aiming for can function best. Consequently my decisions are not stylistic (inert, hard edge, soft edge, antiform) but functional primarily. I am not aiming for a particular look, so visual terms do not apply.

Naturally everyone has preferences that determine what they choose

to do and how this will finally appear. For instance, I don't like heavy-looking things, so I gravitated toward comparatively visually immaterial things. That eventually led me to abandon the visual artist's aim of organizing perceptual patterns. If a system can be seen, I don't object to it and I take care of its looks—much the way a mathematician does with an equation.

A very important difference between the work of Minimal sculptors and my work is that they were interested in inertness, whereas I was concerned with change. From the beginning the concept of change has been the ideological basis of my work. All the way down there's absolutely nothing static—nothing that does not change, or instigate real change. Most Minimal work disregards change. Things claim to be inert, static, immovably beyond time. But the status quo is an illusion, a dangerous illusion politically.

How did your attitude about change manifest itself in these works?

Well, first, by the use of water I got rid of the static illusion and introduced real motion. (At first one only stumbles over the more obvious.) Then I saw the rain boxes condensing and I was very intrigued by it—there was this fantastic cycle of evaporation, condensation, then the droplets falling. That is a process evolving all by itself. This was the first time I had something that was literally responding to its environment. And, all without a little help from a friend, the response was so subtle that one had to come back after a while to notice it—it had a history. One could decipher the history of the process from the condensation patterns on the inside of the container's walls. It was like a living organism reacting in a flexible manner to its environment. It would be more appropriate, however, to liken it to our weather system.

The *Ice Stick,* it should be pointed out, is the reverse of the condensation pieces. In the condensation pieces, you have the cold on the outside and the warm inside (That's what causes condensation). With the *Ice Stick* you have the cold inside and the warm outside. Consequently, environmental moisture settles on the exposed freezing coil and freezes there. This piece, incidentally, has been reproduced rather often, probably because of its erotic connotations. This was not intended. It's just easy to make a straight freezing coil. I am not into Surrealist game-playing and metaphors. My stuff is very open. In other words, there's not much to be said because everything is right there. What can be said is only descriptive. There are no mysteries and psychological investigations would not reveal my secrets.

How did you make the transition from physical systems to biological ones?

The condensation as much as the formation of ice, figuratively speaking, are related to growth. It was a natural step, then, to introduce actual growth—namely, biological growth. The grass pieces went through a life cycle: they were seeded a few days before the exhibition; the seedlings came out of the ground at the time of the opening of the exhibition, they grew during the show, and at the end of the exhibition they were about to die.

Growth is obviously a manifestation of change. Are there conditions other than change upon which a work can depend?

Interference is an existing situation which thereby affects it—this is something that intrigues me. I've brought water into a rather dry forest, a sort of irrigation system, which then changed the existing vegetation.

Is there any difference in communication between social systems and physical or biological ones?

For physical or biological processes to take their course, there is no need for the presence of a viewer—unless, as with some participatory works, his physical energy is required (he then becomes an indispensable part of the system's physical environment). However, there is no need for *anybody* to get mentally involved. These systems function on their own, since their operation does not take place in the viewer's mind (naturally this does not prevent a mental or emotional response).

The rigging of a social situation, however, usually follows a different pattern. There the process takes place exclusively in the minds of people. Without participants there is no social set. Take the "MOMA Poll" in last year's *Information* show: the work was based on a particular political situation circumscribed by the Indochina War, Nixon's and Rockefeller's involvement in it. MOMA's close ties to both, my own little quarrels with the museum as part of the Art Workers Coalition's activities, and then all the minds of the people who had a stake in this game—the Vietcong as much as the Scarsdale lady on her culture tour to the city. The result of the poll—approximately 2 to 1 against Rockefeller/Nixon and the war—is only the top of the iceberg. The figures are not quite reliable because MOMA, as usual, did not follow instructions, and the polls have to be taken with a grain of salt.

Emily Genauer gave us a little glimpse of the large base of the work in her review of the show. She wrote: "One may wonder at the humor (propriety, obviously, is too archaic a concept even to consider) of such poll-taking in a museum founded by the governor's mother, headed now by his brother, and served by himself and other members of his family in

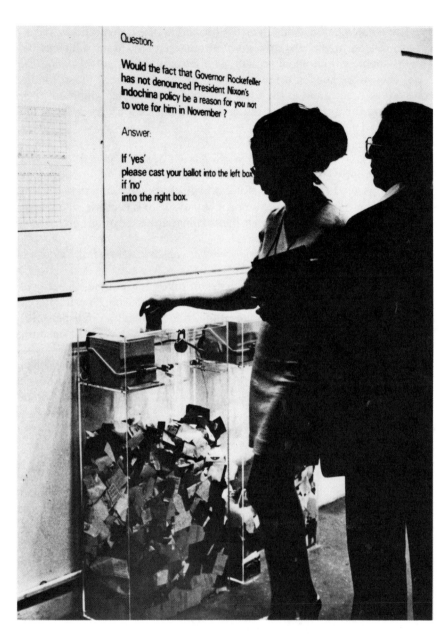

Question:

Would the fact that Governor Rockefeller has not denounced President Nixon's Indochina policy be a reason for you not to vote for him in November?

Answer:

If 'yes'
please cast your ballot into the left box
if 'no'
into the right box.

40. Hans Haacke, *MOMA Poll* (1970)
Courtesy of the artist

important financial and administrative capacities since its founding 40 years ago." With this little paragraph she provided some of the background for the work that was not intelligible for the politically less-informed visitors of the museum. She also articulated feelings that are shared by the top people at numerous museums. It goes like this: We are the guardians of culture. We honor artists by inviting them to show in *our* museum, we want them to behave like guests, proper, polite, and grateful. After all, we have put up the dough for this place.

The energy of information interests me a lot. Information presented at the right time and in the right place can be potentially very powerful. It can affect the general social fabric. Such things go beyond established high culture as it has been perpetrated by a taste-directed art industry. Of course I don't believe that artists really wield any significant power. At best, one can focus attention. But every little bit helps. In concert with other people's activities outside the art scene, maybe the social climate of society can be changed. Anyway, when you work with the "real stuff" you have to think about potential consequences. A lot of things would never enter the decision-making process if one worked with symbolic representations that have to be weighed carefully. If you work with real-time systems, well, you probably go beyond Duchamp's position. Real-time systems are double agents. They might run under the heading "art," but this culturization does not prevent them from operating as normal. The MOMA Poll had even more energy in the museum than it would have had in the street—real sociopolitical energy, not awe-inspiring symbolism.

Can you describe a social work that is not political?

Probably all things dealing with social situations are to a greater or lesser degree political. Take *The Gallery Goer's Residence Profile*. I asked the people that came to my exhibition to mark with a blue pin on large maps where they were living. After the show I traveled to all those spots on the Manhattan map that were marked by a blue pin and took a photograph of the building or approximately that location. I came up with about 730 photographs for Manhattan (naturally not every visitor participated in the game). The photographs were enlarged to 5″ by 7″. They will be displayed on the wall of the Guggenheim according to a geographical score. All those spots that were east of Fifth Avenue go upward on the wall from a horizontal center line, those west go downward. The respective distance from Fifth Avenue determines the sequence of pictures East and West. The Fifth Avenue spine takes up approximately 36 yards of wall space. Sometimes the photographs reach up to the ceiling, on other occasions (e.g., there is only one on the west side and none on

the east side) it becomes a very jagged distribution. The "composition" is a composition determined by the information provided by the gallery-goers. No visual considerations play a role.

All this sounds very innocent and apolitical. The information I collected, however, is sociologically quite revealing. The public of commercial art galleries, and probably that of museums, lives in easily identifiable and restricted areas. The main concentrations are on the upper West Side (Central Park and adjoining blocks, and West End Avenue with adjoining blocks), the Upper East Side, somewhat heavier in the Madison-Park Avenue areas, then below 23rd Street on the East and West sides with clusters on the Lower East Side and the loft district. The photographs give an idea of the economic and social fabric of the immediate neighborhood of the gallery goers. Naturally the Lower East Side pins were not put there by Puerto Ricans. Puerto Ricans and blacks (Harlem is practically not represented) do not take part in an art scene that is obviously dominated by the middle- and upper-income strata of society or their drop-out children. I leave it up to you as far as how you evaluate this situation. You continue the work by drawing your own conclusions from the information presented.

[The interview with Hans Haacke was published in May 1971 in *Arts*.]

41. Joseph Kosuth (1983)
 By: Robert Mapplethorpe
 Courtesy Robert Miller Gallery

Joseph Kosuth: Art as Idea as Idea

This interview was broadcast on WBAI on April 7, 1970. Kosuth, then twenty-five years old, had already caused quite a stir as *the* conceptual artist. One of the four participants in Seth Siegelaub's *January 5-31,* held in a rented space in New York in 1969 and acknowledged as the first exhibition of this art, he had for several years before this interview discovered and brought together conceptual artists from various countries and had been instrumental in organizing exhibitions and publications concerning conceptual art. In the month of this broadcast he was in a show at The New York Cultural Center—the first institutional exhibition of Conceptual art in America—and following that, one at The Museum of Modern Art called *Information.* Joseph Kosuth is represented in New York by the Leo Castelli Gallery. His first exhibition there had taken place in the year before this interview.

Jeanne Siegel: *"Art as Idea as Idea" is a subtitle that you have been giving your work since you first started photostating definitions from the dictionary. Joseph, what do you mean by "art as idea as idea"?*
Joseph Kosuth: Well, obviously, first one would question the necessity for the repetition, why not just 'art as idea'? The 'device' of the phrase is a reference to Ad Reinhardt, an early hero of mine. But the point is very much mine. Like every one else I inherited the idea of art as a set of *formal* problems. So when I began to re-think my ideas of art, I had to re-think that thinking process, and it begins with the making process. So what happened was a shift within what I understood was the context of the work. 'Art as idea' was obvious; ideas or concepts as the work itself. But this is a reification—it's using the idea as an object, to function within the prevailing formalist ideology of art. The addition of the second part—'Art as Idea *as Idea*'—intended to suggest that the real creative process, and the radical shift, was in changing the idea of art itself. In other words, my idea of doing that was the real creative context. And the

value and meaning of individual works was contingent on that larger meaning, because without that larger meaning art was reduced to decorative, formalist stuff.

It's interesting to see, on the level of practice, how work works. The works of mine that are more well known, to use as an example, are the definitions from the *First Investigations*. The early photostats were of definitions of materials I had been working with earlier, such as water, because of their indeterminate formal properties. I was trying to escape formalism, but I was trying to do it within its own terms, unfortunately. Earlier I had used definitions in a different kind of work using objects. It was a bit of a tangent effected by philosophy I had been reading, but very useful in opening up my idea of art. I realized then I could use the definitions alone in solving my dilemma about formless forms—in other words, by just presenting the *idea* of water—'art as idea.' But meaning doesn't function in a linear direction, it's more *multi*-directional. Using a text as art raised questions, using a photograph as art raised questions, the artifact of a dictionary definition raised questions. This was about the time I started reading a lot of language philosophy as well and this paved the way for me to start thinking about art in relation to language. It became clearer to me that the material of the work was these series of contexts or levels. It seems to me that when work works that's how it works.

If "Art as Idea as Idea" is the subtitle, then what's the title?

On the photostats I titled them all the same. It was titled already within the work, so I just titled the title.

Which depends on it being an abstraction?

That's what it was about. It was my way of dealing with abstraction. Art is always abstract. When you think about it, who is more abstract: Duchamp, Magritte, or Pollock? As I was saying a minute ago, besides all the art of this century which is evidence to the contrary, we inherited a philosophy of art that has a strong decorative, formalist bias. So as art students we are handed a set of presumptions: palettes, brushes, canvases, and a philosophy to go with them. Of course often our limitations present themselves as choices—such as the one between geometric and organic forms. I remember feeling very much that they had *both* been used up, but then where was I? If such forms—which together include all forms— had become invisible through overuse it had to mean that they are loaded with too much meaning—traditional meaning. But even if you can't invent new forms you can invent new meanings. I think that's really what an artist does. So I felt that all art was abstract in relation to cultural mean-

ū·ni·vēr′săl, *a.* [ME. and OFr. *universel*; L. *universalis,* universal, from *universus,* universal, lit., turned into one; *unus,* one, and *versum,* pp. of *vertere,* to turn.]

1. of or relating to the universe; extending to or comprehending the whole number, quantity, or space; pertaining to or pervading all or the whole; all-embracing; all-reaching; as, *universal* ruin; *universal* good; *universal* benevolence.

The *universal* cause,
Acts not by partial, but by general laws.
—Pope.

42. Joseph Kosuth, *Universal (Art as Idea as Idea)* (1967)
By: Jay Cantor
Courtesy Leo Castelli Gallery

ing, in the way that the noises we utter called words are meaningful only in relation to a linguistic system, not in relation to the world. That seemed to me a more interesting idea, more open and challenging, than the Cubist idea of abstraction we inherited, which is a formalist one of abstracting *from* . . . from 'nature.' Like in art school where you abstract a leaf to its 'essence' until you can't see that it's a leaf anymore.

What was the progression toward your form of abstraction?

After I stopped doing paintings in the traditional sense, the first piece I did was one using glass because it was clear and there were obviously no compositional problems as far as choice or location or color. (I agree with Judd when he says that composition is old world philosophy. I think it presumes as it constructs an interior, magical space, which ultimately refers back to painting's earlier religious use.) Also, I found that according to color psychology there was more of a transcultural response to achromatic color—black, white, and gray—than to the chromatic scale, which had a much more marked difference among specific individuals as well as between cultures. So my last paintings were achromatic. It's interesting how the serious early work of most artists tends to be achromatic—early Warhol and Lichtenstein, Rauschenberg, Flavin, Stella, Cubism. *Broadway Boogie-Woogie* could only be late Mondrian . . . when you're trying to make a statement there is no place for color.

So I liked glass because it had no color to speak of, except for the color it reflected from its environment. There was always the problem of form, though. So I tried presenting it in different conditions—smashed, ground, stacked, and this led me in another direction. The first use of language began with this work. With the first glass piece it was the label which took on a great importance. That piece was just a five foot sheet of glass which leaned against the wall, and next to it was a label with the title: "Any Five Foot Sheet of Glass To Lean Against Any Wall." (A former friend of mine is making a whole career out of this piece, I guess that's flattery.) I succeeded in avoiding composition, and I had succeeded in making a work of art which was neither a sculpture (on the floor) nor a painting (on the wall). I wasn't certain how 'abstract' it was, but it was certainly ambiguous. From the work with glass I began working with water, for most of the same reasons. Water had the advantage of being 'formless' as well as 'colorless.' Even now this seems too much like the simplistic meanderings of an art student, which I was, but it seemed like very heavy stuff at the time.

Then you made the transition to working with words?

Yes, both the use of words in my work and my interest in language in general began at that time—1965. In the glass piece I just mentioned

and in other glass works, the use of words became increasingly important. One solution to the problem of form at the time was to make a division between 'abstract' and 'concrete' within the work itself, such as the work with three glass boxes I referred to a minute ago—one was filled with smashed glass, one with ground glass, and the other had stacked glass. And on each of these boxes the word 'Glass' was lettered. This way, by reducing the concrete formal properties to the one abstraction 'glass,' the work arrived at a kind of formless, colorless state as a physical 'device' (not unlike language) within that art system which was that work. So you had the abstraction 'glass.' Language began to be seen by me as a legitimate material to use. Part of its attraction too was that by being so contrary to the art one was seeing at that time it seemed very personal to me. I felt I had arrived at it as a personal solution to personal art problems. So then I used photostats of dictionary definitions in a whole series of pieces. I used common, functional objects—such as a chair—and to the left of the object would be a full-scale photograph of it and to the right of the object would be a photostat of a definition of the object from the dictionary. Everything you saw when you looked at the object had to be the same that you saw in the photograph, so each time the work was exhibited the new installation necessitated a new photograph. I liked that the work itself was something other than simply what you saw. By changing the location, the object, the photograph and still having it remain the same work was *very* interesting. It meant you could have an art work which was that *idea* of an art work, and its formal components weren't important. I felt I had found a way to make art without formal components being confused for an expressionist composition. The expression was in the idea, not the form—the forms were only a device in the service of the idea.

So, you were working mainly with language?

Increasingly, yes. It was the system of language itself which I felt held great implications when considered in relation to art which interested me. I've been very wary of using words as objects—concrete poetry and that sort of thing. Its been thinking about language as a cultural system parallel to art which makes it useful, both in theory and in practice. So the works I talk about now, which interest me the most now, are the ones which I learned something from, and have led me to do the work I'm doing now. I've been working on games, and other meaning-generating systems. Even the most abstract work has a kind of concrete level, which is the fact that the functional part of it must be contextually contingent. So instead of working with the relations between objects, or forms, like most art, I'm trying to do work with the relations between relations. The

work with common objects was a simple start, but those works are static. I want this work to be more dynamic—less of an illustration and more of a test.

How have you presented the games?
The earlier work was photographically 'blown-up,' which was just reproducing habits from painting, I suppose, but there was enough going on in the work to sever it from tradition anyway, and if you cut all the connections then no connection is made. But one thing did bother me eventually, which was this *group* experience to works of art, which is necessary for the sort of heroics and monumentality that traditional art feeds on. So the work since the *Second Investigation* has insisted on a kind of individual contemplative state. Usually they're small. Sometimes in notebooks. Or, for example, like the work in the Whitney Biennial, where although I have a whole wall, the parts of the work are typed on normal-sized labels where only one person at a time can read them.

Is it meant to be preserved as a permanent piece?
I have no interest in that. Those labels are thrown away or whatever. It's just the information. And the art really doesn't exist in terms of its reunification.

There it is up on the wall. What do you expect the viewer to do with it?
They are supposed to read it, that's all. I think culture is a kind of intersubjective space. So art connects in a way which is more than simple, visual pleasure. If I pander to the viewer in a kind of show-biz way I compromise those uncomfortable ruptures of the supposed 'normal' way things are expected to go. I don't want to risk doing that. That de-politicizes art, cancels it out. The so-called 'avant-garde' is a political history if it is anything. I couldn't imagine a more banal activity than simply providing visual kicks to the public. Of course that's how a lot of artists see their role. But let's face it: there's a lot more dumb people out there than there are smart ones, so if your goal in life is to be popular, and/or rich, the choice isn't a difficult one.

Is the viewer supposed to solve the riddle itself?
That's part of the riddle, my riddle.

I gather you see little connection of your art to poetry?
Absolutely no relationship at all. It's simply one of things superficially resembling one another. A poet wants to say the unsayable. That's the reason the concrete poets have begun doing 'street work' projects

because of the fact that they don't feel in many ways that language is adequate to make the kind of statements they want to make. And so they've been doing a lot of performance pieces as well. But the typical concrete poem makes the worst sort of superficial connections to work like mine because it's a kind of formalism of typography—it's cute with words, but dumb about language. It's becoming a simplistic and pseudo-avant-garde gimmick, like a new kind of paint.

What do you see as the relationship between your use of words and Wittgenstein's linguistic theories?

That's a long discussion, and a difficult one. On one level there is an obvious, too obvious relationship, which shouldn't be said; and there is another, more complex, less apparently conscious one, which can't be said—at least outside of the work itself. In any case I see no advantage in connecting my work to philosophy any more than it already is. The thing to remember is that such a discussion would be a discussion about art, not philosophy; the point being is that artists use things. Art is itself philosophy made concrete. So the academic exercise of what is called Philosophy isn't particularly relevant, and too easily misunderstood.

There was really only one point in my work when it had a particular relevance, which is that earlier period (1965) we've been discussing. Actually, for quite a while I never really connected the philosophy I was reading with the art I was making. Mostly, I suppose, because like everyone else I'm a product of this system that tends to keep things disconnected (and in their neat categories) rather than connected, with a larger more holistic view. It is very easy to make some kind of superficial relationship with someone like Wittgenstein. But even then, if that were clear, there is early Wittgenstein and late Wittgenstein, with the latter repudiating the former, and even then in a particular way. I would guess that whatever connections there are between his work and my work is also true for all art, it's just that my art makes that connection more visible.

There are aspects to work which preceded mine—people like Andre or Flavin—which have a bearing on the kinds of discussion about art which I've tried to help generate. If you can make your point with work which is somewhat more acceptable as art than your own, then your heuristic task is a couple of notches closer, one hopes. Anyway, issues of function having to do with meaning being contingent on use are particularly relevant to someone like Flavin. The value of his work is the power of his art as an idea—I don't think one can seriously argue that it is due to craft, composition, or the aura of the traces of his hand.

Anyone can have a 'Flavin' by going into a hardware store, but you needed Flavin's initial 'proposal' for it to be art.

That's a similarity between philosophy and art. I suspect that at this moment in time, your work would be subject to misunderstandings. Many people might look at it and say, "Well, this is philosophy, not art."

I call it art and it came out of art. I have had a traditional, even classical, art education—it's perhaps because of that I've been able to work through certain ideas of tradition that others find necessary to appeal to. As for philosophy, serious thought about any endeavor takes on a philosophical character; as for Philosophy (capital P), it's an academic subject with no real social life and little cultural effect. It seems we are in a kind of post-philosophical period; as the power of philosophy atrophied beginning with this century, the philosophical thrust of art increased and I don't think that is a coincidence. As science replaced religion, philosophy also lost its social base and became a subject for universities only. Because we are in this long-term transition, art's actual role is ambiguous—in many ways it is a manifested form of the very cultural mechanism itself—but the role it is forming for itself is not unrelated to the gaps forming by these shifts.

There seem to be certain premises that you have accepted as absolute bases for your work. One of them is the Duchampian-based idea that "if someone calls it art it's art."

What else could be the case? If one says otherwise it means you are suggesting that the work itself must tell you. This, of course, suggests the most reactionary kind of theory of art, one based on morphological characteristics as the sole definition of art. The culture—greatly thanks to Duchamp—has already been forced to accept a larger concept of art.

That appears to be another premise—the fact that your definition of what art is, is what separates you from all of the other art before. Can you state what your idea of art is?

That's no single simple statement. What my idea of art is comes out in both my propositions—that is to say, the specific work I show—and my activities in the production of any meaning in relation to art: such as articles I write, lectures at universities, my teaching at the School of Visual Arts, or conversations such as this one. (In fact, you could say this interview is the answer to your question.) An example I always use for my students is Ad Reinhardt—what makes him an artist isn't just that he painted black paintings. What those paintings mean is a product of his total signifying activity: lectures, panel discussions, "The Rules For A

New Academy,'' cartoons, and so forth. Our experience, and the meaning of that experience, is framed by language, by information. Seeing is not as simple as looking.

Let's just take one idea, for instance, the idea that an artist is now one who questions the nature of art.

I think to be an artist now means to question the nature of art—that's what being 'creative' means to me because that includes the whole responsibility of the artist as a person: the social and political as well as the cultural implications of his or her activity. To say that the artist only makes high-brow craft for a cottage industry's specialized market might satisfy the needs of this society from the point of view of some people, but it's an insult to the valued remains of an 'avant-garde' tradition, and a denial to artists of their historical role. And unless artists re-conceptualize their activity to include responsibility for re-thinking art itself, then all that is of value in art will be subsumed by the market, because then we will have lost the moral tool to keep art from just becoming another high-class business. In any case, what is more 'creative' than creating a new idea of what art is? And hasn't the best art of this century been concerned with just this task? The best art when it was new seldom 'looked like art' and was never beautiful—to most of the public it was ugly and boring.

In contrast, a lot of the stuff that at the time becomes fashionable and people are interested in because it's exciting often fades away because it is really glamour, a high-brow version of show business. There is still so much of that.

If you feel that the artist is now stating the intentions, what do you feel will be the role of the critic, if any?

I don't know. It's hard for me to imagine. There are people who write and it seems like a lot of science, but it's really a kind of journalism. I guess it can be more obviously journalism. Instead of magazines like *Artforum* or *ARTnews*—it will all probably be written about in *Newsweek* and *Time* and *New York* magazine, God forbid the thought! But critics today really seldom get into the nitty-gritty of what the works of art are.

Perhaps this is just what separates the good from the bad critics.

Yes, the better ones, I suppose, are closer to artists, in a sense. But argument is with artists who feel that they can fashion an object in some sense and put it out in the world and not say a word about it and let all the thinking about it be done by others. The artist has just become a sort of a prop man, a dummy, and the critics do all the thinking and order the

way in which you see it, and any sort of thinking around the work is presented by them and not by the artist. So that they really become makers of the Readymade, for the critic. That's what I object to.

How do you see your relationship to the other conceptual artists at this moment?

Pretty hostile at this point. There are only a few that I'm interested in. Some of the hostility is patricidal, frankly; in other cases I have to take some of the responsibility because they don't like things I've said about them (or didn't say about them) in articles or interviews or their treatment in exhibitions that I have input into . . . things like that. I don't think my influence in this area is inappropriate, of course. My work, as well as my activity in promulgating this point of view precedes others by at least a couple of years. I feel many of them 'arrived' after most of the hard work was done and it was a fashionable 'art movement.' I suppose they know I feel this way and understandably resent it. Many of my American friends also don't understand my support of Art & Language in England. They are important to me because I can talk to them about art from a perspective, theoretically, that my American friends can't or won't.[1] Whether it is simplistic to attribute it to England's rich linguistic/literary tradition I don't know, but philosophically my exchange with them is good. As far as their actual art practice is concerned it is much less strong, they seem to be embarrassed by their own subjectivity, maybe that's an English tradition, too. With American artists it is the reverse. Their ideas of art are much more traditional—much of it is really a kind of Minimal art using words—but they at least have the strength of conviction to actually make it. So straddled as I am between the two, I seem to be in a good position to make the points I need to.

What do you consider to be the influence of Duchamp?

I don't find it pervasive in the way it's usually thought of; if that were the case work like mine would have occurred much sooner. He may very well turn out to be the most important artist in the first half of this century (thanks, of course, to what we are planning in *this* half!) . . . an outrageous thought to the rabid protectors of institutionalized modernism. Poor Picasso, poor Matisse. The uncomfortable truth is that an artist like Picasso provides the dirt in which an artist like Duchamp grows. And Matisse? That's the fertilizer.

Seriously, though, Duchamp maintained the radical alternative all the while modernism was gaining respectability; it is almost as though art had to reach a point of maturation before Duchamp could really be usable. This is, of course, all terribly unhistorical, but it's not simply sentimental.

The implications of Duchamp's work are vastly more profound than any artist I can think of. Certain aspects of his work have been slowly internalized, certainly, but I can't imagine how one could proceed with a radical re-thinking of the art of this century without Marcel Duchamp providing a source for the tools which could make that possible. Duchamp has been there for others as a source, in various ways and for some time. Certainly Johns and later Morris and others kept his ideas alive, but that was because they used and got certain things from that work, while perhaps I'm getting other things from it.

Like what, for example?
 Well, for one thing, in the idea of the unassisted Readymades, there is a shift in our conception of art from one of "What does it look like?" to a question of function, or "How does an object work as art?" which brings into question the whole framing device of context. . . .

I'm sorry but I'm afraid I'm going to have to interrupt you in the middle of Marcel Duchamp because we're running out of time.
 I'm sure he wouldn't have minded anyway.

[This interview with Joseph Kosuth was broadcast on WBAI on April 7, 1970.]

Notes

1. Among his American friends Kosuth is referring to Robert Barry, Lawrence Weiner, and Douglas Huebler. The leading Art & Language people were Charles Harrison, Terry Atkinson, and Michael Baldwin.

Index

Other DACAPO titles of interest

Available at your bookstore

OR ORDER DIRECTLY FROM

DA CAPO PRESS, INC.

1-800-321-0050